Through a Native Lens

The Charles M. Russell Center Series on Art
and Photography of the American West
B. Byron Price, General Editor

Through a Native Lens

AMERICAN INDIAN PHOTOGRAPHY

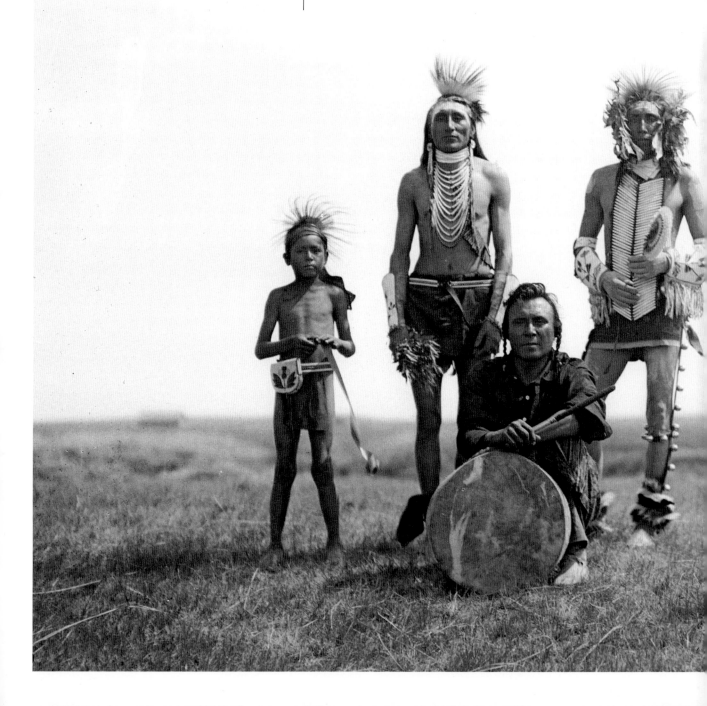

NICOLE DAWN STRATHMAN

University of Oklahoma Press : Norman

 Publication of this book has been aided by a grant from the Wyeth Foundation for American Art Publication Fund of CAA.

 Generous assistance has been granted by Furthermore: a program of the J. M. Kaplan Fund.

Uncaptioned images appear on the following pages, as noted:

Pages ii–iii: Crow Male Dancers, c. 1905–11. (*Center, front*) Caleb Bull Shows with drum; (*standing, left to right*) Harry Bull Shows [son of Caleb], Frank Hawk, unknown man, and Mortimer Dreamer. Photo by Richard Throssel. Richard Throssel Collection, American Heritage Center, University of Wyoming, ah02394_0645

Page vi: Harry A-hote (detail), c. 1930. Photo by Horace Poolaw. See figure 4.2, page 92.

Page viii: Two indigenous girls, c. 1905. Photo by Benjamin Haldane. National Archives, Sir Henry Wellcome Collection, 297485

Page xii: *Self Portrait of Benjamin A. Haldane from View of Metlakatla, Alaska, Residences* (detail), c. 1900. Photo by Benjamin A. Haldane. National Archives, Sir Henry Wellcome Collection, 297865

Page 182: Unidentified indigenous man, c. 1910. Photo by Benjamin A. Haldane. National Archives, Sir Henry Wellcome Collection, 297528

Page 196: Eaton family portrait, c. 1910. Photo by Benjamin A. Haldane. National Archives, Sir Henry Wellcome Collection, 297620

Library of Congress Cataloging-in-Publication Data

Names: Strathman, Nicole Dawn, 1974– author.
Title: Through a Native lens : American Indian photography / Nicole Dawn Strathman.
Other titles: Through Native lenses
Description: First. | Norman : University of Oklahoma Press, [2020] | Series: Volume 37 in The Charles M. Russell Center series on art and photography of the American West | Revision of the author's thesis (doctoral—University of California, Los Angeles, 2013) under title: Through Native lenses. | Includes bibliographical references and index. | Summary: "A critical overview of how Native Americans appropriated photography and integrated it into their ways of life, both as patrons who commissioned portraits and as photographers who created collections, between 1840–1940 throughout the United States and Canada"—Provided by publisher.
Identifiers: LCCN 2019030454 | ISBN 978-0-8061-6484-7 (hardcover)
Subjects: LCSH: Indians of North America—Portraits. | Indian photographers. | Photography—Social aspects—United States. | Photography—Social aspects—Canada.
Classification: LCC TR681.I58 S77 2020 | DDC 770.89/970973—dc23
LC record available at https://lccn.loc.gov/2019030454

Through a Native Lens: American Indian Photography is Volume 37 in The Charles M. Russell Center Series on Art and Photography of the American West.

The paper in this book meets the guidelines for permanence and durability of the Committee on Production Guidelines for Book Longevity of the Council on Library Resources, Inc. ∞

1 2 3 4 5 6 7 8 9 10

For Clayton Sampson and Polly Roberts

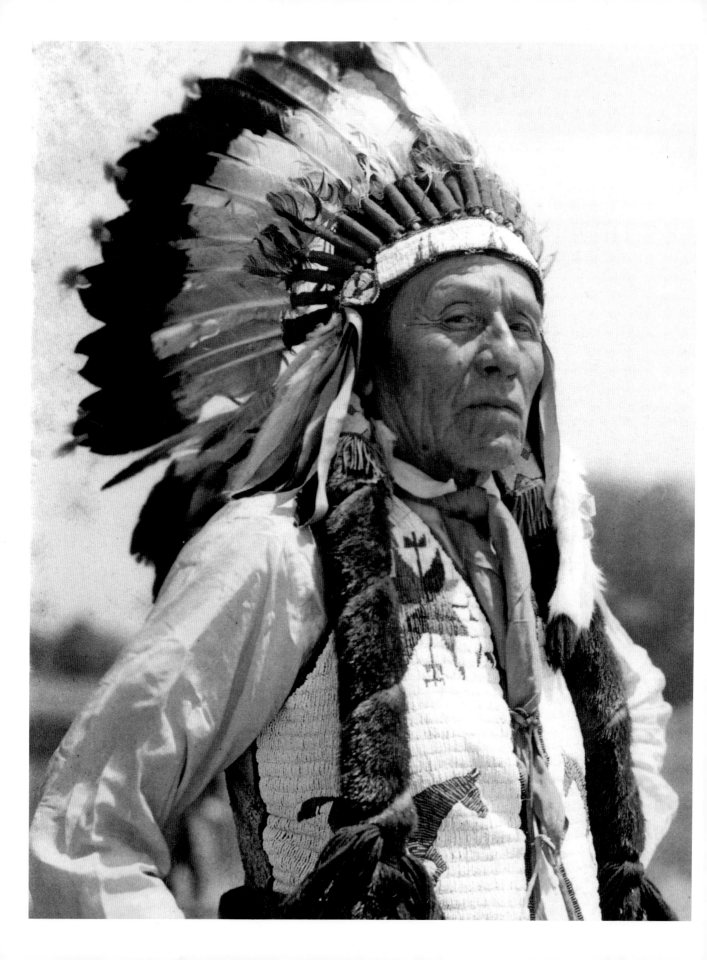

Contents

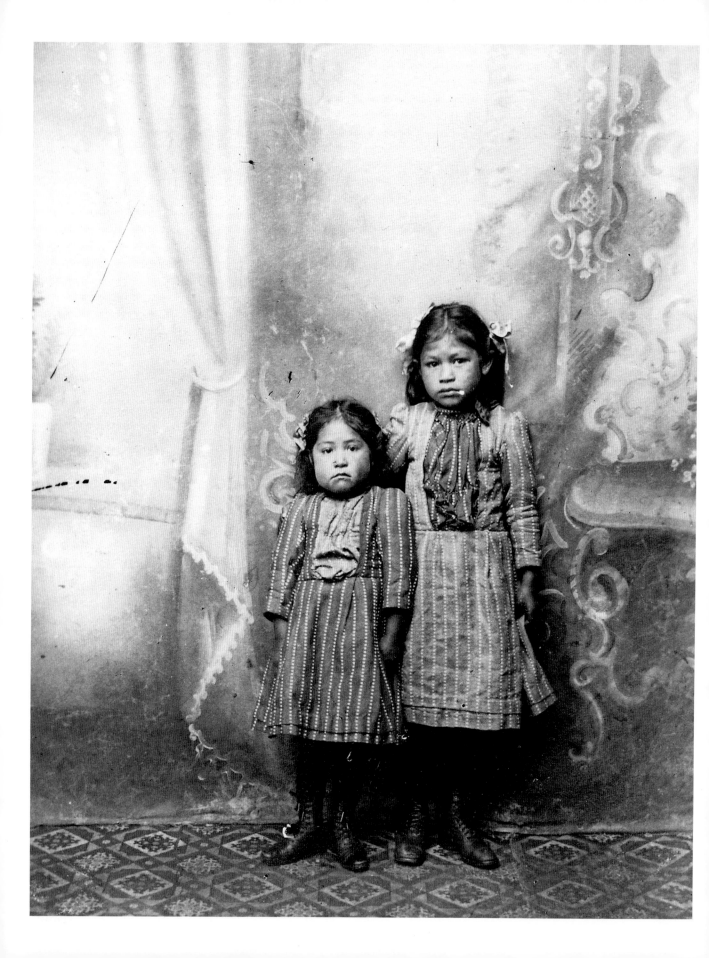

Acknowledgments

First and foremost, I want to thank the indigenous photographers and Native sitters whose participation in the medium made this book possible. I also extend my thanks to their families and tribal communities who graciously shared their photographs with me.

Joanna Cohan Scherer, illustrations researcher for the *Handbook of North American Indians,* was instrumental in the early phases of my project by sponsoring me for a Smithsonian Fellowship. Without her, I would have been unable to find the vast array of Native-produced photographs located throughout the United States and Canada. She introduced me to her colleagues at the Smithsonian, including Rayna Greene, Frank Goodyear III, and Jennifer Brathovde, all of whom provided valuable feedback. At the Smithsonian, I also participated in the Summer Institute in Museum Anthropology (SIMA) program. The program mentors, Candace Greene and Nancy Parezo, led workshops that were germane to my work.

I extend my appreciation to the many archivists and librarians who have assisted me in my research, particularly Chester Cowan and William Welge at the Oklahoma Historical Society; Kim Walters at the Autry National Center's Braun Research Library; Shirley Erhart at the Mason County Historical Society; Brenda Berezan and Nadine Helm at the Yukon Archives; and the staff members at the Cherokee

National Archives, National Anthropological Archives, Cumberland Historical Society, Northeastern University Archives, University of Oklahoma Western History Collections, and the American Heritage Center at the University of Wyoming.

Special thanks go to former museum director Sharron Chatterton at the George Johnston Museum in Teslin, Yukon Territory. Over the years, she patiently answered my questions via phone, email, and in person. The current museum manager, Ryan Durack, should be commended for answering all of my follow-up questions. In Teslin, I also had the opportunity to speak with former museum director Tip Evans, who is currently the director of heritage for the Teslin Tlingit Council. A longtime resident of Teslin, he provided a valuable history of the area. Scholars who work in the Yukon have also been incredibly helpful; of note are University of British Columbia professors Jennifer Kramer and Julie Cruikshank. Both took the time to speak with me and share their scholarship. Yukon historian and journalist Jim Robb was an endless source of information on local history and lore. Archivist Linda Johnson and the Council for Yukon First Nations allowed me to include some of George Johnston's images. Thanks to the Teslin Tlingit elders, especially Sam Johnston, Pearl Keenan, Carol Geddes, Marian Horne, and Pauline Sidney.

In Tahlequah, Oklahoma, David Fowler, the director of Hunter's Home, served as my point of contact for his Cherokee community. I called upon him frequently, and he made sure that my numerous questions were answered. On more than one occasion, he stopped what he was doing in order to drive me across town to introduce me to someone who could help with my research. His generosity knows no bounds. His assistant in charge of Hunter's Home, Amanda Burnett, was equally accommodating. Shirley Pettingill, the former director of the house museum, also shared her extensive knowledge of the site and the Ross family. But Robert Bruce Ross IV provided the most detailed information about his family's home and aunt's photographs. Elsewhere in Tahlequah, Karen Harrington, the former proprietor of the Black Valley Trading Post, kindly shared her collection of Jennie Ross Cobb images with me. The foremost scholar of Jennie Ross Cobb, Joan M. Jensen, professor emeritus at the University of New Mexico, took time to compare notes and point me in new directions. In addition, I would like to thank Linda Poolaw and Charles Junkerman for their contributions on the photographs of Kiowa photographer Horace Poolaw. And thanks to the late great Clayton Sampson, who spoke to me for hours about his father, Harry Sampson, and their tribal community, the Reno Sparks Indian Colony.

Scholars who were kind enough to respond to my questions and often shared unpublished research and interviews with me include Clyde Ellis, Mique'l (Askren) Dangeli, Veronica Passalacqua, and Llyn De Danaan. I am indebted to my reviewers, Sergei Kan and an anonymous scholar, who both read and reread my manuscript,

each time providing invaluable constructive criticism. My editor, Alessandra Jacobi Tamulevich, is nothing short of amazing, and I appreciate her gentle hand-holding throughout this entire process. Her colleagues at the University of Oklahoma Press are equally incredible. The Press itself should be acknowledged for its long-standing commitment to American Indian scholarship, and I feel honored to have my work included in their catalogue.

I am grateful to the institutions and organizations that funded my research, including the Smithsonian Institution, American Philosophical Society Phillips Fund for Native American Research, UCLA Eugene Cota Robles Fellowship, Autry National Center, UCLA Institute of American Cultures, Department of Women's Studies at UCLA, and my home department at UCLA, World Arts and Cultures. This book could not have been published without the generous support from the J. M. Kaplan Fund (Furthermore Grant), the Wyeth Foundation for American Art, Textbook and Academic Authors Association, and the Charles M. Russell Center.

Special thanks to my mentors at UC Riverside, who started me on this amazing journey—Cliff Trafzer, Monte Kugel, and Catherine Allegor. At UCLA, I would like to thank Peter Nabokov, Jessica Cattelino, and David Shorter for their time and thoughtful critiques of my work. I was blessed with an amazing doctoral committee comprising Polly Roberts, Steve Aron, and Al Roberts. As a role model, Polly Roberts brought years of experience working in museums and academia to my project. Steve Aron, whom I met ten years ago while working a job in the "real world," provided frank criticism and insisted on a solid, historical foundation for my work. My chair, Al Roberts, made me feel like his only student. I truly appreciate the time and effort he put into perfecting my prose and supporting my academic endeavors. It was a long road from dissertation to book manuscript, and I sincerely appreciate all of the individuals who offered praise, commentary, and coffee.

Finally, I could have never completed this book without my kids, Elspeth and Alta, who ensured that I took sufficient breaks for picnics and dress-up time. I am grateful for my parents, Carl and Mary Goude, who encouraged me to keep pressing forward even when faith in myself was lacking. And last, but not least, many thanks to my husband, Josh. His careful editing gave me the chance to say that "my lawyer looked it over," and his love has kept me strong. Thank you all for your patience in realizing this project.

Through a
Native Lens

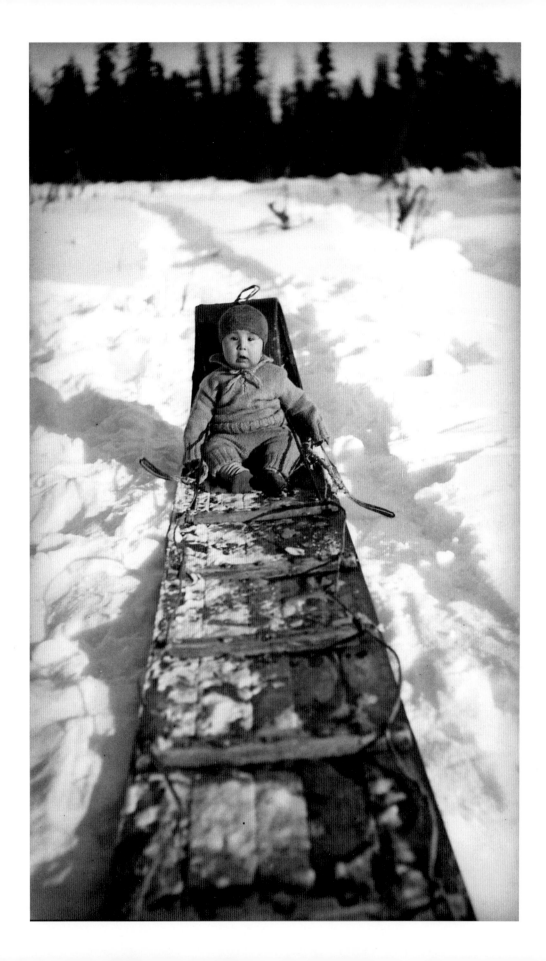

Introduction
Native American Photography

When Native people do pick up the camera, often their image making is greeted with a patronizing welcome. The "Indian" no longer sits passively before the camera, but now operates the camera—a symbol of white man's technology.

— **THERESA HARLAN** (Santo Domingo/Jemez Pueblo)

The phrase "Native American photography" more often refers to the work of non-Native photographers like Edward Curtis than to Native Americans taking pictures themselves. Yet starting in the latter half of the nineteenth century, American Indians were using cameras to record events from daily life and to remember tribal members. Like their Euro-American counterparts, they visited photography studios to have their portraits made, and they snapped pictures of friends, family, personal belongings, and special events. But unlike the Western photographers of Native Americans, indigenous photographers generally did not emphasize or deemphasize the "Indianness" of their subjects. The images they created did not show noble savages or assimilated groups but instead depicted a proud and resolute people retaining their cultures while embracing modern technologies. For instance, in remote Yukon Territory, George Johnston (Inland Tlingit) always had his Kodak Brownie with him, and from 1915 to 1942 he recorded the "golden age" of his people, the Teslin Tlingits, before the Alaska Highway bisected their village (figures i.1 and i.2). In this same region, Benjamin Haldane (Tsimshian) opened what is perhaps the first photography studio on a reservation, the Annette Island Indian Reserve, in Metlakatla, Alaska. From approximately 1899 to 1930, First Nations people frequented his studio to have their portraits made (figures i.3 and i.4). These are just two examples of the Native

FIGURE i.1

Matthew Thom on a Teslin-built birch toboggan, c. 1940
Photo by George Johnston
Yukon Archives, George Johnston fonds, 82/428 #86

FIGURE i.2

One boy and five men
standing in front of Jack
Morris's house, c. 1920
(*Left to right*) Matthew
Jackson, Jack Morris, Charlie
Jackson, William Johnston,
Frank Johnston, and Shorty
Johnston, all Wolf moiety
Photo by George Johnston
Yukon Archives, George Johnston
fonds, 82/428 #63

photographic practices to be discussed here. Please note, this is not a comparative study. I do not attempt to make aesthetic judgments about the photos, in relation to the work of other indigenous photographers or their non-Native contemporaries. Given that the photographers had different levels of expertise, access to camera equipment of varying quality, and the facility to store prints and negatives effectively, it would simply be an unfair analysis. I consider each of the Native photographic consumers and producers in turn, standing on their own merits. It would also be irresponsible to ignore the work of non-Native photographers entirely, since such figures as Edward Curtis were influencing (and in one case training) indigenous photographers. As art historian Teresa Harlan (Santo Domingo/Jemez Pueblo) says, "The camera technique and even the choice of subject may be similar, but the interest and the treatment of the resulting works is not."[1]

This book offers a critical overview of how Native North Americans appropriated photography and integrated it into their ways of life in the second half of the nineteenth and early twentieth centuries, both as patrons who commissioned portraits and as photographers who created collections. Presented as a type of visual genealogy, the text traces the origins of Native participation in photography from the first individuals and groups who commissioned and controlled their own images to the Native practitioners of photography who adopted the medium to document the lives of their communities. This includes professionals such as Benjamin Haldane

FIGURE i.3

Indigenous boy with
a toy gun, c. 1900

Photo by Benjamin Haldane

National Archives, Sir Henry
Wellcome Collection, ARC 297483

(Tsimshian) and Richard Throssel (Crow/Scottish/adopted Cree), who opened studios on their respective reservations, and amateur snap-shooters, like Harry Sampson (Northern Paiute) and Jennie Ross Cobb (Cherokee), who left a wealth of visual information through their collections. The primary sources under investigation are early photographic images dating between 1840 and 1940, created for and by indigenous peoples throughout the United States and Canada.

It should be noted that some individuals (such as Richard Throssel) included in this survey of indigenous photographers are people of mixed-race descent. Because of colonization, assimilation practices, and tribal policies, Native North American

communities comprise tribal members with complex and varied racial backgrounds.[2] Regardless of their mixed ancestry, the people I discuss generally identified as members of their Native communities. Through their documentation, both visual and otherwise, they exhibited a sense of cultural pride and ethnic identity. Furthermore, most of these individuals maintained ties to their tribal homelands, so their photography collections have stayed with their people and retained their cultural context.

In recent years, snapshots of indigenous peoples by non-Native local photographers (including teachers, clergy, doctors, ranchers, and Indian agents) have been a popular topic of study—understandably so, since many of the figures lived among, married into, or were adopted by the tribal groups. These non-Native local photographers include amateur Annette Ross Hume in Oklahoma, Indian agent Lee Moorehouse in the Pacific Northwest, ethnographer Thomas B. Marquis in the Plains, Indian post photographer L. A. Huffman in Montana, Russian-American amateur Vincent Soboleff in Alaska, local commercial tourist photographer H. H. Bennett in the Wisconsin Dells, and former government photographer Walter McClintock in Montana.[3] Collectively, these images are important for illustrating the daily lives of the indigenous communities. In many cases, these photos are indiscernible from the Native-produced snapshots to be discussed here, and just as candid. The main difference is that the photographs did not stay and circulate within the family albums of the tribal communities pictured but instead were destined for the archives.

Some historical family photographs have been published by the people themselves, particularly Native authors who use photos to support personal stories and autobiographies.[4] For these authors, the photographs are not just illustrations but an integral part of telling one's personal history, so that the authors' life stories become intertwined with the imagery. As Leslie Marmon Silko (Laguna Pueblo) writes in *Storyteller,* "The photographs are here because they are part of many of the stories and because many of the stories can be traced in the photographs."[5]

Texts devoted exclusively to photography produced by American Indians are few and far between. Most fall into one of the following categories: photo-elicitation projects, exhibition catalogues, or reflection essays. Photo-elicitation projects involve collecting photographs from the archives, or from the communities themselves, and using them in interviews to solicit oral histories.[6] Though elicited stories are important in and of themselves, this research method focuses so much on the people pictured that it nearly overlooks the lives and practices of the Native photographers. Some exhibition catalogues provide more information on indigenous photographers, but the text is often limited to a brief biographical sketch or a short caption.[7] Reflection essays, personal impressions regarding an image or a set of images, have been written by both Native and non-Native authors. For example, Simon Ortiz's

FIGURE i.4

George Bond Kininnock,
his wife Maggie, and his
children Emma and Maude,
c. 1900
Photo by Benjamin Haldane
National Archives, Sir Henry
Wellcome Collection, ARC 297969

edited volume *Beyond the Reach of Time and Change: Native American Reflections on the Frank A. Rinehart Collection* (2004) features fourteen essays by indigenous artists and scholars—some of whom are descendants of the photographic subjects—commenting on a selection of American Indian portraits housed at Haskell Indian Nations University. Similarly, in Lucy Lippard's *Partial Recall: Photographs of Native*

North Americans (1992), each of the thirteen contributors selected a family photograph or archival image through which to discuss his or her ancestors and Native continuance, and generally to disrupt the normative meanings of the images. These types of critical commentaries provide useful insights on Native photographies, and this text is intended to add to that discussion.

This book differs from these earlier examples in several ways. First, I do not deal with repatriated archival images. Returning images to their source communities has been a popular research method, but rather than concentrate on *recovered histories* this text focuses on *enduring memories.*[8] Second, I do not focus exclusively on the work of professional photographers. Although there are some remarkable Native photographers working today, including Zig Jackson (Diné/Bilagáana), Larry McNeil (Tlingit), Wendy Red Star (Crow), Will Wilson (Diné), and Hulleah Tsinhnahjinnie (Seminole/Muscogee/Diné)—just to name a few—there is relatively little research completed on indigenous photographers working prior to 1950. Finally, I do not attempt to reconcile "inaccuracies" in Native American photography.[9] Dispelling misconceptions about American Indian culture by calling attention to the myths and stereotypes in photography has been a prevalent trend in scholarship for the past few decades, especially since Christopher Lyman exposed the fallacies in Edward Curtis's work.[10] Instead, I focus on early photographs produced and commissioned by American Indian and First Nations peoples.

The goal of this book is to show that the photographs taken by early Native photographers and created for indigenous sitters stand as counterimages to the more prominent visual narrative of a disappearing race. Of course, I am not the first author to address the issue of indigenous agency in regards to photographic representation. Shamoon Zamir (2014) argued that Edward Curtis's Native subjects had more input in their photographs than was previously suggested by Lyman. In her 2002 book, *Print the Legend,* Martha Sandweiss included a chapter that richly contextualizes the relationship between American Indians and photography. And several monographs have explored Native uses of photography, such as Frank Goodyear III's photographic biography of Red Cloud (2003) and Peggy Albright's (1997) catalogue raisonné of Richard Throssel. In this book, I build upon these previous works to provide a survey of early indigenous photography, and I offer a working classification of Native photographers according to their degree of professional training—or lack thereof.

I originally became interested in this topic while working at the Autry Museum in 2003. At that time, the museum had recently merged with the Southwest Museum of the American Indian, and there was talk of creating an exhibition based on some Edward Curtis photographs that were found during an inventory. I asked if there were also Native-produced photographs made during the time Curtis was active

(1900–25), but the staff was unaware of any extant examples. A colleague put me in touch with visual anthropologist Joanna Cohan Scherer, the illustrations researcher for the Smithsonian's *Handbook of North American Indians* (a fifteen-volume ency- clopedic reference source), who strongly believed that a text written about a people should be illustrated by those same people. Under her mentorship as a Smithsonian fellow, I reviewed her field notes, examined the unpublished photographs collected for the *Handbook,* and followed up with her Native contacts. It is this experience that provided my initial foray into image research in Indian country.

Much of the photographic data was collected from state, territorial, and tribal archives in the United States and Canada. I also identified and obtained images from photo collections at the National Anthropological Archives, the American Heritage Center in Wyoming, and various historical societies. Other sources included small community museums, libraries, heritage centers, and in a few cases the Native families themselves. It may be evident that I did not limit my research to only one tribe or geographic area. For the period covered (pre-1940), relatively few tribes have extensive collections of early images. The resulting research presents a broad swath of indigenous-produced imagery from Native North America. It goes without saying that most of the photographs discussed here have not been published previously.

To account for activity in front of—and behind—the camera, the text is divided into two parts: participants and practitioners. Part I focuses on Native participants, the active sitters who were agents in their own representations. I identify two basic types of sitters—famous Indian leaders and everyone else—and in each case they had their own motivations for curating and controlling their own images. Part II examines Native practitioners, whom I divide into three categories based on their level of experience: professional, semiprofessional, and amateur. Both parts provide additional contextualization as follows.

Part I situates American Indian photography within the history of photography. Native Americans were familiar with photography before they picked up cameras themselves. Rather than consider indigenous subjects as passive victims of Western photographers (although they were sometimes just that), I emphasize their *partici- pation* in their own photographic representations. Such an approach runs counter to some earlier scholarship, which found that images of Native Americans were produced by institutions and individuals acting as agents of cultural imperialism and structural racism.[11] Although there is no denying the nefarious intent or unfortunate outcomes of some Western photographers, I show that studio portraiture was often a collaborative process in which the sitters' motivations and desires for self-representa- tion can be explored. Therefore, chapter 1 focuses on the agency of early indigenous sitters, such as Red Cloud and Sarah Winnemucca, and how they harnessed the power of photographic imagery for their own personal, political, social, and com- mercial purposes.

Chapter 2 examines the relationships between non-Native photographers and Native subjects, particularly the regulations and rapport that defined their interactions. For example, some tribal communities placed strict requirements on photographers, thereby regulating who was permitted to take photographs, of what subjects, where, and when. Other groups and individuals charged modeling fees. Some photographers did not have to pay fees because, as previously mentioned, they were friends and neighbors of their photographic subjects and thus had a particular rapport with the Native sitters. This chapter explores those relationships.

Part II examines the emergence of Native photographers and their motivations for employing photography to document their own communities. Each practitioner to be discussed in this section had different levels of experience with the camera. Starting with trained professionals and moving on to semiprofessional and, finally, amateur indigenous photographers, I underscore the different types of Native photographies by stressing the multiple values and perspectives across Native North America.

The opening chapter in this section—chapter 3—examines the work of professional Native photographers who were paid for their images: George Hunt (Tlingit/British), Louis Shotridge (Tlingit), Richard Throssel (Crow/Scottish/Adopted Cree), and Benjamin Haldane (Tsimshian). These individuals either owned and operated their own photography studio or created images as part of their job for an institution (e.g., government, museums).

Chapter 4 concentrates on two semiprofessional trained photographers. The first, Horace Poolaw (Kiowa), apprenticed under a studio photographer, then learned aerial photography in the army. He would later become an unofficial photographer of Kiowa community events. The second, John Leslie (Squaxin Island), studied photography at Carlisle Indian Industrial School and reportedly continued publishing his pictures after leaving school. Leslie's work is not well documented; Poolaw's photographs are extensively studied and exhibited, most recently in a solo show at the National Museum of the American Indian.[12]

Self-taught amateur photographers are the focus of the last, and largest, chapter in the book. Chapter 5 features Native individuals who recorded their families and communities in snapshots before the end of the 1940s. Some photographers left only small collections of fewer than twenty pictures, whereas others have thousands of images stored in tribal and community archives. Yet all depicted their traditional ways of life in transition, demonstrating that photographs are an important part of indigenous visual heritage and a dynamic, tangible link between the past, present, and future.

PART I | Native Participants

Native Participants in Photography

> *Formal presences in a photograph, they serve to remind me of who I was and therefore am.*
>
> —**LOUIS OWENS** (Choctaw/Cherokee)

All too often scholars focus on the agenda of Western photographers and their roles in salvaging, staging, and showcasing traditional Native cultures.[1] In this way, the Native subject simply becomes a helpless victim of the Western gaze. Undoubtedly, the power relationships were often asymmetrical, but I object to the wholesale reduction of the role played by Native peoples in the authoring of their pictures. I am interested in the *participation* of indigenous peoples in their photographic representations and what they hoped photography could do for them. This chapter focuses on early Native North American portraiture (1840–1940) and how, as subjects, the indigenous sitters exercised a large degree of agency in their own representations.

HAWAIIAN NOBILITY: AUGMENTING THEIR OWN DIVINITY

In 1843, a mere four years after the invention of the medium, a Hawaiian diplomat commissioned a photographic portrait of himself to commemorate an overseas mission to campaign for Hawaiian independence.[2] The resulting image is currently regarded as the oldest photograph of an indigenous person in what would eventually be the United States.[3] It came about because Timothy Kamalehua Haʻalilio (1808–44), also known as Timoteo, was unable to find "a good portrait painter" in

Chief Red Cloud Oglala, c. 1881
Photo by William Cross
Library of Congress, Prints and
Photographs Division, 2015651533

FIGURE 1.1

Timoteo Haʻalilio, 1843

Photographer unknown

Hawaiʻi State Archives,

PP-72-6-029-S

⤳ Timoteo died of tuberculosis (or consumption, as it was called) off the coast of New York on his return home from this diplomatic mission.

Paris and settled on having a daguerreotype made.[4] His portrait (figure 1.1) features him sitting with one hand on his abdomen and the other resting on a book in a convention traditionally used by European scholars and statesmen.

Gazing outward toward the viewer—or perhaps inward with an acute sense of self-awareness—Timoteo provides us with a confident and squarely frontal pose. Of course, his posture can be attributed to the state of technology at the time, which required sitters to hold perfectly still or risk a blurry image. The body clamps and headrests employed by studio photographers thus created an era of standardized,

FIGURE 1.2

Portrait of the Reverend Peter Jones, or Kahkewaquonaby ("Waving Plume"), August 4, 1845

Photo by David Octavius Hill and Robert Adamson

Yale Collection of Western Americana, Beinecke Rare Book and Manuscript Library

❧ *The Ojibwe missionary lectured abroad in Scotland, where this portrait was taken. It is part of a larger photo session that includes him seated or standing in both Native and non-Native dress. This photograph is currently the oldest surviving portrait of a Native North American from the continental United States.*

frontal portraits.[5] In other words, everyone, regardless of race, had to assume a similar pose in front of the lens. But in contrast to Euro-American subjects, early Native sitters were often placed against natural settings or backdrops that visually linked them to the natural environment and thus emphasized their indigeneity; see the portrait of the Reverend Peter Jones, or Kahkewaquonaby (meaning "Waving Plume"), figure 1.2).[6] Yet in Timoteo's case the (anonymous) photographer seems to have had no interest in portraying an exotic Other. Accordingly, the photograph expresses more about the sitter's self-representation than the photographer's preconception about Native subjects.

FIGURE 1.3

House of Kamehameha, c. 1852

front: Queen Kalama, Kamehameha III (Kauikeaouli), Princess Victoria Kamamalu; *rear:* Prince Alexander Liholiho (later Kamehameha IV), Prince Lot (later Kamehameha V)

Photo by Hugo Stangerwald

Bishop Museum, SP41657

Perhaps one of the most striking aspects of Timoteo's portrait is his dark, button-down suit. It should be noted that he was not the first Hawaiian to adopt European clothing. Even before the advent of photography, Native Hawaiians were appropriating European dress. Anthropologist Marshall Sahlins found that "by the early nineteenth century the putting-on of prominent European identities had become high fashion in Hawaii." As a matter of fact, the Hawaiian royal family used clothing in accordance with the Polynesian worldview regarding *mana,* or spiritual energy. According to Sahlins, "It took the form of ostentatious consumption of foreign luxury goods—but then, *mana* had been traditionally associated with a style of celestial brilliance. Fine clothing was the main item."[7] By circulating photographs of themselves in lavish attire (figures 1.3 and 1.4), the royal family could display the sacred power of *mana* while enhancing their divinity among their people.

For the Hawaiian royal family, photographs were not just a vehicle for the exhibition and preservation of spiritual power but an effective tool in the fight against colonial forces.[8] By cultivating an image reflective of contemporary Western society, the royals believed they could influence Western public opinion in their favor. They strived to be depicted as sophisticated, refined, and civilized—not as poor, undeveloped primitives in grass skirts. This method of self-fashioning seemed to be

working with the British public, who were surprised to see a stylish image of the young queen consort Emma upon her marriage to King Kamehameha IV on display in London during the 1860s.[9] Emma also impressed European nobility by participating in the popular trend of exchanging *cartes-de-visite* (visiting cards). In a letter to Queen Victoria, Emma stated: "I have ordered that a photograph of myself by Mr. Watkins, who I think has been the most successful of the Artists to whom I have given sittings, be sent to Your Majesty in accordance with the promise I made upon your so kindly expressing a desire to have one. Please to accept it and with it the expressions of my heartfelt regard and esteem."[10] The resulting carte-de-visite can be found in the British Royal Archives. Queen Emma would later visit heads of state in France, Italy, and Germany, where she would also leave her visiting cards. Although the photographic public relations campaign failed to maintain Hawaiian sovereignty, such photographs were used so effectively to promote independence that the pictures continued to stymie the U.S. government into the twentieth century.[11]

FIGURE 1.4
Emma, Queen Consort of Kamehameha IV, c. 1880
Photo by A. A. Montano
Hawai'i State Archives,
PPWD-15-2-017

❧ *The item on the table to her right is the christening font for her son Albert Edward Kauikeaouli Leiopapa a Kamehameha, a gift from Queen Victoria of England.*

Postcolonial theorist Homi Bhabha provides a useful concept for understanding why these images were such a thorn in the side of the West. In his essay "Of Mimicry and Man," Bhabha explains that mimicry is a particular form of behavior that involves copying the person or group in power in order to have access to that same power. In the case of portrait photography, this tactic can be especially subversive. The very use and practice of photography disrupted the Western belief that indigenous people were primitive and incapable of partaking in modern technology. Additionally, by presenting themselves in European dress and performing Whiteness, Native people made it difficult for the colonizers to label them as Others. Combined with the fact that technology allowed for images to be circulated (through cartes de visite), and for their visual voices to be heard, the use of photographic portraiture by the colonized was indeed a powerful tool of resistance. As Bhabha states, "The success of colonial appropriation depends on a proliferation of inappropriate objects . . . so that mimicry is at once resemblance and menace."[12] As we see throughout this volume, there are other cases of Native North Americans using photography as a mode of representation and resistance.

RED CLOUD

In the mainland United States, Red Cloud (1822–1909) used photographic portraits as a way of presenting a public face to tribal concerns. From 1868 to 1909 the Lakota chief led his people (also known as the Oglala Sioux) through the long process from freedom to reservation life. This is suggested by the transformations of dress and demeanor as illustrated in his photographs. For example, in one image (figure 1.5) he displays all the trappings of an Indian diplomat. In one hand he holds what is commonly known as a peace pipe (also known as a calumet, or *čhaŋnúŋpa* in Lakota), in the other he clasps a treaty document, and around his neck are not one but two peace medals. At this time, he wore is hair long and wrapped, ornamented with a single eagle feather—one of the highest honors bestowed upon a Lakota man—which signifies courage, wisdom, and fortitude. In a later image (figure 1.6), he has cut his hair short and dons the typical three-piece suit of a "civilized" man. During his decades-long tenure as chief, he fashioned himself as the tribal spokesman through such various photographic portraits. Former Smithsonian curator Frank Goodyear III found that Red Cloud "posed before the camera some fifty times and appears in over one hundred photographs, rivaling the number taken of Abraham Lincoln."[13]

Given the frequency with which he appeared in portraits, Red Cloud must have found the medium to be a useful propagandistic tool. Photography allowed him to create a public persona and broadcast his right to power on a scale never before seen in tribal life. Since, as Goodyear states, "political and social standing in Oglala society was determined more by public displays and performances than hereditary association, the ability to manifest authority was vital. Red Cloud's embrace of photography to do this work was entirely new in the context of Native American society."[14] Red Cloud did not need photography to *establish* his authority. Early in his life, he gained much acclaim and status among his people for leading armed attacks against U.S. government forces.[15] During the 1870s his exploits made the news: "The fame of Red Cloud, the Chief of the Sioux Nation, the most powerful band of savages on the American continent, is now world-wide. . . . His name has been heralded with electric speed, within a month to the

FIGURE 1.5

Red Cloud, c. 1875

Photo by William Godkin

National Anthropological Archives, Smithsonian Institution, NAA INV 09984800

❧ *Peace medals were presented to Native leaders by the government to reinforce diplomatic relations. Usually the awarding of peace medals accompanied a formal negotiation or treaty, but not necessarily. Native figures proudly wore these gifts in portraits to signify the honor of representing their people in talks with a foreign power. The earliest documented use of peace medals by the U.S. government dates to 1785 with the Treaty of Hopewell, but European countries issued medals much earlier in an effort to build alliances with Native nations.*

FIGURE 1.6

Red Cloud, 1890

Photo by John Nephew

National Anthropological

Archives, Smithsonian Institution,

BAE GN 03238A/06535900

remotest parts of the civilized world, and his position has made him in name, if not in reality, great."[16] Though celebrated as a fearless warrior, as time went on Red Cloud was forced to settle into a quiet life on the reservation. Yet he continued to work tirelessly to negotiate treaties and fight for the fair treatment of his people. To stay relevant and in the public eye, he used photography to promote himself as the tribal diplomat for the Oglala community.

Red Cloud wished to be perceived as a preeminent statesman, and he knew exactly how to pose to project that ideal. In most of his portraits he has the same

dignified, unsmiling countenance. He was essentially adhering to Western portrait convention and carefully composing his public persona.[17] This is consistent with what art historian Richard Brilliant found regarding portraiture: "Most portraits exhibit a formal stillness, a heightened degree of self-composure that responds to the formality of the portrait-making situation. . . . Portraits of persons who occupy significant positions in the public eye—statesmen, intellectuals, creative artists, war heroes, and approved champions—usually bear the gravamen of their 'exemplary' public roles; they offer up images of serious men and women, worthy of respect, persons who should be taken equally seriously by the viewing audience."[18] Red Cloud consciously and deliberately presented a well-rehearsed identity to the public.

Unfortunately, Red Cloud's attempts at gravitas may have had the unintended effect of providing us with more examples of what has been deemed the "stoic Indian" stereotype. With this, the question then arises: is it possible to understand the sitter's intent without dismissing it as a visual cliché? It is, according to historian Devon Mihesuah (Choctaw), but we must consider the context within which these images were taken. For her, "historic Indians are not painted or photographed smiling, and with good reason: often photographs were taken or portraits were drawn during a treaty-signing or after they had been captured."[19] Though I agree that the contemporary state of affairs may register on the indigenous sitter's face, I do not believe that an unsmiling expression is merely a reflection of current events. As artist Gail Tremblay (Mi'kmaq/Onondaga) states, "Their expressions are sometimes sad, sometimes angry, and sometimes carefully composed in order to represent themselves and their people favorably as they travelled among strangers."[20] What she describes is a more calculated response to the picture-taking process—an awareness of the power of images and of the fashioning of self.

ZITKALA-ŠA

Like Red Cloud, the Yankton Sioux intellectual and activist Zitkala-Ša (a.k.a. Gertrude Simmons Bonnin, 1876–1938) understood the importance of curating a public persona by circulating photographs. During the early 1890s, while studying at White's Manual Labor Institute in Indiana, she decided to embark on a career as a musician and author.[21] By the end of the decade, she was a rising star who had proven her oratory skills at Earlham College and had begun a course of study in violin at the prestigious New England Conservatory of Music. Around 1898 she gave herself the name Zitkala-Ša (meaning "Red Bird") to better identify with her mother's Sioux heritage (her white father had abandoned them when she was very young), and she started publishing her stories on Native American life under this name.[22] To build her publicity portfolio, she traveled to New York City, where she had several portraits made by studio photographer Gertrude Käsebier (figures 1.7 and 1.8).

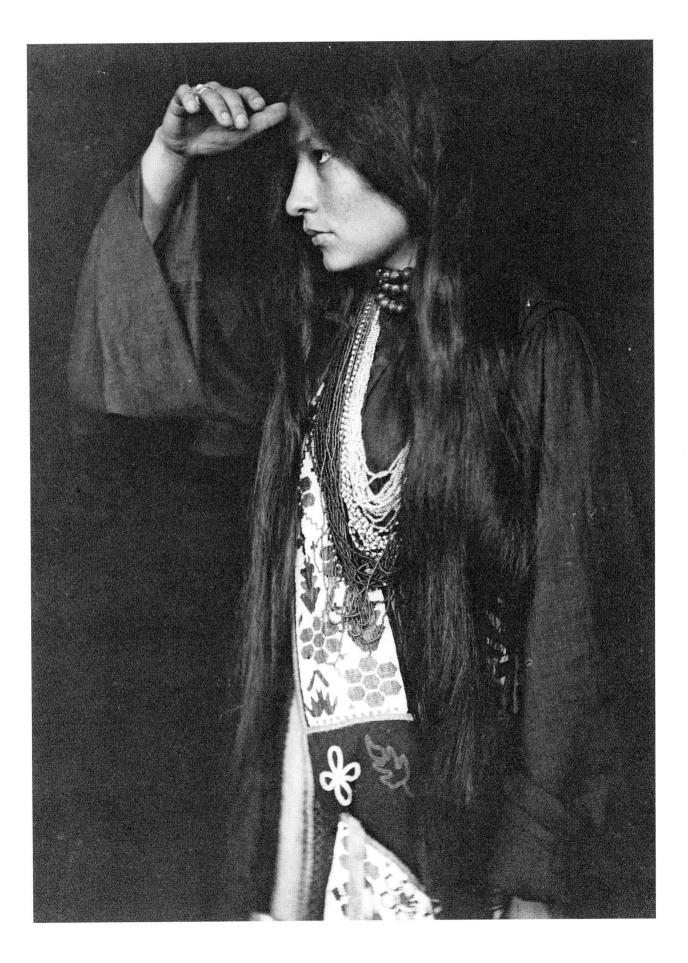

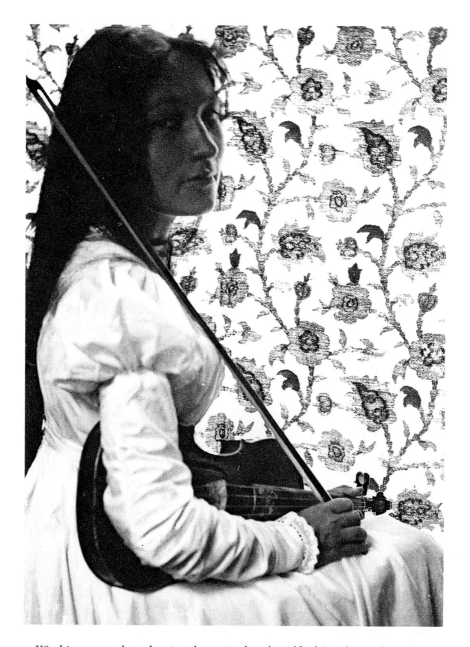

Käsebier was a talented artist who trained under Alfred Stieglitz and was becoming a prominent photographer within the pictorialist movement. Her Fifth Avenue studio was barely open a year when Zitkala-Ša came for her sitting in August 1898.[23] Yet she was not the first Native person to visit the artist. In April of that same year, Käsebier photographed the American Indian cast members of Buffalo Bill's Wild West, whom she invited for a sitting after seeing them parade in front of her studio.[24] Scholars have not really questioned why Zitkala-Ša would travel from her home in Pennsylvania, where she was teaching music at Carlisle Indian Industrial School, to

have her portrait made by the relatively unknown photographer in New York City. We may never know, but art historian Elizabeth Hutchinson argues that it is a little offensive to assume that because Käsebier was photographing American Indians in 1898 they all knew each other.[25] Regardless of the impetus, both women were at the start of their respective careers, and their brief collaboration would result in a set of striking, critically acclaimed images.[26]

Of the nine photographs produced during that studio sitting in 1898, Zitkala-Ša wears either Western clothing or Plains-style dress and uses three different props: a book, a basket, and a violin. In the some of the images, Zitkala-Ša appears cool and reserved; in others she seems almost coquettish and charming. Even in photos that emphasize her "Indianness" (e.g., figure 1.7), Zitkala-Ša is poised and dignified, transforming a simple stereotype—the Indian staring off into the distance using a hand as a sun visor—into a graceful pose. Unlike materials seen in photographs by Edward Curtis, who often provided outfits for his sitters, the clothing and props used in Zitkala-Ša's portraits do not appear in any other images by Käsebier. In fact, Käsebier reportedly removed clothing from figures to better focus on capturing their personalities.[27] Most likely, then, the client furnished her own outfits for the portrait session—ones that correspond to the multiple identities she was projecting: American Indian, musician, author, and activist.

Evidently she recognized that she could manipulate opinions by altering her public persona. For example, we know that Zitkala-Ša used her Yankton Sioux name for her creative work as a musician and author but her English name, Gertrude Simmons Bonnin, in legal affairs and in her correspondence with the Bureau of Indian Affairs (BIA). She acquired the name Bonnin after marrying BIA coworker Captain Raymond T. Bonnin (also Yankton Sioux) in 1902. Shortly thereafter, the Bureau transferred the couple to Utah, where they would live and work at the Uintah-Ouray reservation for almost fourteen years. While there, Zitkala-Ša collaborated with music teacher William F. Hanson to create the first Native American opera, *The Sun Dance Opera*, in 1913.

Her participation in the *Sun Dance Opera* is curious. Even though she co-authored it with Hanson, her correspondence and diary make no mention of her involvement in the project at all. In his papers, Hanson notes that in composing the opera Zitkala-Ša used her instruments, including her violin and a traditional Native flute, to play Sioux melodies and that together they wrote the lyrics. They named the protagonist after her son, Ohiya (meaning "Winner"), and before some performances she gave a brief introduction to the history of the Sun Dance. As Hanson remembered, "For her lectures Zitkala-Ša always appeared in her gorgeous full dress of buckskin, beads, and feathers. Her two long braids of hair hung to her knees."[28] Although Zitkala-Ša is credited in local newspaper articles and

performance programs for the opera, she left no personal record of her role in the collaboration or, indeed, of even knowing Hanson. Their partnership is perhaps best recorded in the promotional photographs taken of Zitkala-Ša and Hanson both wearing fringed buckskin.[29]

In one of the images (figure 1.9), Zitkala-Ša assumes a three-quarter pose and appears rather self-assured in front of the camera, while Hanson stands facing the viewer, his buckskin costume hanging awkwardly on his slender frame. During this portrait session, Hanson would also don a large feather headdress (not shown), but Zitkala-Ša would remain unchanged in the same buckskin dress and metal belt. For all intents and purposes, she is being portrayed as the Native consultant and expert for the project. He reproduced one of these promotional photographs (figure 1.9) as the first page of his memoir, *Sun Dance Land*, and stated that "Mrs. Bonnin became a full collaborator in recording and producing the *Sun Dance Opera*."[30] Despite this claim, scholars have accused Hanson of downplaying his partner's involvement to the point that she was almost written out of its creation by the time it was selected as 1938 Opera of the Year by the New York Light Opera Guild.[31] But the fact that she herself did not write about the opera in any public or private manner, leaving only a few photographs as visual evidence of her participation, suggests that she did not place a great deal of importance on her involvement in the project. At this time, in fact, she was witnessing the growing popularity of peyote among the Utes and started a staunch anti-peyote crusade.

Her move to Washington, D.C., in 1916 marked a dramatic shift from an artistic to a political career. Prior to this point she had penned autobiographical narratives, wrote about Native American legends, and played and composed music. In other words, her output was largely a series of creative endeavors. But after being elected secretary of the Society of American Indians (SAI) in 1916, she dedicated her life to reforming U.S. Indian policies and quickly became a high-profile activist. Known as "Red Progressives," the SAI consisted of highly educated, acculturated professionals like herself who advocated Indian citizenship, Native sovereignty, and government reforms. At her first meeting as an officer of the SAI, Mrs. Gertrude Bonnin spoke about her community service among the Utes and was pictured with her fellow Society members at their annual conference (in the front row holding a hat, figure 1.10). The attendees are all wearing contemporary Western fashions with no element of traditional Native attire—except for Bonnin's feathered fan and a beaded bag that hangs in the shadows. The attendees are neither dressing in costume nor otherwise "playing Indian" to conform to popular conceptions. In fact, the image is not one most would conjure as representing the first national pan-Indian organization run for and by Native Americans. Collectively, their dark suits and unsmiling faces illustrate the seriousness of their cause. After all, this 1916 conference marks the first

FIGURE 1.9

William F. Hanson and
Zitkala Ša, 1913
Photo by William Willard
Courtesy of L. Tom Perry Special
Collections, Harold B. Lee Library,
Brigham Young University,
William F. Hanson Collection,
MSS 299

time peyote consumption was a hot topic for discussion, which would eventually lead
to factionalism and the demise of the organization.[32]

Bonnin pursued her activism against peyote, which she called "the twin brother
of alcohol," by writing articles and appealing for legislation to prohibit use of the
hallucinogenic plant.[33] Consequently she was called to testify in the 1918 congres-
sional hearings on peyote. In anticipation of the hearing, she gave an interview
to the *Washington Times* under the headline "Indian Woman in Capital to Fight
Growing Use of Peyote Drug—Mrs. Gertrude Bonnin, Carlisle Graduate, Relative
of Sitting Bull, Describes Effects of Mind Poison."[34] The article was intended to
influence public opinion, and she made no effort to correct the inaccuracies (she did

FIGURE 1.10

A group of members from the Society of American Indians pictured on the steps of Carnegie Library during their sixth annual conference in Cedar Rapids, Iowa, September 29, 1916. Zitkala-Ša is in the front row, holding her hat, and Richard Henry Pratt is at the far right.

Photographer unknown

Reproduced from *American Indian Magazine, The Quarterly Journal of the Society of American Indians* 4, no. 3, July–September 1916, plate 7

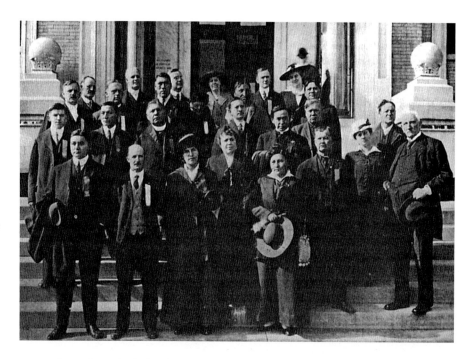

not graduate from Carlisle, nor was she a descendant of Sitting Bull).[35] Her adversary, peyote advocate and noted ethnologist James Mooney, attempted to discredit her before she took the stand by analyzing a photograph from this news story. He stated, "The article is accompanied by a picture of the author, who claims to be a Sioux woman, in Indian costume. The dress is a woman's dress from some southern tribe, as shown by the long fringes; the belt is a Navajo man's belt; the fan is a peyote man's fan, carried only by men, usually in the peyote ceremony." Unfortunately, the image could not be reproduced here (although the dress and belt are the same as in figure 1.11, and the fan appears to be the one from the SAI conference, figure 1.10). Mooney's verbal attack on Bonnin's regalia was meant to call into the question her Native "authenticity" and reliability as a witness while demonstrating his own anthropological knowledge of indigenous cultures. Yet, when it came time for her to speak, Zitkala-Ša proved her oratory skills by stating that she had lived on the reservation for fourteen years and had witnessed firsthand the harmful effects of peyote, and (in a dig at Mooney) that Indians practice restraint when an ethnologist is visiting.[36] Her testimony ultimately helped the bill pass through the House, but it failed to pass in the Senate. Within the next few years she successfully lobbied several states, including Colorado, Nevada, and Utah, to adopt legislation outlawing the use of peyote.[37]

In addition to her work on peyote suppression, Zitkala-Ša devoted her time to Native land claims, Indian citizenship, and educational reforms, all in an effort to achieve greater tribal sovereignty and self-determination. When she wasn't writing

FIGURE 1.11
Gertrude Bonnin, 1921
Photo by Harris and Ewing
Deaccessioned NEA copy print,
Collection of the author

FIGURE 1.12
Gertrude Bonnin at the
Catholic Sioux Congress at
Pine Ridge Reservation,
July 1920
Photographer unknown
Marquette University Archives,
Bureau of Catholic Indian
Missions Records, ID 00684

articles, attending committee meetings, or testifying before Congress, she went on lecture tours, often wearing traditional buckskin clothing. For instance, in 1921 she was photographed by famous photojournalists Harris and Ewing in a traditional Plains-style fringed, buckskin dress with moccasins and her hair in long braids (figure 1.11). The caption reads, "Indian legislation in Washington is watched closely by Mrs. Gertrude Bonnin, Sioux princess, who has permanent headquarters in the National Capital during sessions of Congress. She has for several years been an influential leader of her people." This publicity image was taken just before she was named president of the National Council of American Indians—an organization she cofounded with her husband. Just a year prior, in 1920, she was pictured at the Catholic Sioux Congress (figure 1.12) wearing a contemporary woman's pantsuit with a lace collar and pearl necklace. In this case, her hair is not in long braids but tucked into a neat French twist. Standing in the same relaxed pose as she did with Hanson (see figure 1.9), Bonnin exudes an air of casual self-confidence. She would maintain her role as an activist at the nation's capital until her death in 1938. In the few remaining photos featuring her as a lobbyist for Native rights, she alternates her image between Plains-style dress and contemporary Western fashions.

With her photographs and public appearances, Zitkala-Ša provided a public presence for American Indians, who were commonly believed to be disappearing. Throughout her life, she promoted Native sovereignty and self-determination, as well as the health of indigenous communities through her anti-peyote crusade. She

increased awareness of Native issues by translating traditional stories into English, writing autobiographical narratives, and lobbying for Native rights. By appearing in the public eye as a successful figure with diverse ambitions, she served as a role model for the opportunities available to American Indian society.

PRINCESS SARAH

Several years before Zitkala-Ša promoted herself as an indigenous influencer, Sarah Winnemucca (1844–91), a Native American activist and daughter of a Northern Paiute chief, fostered her own image using photography. Over her lifetime, she gave more than three hundred speeches defending Paiute rights, wrote an autobiography discussing the plight of her people, and met with U.S. president Rutherford B. Hayes to protest reservation life. Given the birth name Thocmentony ("Shell Flower"), she used her English married name, Sarah Winnemucca Hopkins, in publications and correspondence. But she was commonly known as Princess Sarah. She further encouraged the princess identification by appearing in costumes of her own making.

From 1879 to 1884, Sarah Winnemucca had at least nine different photographic portraits made, and in all but three she is wearing elaborate costumes of nontraditional materials (figures 1.13 and 1.14). Her Indian outfits, which she also wore on the lecture circuit, consisted of short-sleeved fringed dresses, leggings, and moccasins.

FIGURE 1.13

Sarah Winnemucca, 1883
Photo by Elmer Chickering
Washington State Historical
Society, 1949.12.1.1

❧ In 1883, Sarah Winnemucca conducted a public speaking tour of the Northeast, delivering more than three hundred lectures that exposed the plight of her people and unfair government practices. The large crowds attest to the fact that she was the most famous Native woman in America at the time. This publicity photograph was taken during a stop in Boston by Elmer Chickering, who frequently photographed celebrities in his studio.

Although Northern Paiutes did wear fringed skirts of either grass or buckskin, Sarah Winnemucca's garments were composed of cotton and embellished with sequins or tassels, "some of which," notes Joanna Cohan Scherer, "are ready-made fringes used on lampshades, curtains, and chairs."[38] Though it was common for indigenous groups (worldwide) to incorporate Western goods such as glass beads and metal buttons into their garments, Winnemucca seems to have created entire outfits and accessories from manufactured merchandise and mass-produced items. For example, her bag is adorned with a beaded cupid figure, and she often wore a felt crown decorated with stars. As a whole, these costumes make use of stereotypical iconography (e.g., fringed buckskin and

a crown) familiar to Euro-Americans that would signify her as an Indian princess.

Winnemucca's portraits best illustrate what historian Philip Deloria (Dakota) calls "playing Indian," that is, dressing up to assume an Indian identity.[39] However, the Indian identity she is performing never actually existed. The Indian princess is an invented character, one formulated by Euro-American society from the tales of Native heroines such as Pocahontas and Sacagawea.[40] Winnemucca's willingness to participate in the myth of the Indian princess would seem to be counterintuitive to her efforts as an Indian activist. Indeed, critics have accused her of being complicit in serving as a "White Man's Indian."[41] Yet Winnemucca's situation was much

FIGURE 1.14
Sarah Winnemucca, 1883
Photo by Norval H. Busey
National Portrait Gallery,
Smithsonian Institution,
NPG 82.137

↬ *Her famous book,* Life among the Piutes: Their Wrongs and Claims, *was written the same year she barnstormed the Northeast on tour. At a stop in Baltimore, she had this publicity photograph taken so that she could sell copies during her speaking engagements. The funds from her image, as well as the proceeds from her book, would go toward establishing a school for Paiute children.*

more problematic than just providing a "correct" image for her people. Although her assuming the identity of an Indian princess may have captivated Euro-Americans, Deloria reminds us that "the fact that native people turned to playing Indian—miming Indianness back at Americans in order to redefine it—indicates how little cultural capital Indian people possessed at the time."[42]

It seems that Sarah Winnemucca was using that little bit of cultural capital to her advantage. By "playing Indian" and using iconography recognizable to her audience, she manipulated a well-established publicity ploy—an appeal to authority. Her costume provided her with an instant level of credibility, and, as Scherer points out, "She would have known from the stereotype that the 'princess' image gave Indian women a favorable status, associated with royalty, which would facilitate their reception as citizens in Euro-American society."[43] In catering to popular cultural imaginings, Winnemucca was afforded some amount of respect and esteem that she would not have had otherwise, considering the relative status of women and Indians within the Euro-American majority during the latter half of the nineteenth century.

It is curious, then, that Sarah Winnemucca did not wear her costume when she appeared as a tribal delegate to meet with President Hayes in 1880 (figure 1.15). Authorized by the commissioner of Indian affairs, the official delegation photograph

FIGURE 1.15

Paiute delegation, 1880
(Left to right) Sarah
Winnemucca, Chief
Winnemucca, Natchez,
Captain Jim, and white
boy who conducted the
party occasionally (per
handwritten caption).
Photographer unknown
National Archives, Still Picture
Branch, photograph no.
75-IP-3-26

features Sarah and her brother, Natchez, standing on either side of their father, while another Paiute leader, Captain Jim, is seated on the right with an unidentified boy next to him. All of the men wear suits provided to them by the government.[44] In response to the men's contemporary American fashions, Sarah probably chose to wear a dress that would complement their attire.[45] She wears the current style of the day, a high-necked blouse with a fitted jacket over a long, bustled skirt. In this case, it is not her Euro-American style that is remarkable but the fact that she even appears in a delegation photograph at all. Native women rarely appeared in delegation photographs, so her presence highlights her status as representative for the Paiute people.[46]

Although the picture was not made at the request of Sarah Winnemucca, she most likely received a copy. At the very beginnings of delegation photography in the 1850s, secretary of the Smithsonian Joseph Henry wrote that "nothing would be more agreeable to the Indians themselves who might be furnished with a copy." Thereafter the practice of providing photographs to Native diplomats became

FIGURE 1.16

Meshekigishig ("Sky Striking
the Earth"), 1896

Photo by William Dinwiddie

National Anthropological
Archives, BAE GN 0059A

06153500

common. Thus, in 1880, after the Paiute delegation sat for this portrait, the commissioner of Indian affairs placed an order for six duplicates of the "group, Winnemucca and others." In a noteworthy event regarding this practice, Chief Red Cloud, who was a frequent visitor to the capital, asked the commissioner to reciprocate by sending additional photographs of two government employees, including "the one with black hair and goatee or small whiskers who occupied a desk near yours. I shall be very glad to get their pictures as they are friends of mine."[47]

Although Native delegates were usually high-ranking members of their tribes, group photographs are frequently misidentified because of incorrect captions or subjects who wore regalia incongruous to their tribal identities. Often it was the photographer who insisted that the Native sitters wear traditional indigenous clothing such as headdresses, breastplates, and leggings, regardless of whether such pieces

were relevant to the sitter's specific tribe.[48] For example, Alexander Gardner, the famous Civil War photographer, worked as a delegation photographer for the Office of Indian Affairs from the mid-1860s to 1880 and had a collection of Indian outfits in his studio. Gardner's wife reportedly "had the unhappy task of assisting her husband in the posing of the Indians and outfitting them in feathers and beads and tribal garments from a 'smelly collection' of native costumes maintained by the Gallery. For they often came to Washington dressed in odds and ends of white man's clothing rather than in their traditional dress."[49]

Costuming American Indians was a common occurrence, and Gardner was by no means the only studio photographer to resort to such practices. Scholars have found examples of costuming in photographs by William Soule, John K. Hillers, DeLancey Gill, Christian Barthlemess, and Major Moorhouse—just to name a few.[50] Yet it would be erroneous to assume that Native sitters had no say in their appearance. As we have already seen, Zitkala-Ša and Red Cloud fashioned themselves in front of the lens. Smithsonian curator Rayna Green (Cherokee) argues that "Indian people have been trading with each other for centuries before the Europeans came. . . . thus, it was perfectly feasible that people might be wearing items that weren't particularly from their tribe." There is, however, a caveat. Green contends that, "in these paintings and photographs, so much of what one sees is not even an accurate representation of what a group might have been trading. . . . Only after much research can we look at some of these images and reconstruct who these persons were and what their history was."[51] Her point is exemplified with a portrait of Native American elder Meshekigishig ("Sky Striking the Earth"), photographed in 1896 by the Bureau of American Ethnology (figure 1.16). In this image, the Chippewa delegate sits posed in a three-quarter view with a feather duster tucked firmly in his headband.[52]

Many viewers might assume that the photographer insisted on this prop to make the sitter appear more "Indian." Yet this assumption may be erroneous, especially if we consider that the sitter most likely wanted to wear the feather duster in order to be depicted as a warrior—since Chippewas traditionally wore upright feathers "to show that a man had met an enemy."[53] If this is the case, then it is a demonstration of resistance and self-expression by an Indian delegate in the nation's capital—despite the apparent irony of that man's choice of prop.

Relationships with Photographers

> *Photographs can, at best, lead viewers not so much into the familiar morass of stereotypes and set images, but into new ways of viewing the past, new ways of creating connections with our relatives, new ways of reaffirming cultural identity.*
>
> —**GEARY HOBSON** (Quapaw/Cherokee/Chickasaw)

In interpreting historical photographs of American Indians, many scholars consider only the goals and biases of the photographer who has created the image, without discussing the sitter's intent. It is as if photographers have choreographed the entire scene, without any input from their indigenous subjects, who are simply mute objects to be moved around within the frame. Yet Native subjects have exercised their visual voices. There are many cases of a Native sitter demanding payment, or "modeling fee." Entire indigenous communities, such as the Hopi and Zuni, have placed strict regulations on photographers, thereby controlling who, what, where, and when they might photograph. Some photographers were not subject to such requirements because they were friends and neighbors of the people. This chapter explores those relationships and regulations.

SELLING THE SHADOW

Receiving monetary compensation for an image is a long-standing practice in the art world. In 1895, Edward Curtis's first Native model, Princess Angeline—the oldest surviving daughter of Chief Seattle—was paid for her time by the photographer. "I paid the Princess a dollar for each picture made," Curtis stated. "This seemed

to please her greatly and with hands and jargon she indicated that she preferred to spend her time having pictures made than in digging clams."[1] Curtis's gesture is significant in regard to his reciprocity, especially considering the purchasing power of the dollar in 1895. This rather significant amount would have been difficult for the impoverished elder to refuse. Yet there are cases where American Indian people declined substantial amounts of money for their photographic images. For instance, the Northern Paiute Ghost Dance prophet Wovoka turned down an offer of five dollars for his picture—not necessarily because the price was too low, but because of federal prohibitions against the Ghost Dance movement and his involvement therein.[2]

Obviously, images of famous figures were more in demand, so famous subjects could dictate their price. In 1915 a contemporary journalist seemed astonished to find that the Apache leader Geronimo had his own sliding scale of fees; a portrait made with an ordinary hand camera cost ten cents, using a tripod increased the price to twenty-five cents, and, "if he were ushered into a studio, as far as he was concerned 'the sky was the limit.'" Geronimo charged all types of photographers, from casual to professional. In dealing with the U.S. government delegation photographer De Lancey Gill, he charged a two dollar fee (and demanded an additional quarter, claiming that he was not given the full amount) and thereby enjoyed "the distinction of being the only Indian who made Mr. Gill pay him for posing."[3]

Notable figures often profited from their celebrity status and supplemented their income with the sale of photographs. As visual anthropologist Joanna Scherer explained, "Charging a fee for a photographer to make one's image or selling one's photograph was a long and honorable tradition among both Euro-American and Indian celebrities."[4] African American civil rights activist Sojourner Truth, who sold copies of her image to finance her travels and speaking engagements, is one example (figure 2.1); reportedly, her favorite image was captioned "I Sell the Shadow to Support the Substance."[5] In a similar fashion, Sarah Winnemucca, while on the lecture circuit, charged fifty cents for an autographed carte-de-visite.[6] Although public speaking engagements were always a popular venue to sell one's photograph, commercially savvy indigenous celebrities marketed themselves at locations with far more foot traffic, such as world's fairs and Wild West shows.

Some Native individuals, including Geronimo and Sitting Bull, actively sought out photo opportunities to profit from the sale of their image. According to his autobiography, Geronimo promoted himself at the St. Louis World's Fair in 1904: "I sold my photographs for twenty-five cents I also wrote my name for ten, fifteen, or twenty-five cents. . . . I often made as much as two dollars a day, and when I returned I had plenty of money—more than I had ever owned before."[7] Despite the fact that selling pictures was a commercially successful venture for these Native celebrities, we must remember that the source of their celebrity status—that they were considered an

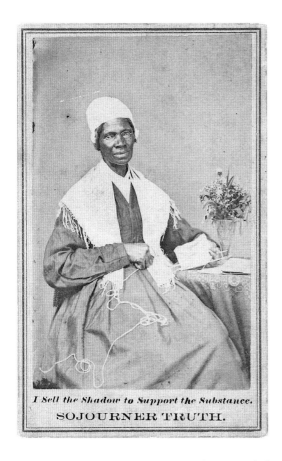

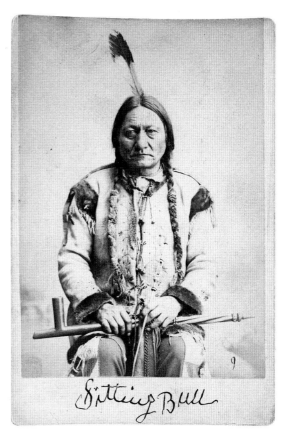

I Sell the Shadow to Support the Substance.

SOJOURNER TRUTH.

exotic, vanishing, and conquered people—provided no other benefit to them in their daily lives, which they lived under increasingly oppressive conditions. My point, however, is that they made the best of their situation by recognizing the demand and engaging in image-market practices for their own benefit.

Not to be taken advantage of by Buffalo Bill and his Wild West show, Sitting Bull, the famous Hunkpapa Sioux chief, negotiated a contract that allowed him exclusive rights to sell his image.[8] Sitting Bull set up an arrangement with a St. Paul studio to serve as the exclusive photographer and distributer of his portrait and, to maintain copyright, he refused to let anyone else take pictures of him.[9] A consummate businessman and entrepreneur, he learned how to write his name and started autographing memorabilia, mostly photos, but he also kept extra pipe bags on hand to sign and sell to his fans. He provided his autograph free to women but charged men anywhere from one to five dollars for the privilege.[10] Most of his pictures in circulation (both authentic and forged) are autographed with his scrawling signature at the bottom (figure 2.2). So successful was he in this endeavor that at one point he ran out of photographs to sell and had to enter a studio in Montreal to replenish his supply.[11]

FIGURE 2.1

Sojourner Truth, 1864

Photographer unknown

Library of Congress, Prints and Photographs Division, 98501244

FIGURE 2.2

Sitting Bull, 1884

Photo by Palmquist and Jurgens

Library of Congress, Prints and Photographs Division, LC-USZC4-7960

NATIVE REGULATION OF PHOTOGRAPHY

The sale and control of photographs are not limited to Native individuals; entire tribal communities have collectively controlled and restricted photography. The most prominent example are the Hopis. When the tourist industry started to grow, Hopis charged photographers a dollar to bring cameras onto the reservation and levied additional fees for photographs of people.[12] Payment did not take the form of cash exclusively. In one case, a group of Hopi women demanded new dresses from visitors before allowing them to take their picture. Hopis, like other Native communities, became skilled at bartering with photographers. They recognized that tourists often traveled great distances to see them, and to ensure their cooperation in the image-making process they required some form of compensation. According to former Zuni museum director Nigel Holman, "Zuni people began to see photography as a form of economic exchange. . . . community members actively controlled rather than passively endured an encounter with a photographer. . . . many Zuni people saw photography as an opportunity to profit financially."[13] What he is describing is a transactional relationship, one in which both parties exercise free will and recognize the terms of the arrangement. However, this relationship would be tested by the technological improvements that brought vast numbers of new photographers to the tribal communities.

In 1888, George Eastman mass-produced a simple hand-held camera with the slogan "You Press the Button, We Do the Rest." Before long, photography was practiced not only by professionals but by weekend hobbyists. Amateur photography clubs formed quickly, and their members would often take field trips to go "kodaking." The city of Pasadena, California, became a hub for amateur photographers— especially those interested in the American West. The Pasadena Camera Club was home to some of the most prolific photographers of the Southwest tribes, including George Wharton James, Adam Clark Vroman, and Charles Fletcher Lummis of the famous "Pasadena Eight." Together, they would partake in outings to photograph the regional Native communities, and over the course of forty years (1890–30) they collectively took tens of thousands of photographs.[14]

Witnessing and recording indigenous rituals was perhaps the most popular attraction for amateur photographers. In particular, the Hopi Snake Dance, with its handling of poisonous snakes, was a magnet for both Native and non-Native visitors alike. Held biannually over the course sixteen days in August, the Snake Dance culminated in a performative prayer for rain in which priests danced with live snakes in their mouths. Smithsonian curator William Truettner declared that "from the 1890s on, the Snake Dance was the most frequently described and photographed Indian ceremony in the Southwest."[15] Through the images and reports of amateur photographers, it is possible to see the impact photography had on this ritual. When

FIGURE 2.3

Beginning of a Snake Dance,
Moqui Pueblo of Hualpi,
Arizona, August 21, 1897
Photo by Ben Wittick
Library of Congress,
Prints and Photographs
Division, LC-USZ62-101155

Vroman witnessed his first Snake Dance in 1895, he found about forty other tourists in attendance, but two years later he counted more than two hundred visitors.[16] The popularity of this event is clearly illustrated in an image by Pasadena Eight photographer Ben Wittick (figure 2.3). His photograph from 1897 shows a large group of Euro-American tourists mixed with local tribal members and surrounding the event space. In the lower left side of the image, one of the many photographers has set up a tripod to capture the action.

Controlling and policing photographers became increasingly difficult as the crowds swelled. Southwest tribal communities were particularly susceptible to tourism because of the ease of access from Beale's Wagon Road (which became part of Route 66), the Santa Fe railroad, and Fred Harvey's services, which delivered sightseers to the front steps of the pueblos. During the summer, the hot desert heat caused some visitors to become unruly and disruptive. While attending a Snake Dance in 1902, photographer and journalist George Wharton James complained that visiting photographers aggressively angled for a good shot, "kicking down another fellow's tripod and sticking his elbow in the next fellow's lens."[17]

Irritated with the disruptions, indigenous community members reacted against the presence of photographers. At the Hopi village of Santo Domingo Pueblo, the (often physical) responses to photography are well documented. In 1913 the *Santa Fe New Mexican* reported that Hopis "cast showers of pebbles at Kodak fiends" who

were trying to photograph the Corn Dance.[18] Five years later, the same newspaper ran a headline stating, "Photographs Prohibited and Cameras Busted by Indian Guards."[19] In 1926 a visitor to the Happiness Dance at Santo Domingo Pueblo testified that "there were two busloads on the tour, and as they drew up to the pueblo, full half the men grabbed their cameras, jumped off the bus, and started snapping away at the dancing Indians. Without a sound, Indians poured out of every doorway, all carrying clubs. . . . there was a general smashing of cameras."[20] The English novelist D. H. Lawrence, who lived in New Mexico during the 1920s, stated that "several kodaks were broken" by frustrated tribal members at one of his many visits to Hotevilla Pueblo.[21]

Permitting photography and controlling spectators were different for each tribal community. As Holeman noted, "Decisions about whether photography would be permitted during a religious activity generally devolved to those responsible for that particular activity rather than those holding positions of communitywide responsibility."[22] This means that, in addition to participating in the dance or ceremony, the performers also had to police the audience. For example, Hopi Koshare (sacred clowns) almost "started a riot" in 1921 when they found a man with a camera.[23] It was only a matter of time before Native communities severely restricted or banned photography.

In the Southwest, twenty-one tribal communities ended up prohibiting photography. Taos and Sandia pueblos forbade photography of ceremonies in 1920, Isleta in 1889, and the three communities of San Felipe, Santa Ana, and Zia as early as the 1850s.[24] These prohibitions were not, however, due solely to the invasiveness of photographers. There were several reasons to ban photography, including the disrespect of a sacred space, potential loss of ritual power, and commercialization of religion (from the sale of photos), but, perhaps most important, photographs could be used to document outlawed religious practices.

Beginning in the 1880s, the federal government (both U.S. and Canadian) increasingly passed laws prohibiting indigenous spiritual practices.[25] Pictures of ceremonies could be used to help persecute Native practitioners, as it happened in Canada in 1907, when a group of First Nations people were convicted for potlatching based on photographic evidence.[26] In the United States, the BIA helped enforce the ban on photography, not to assist the Native communities in avoiding persecution but because it was felt that "photographing ceremonies provided unwanted encouragement for the Indian to retain Native customs and discouraged the assimilation of white ways."[27] Not all government Indian agents agreed with the ban. Agent Leo Crane called it "foolish," because he thought that continuing to charge a fee for photography was "preferential for all parties involved. Nearly everyone was happy when he could bang away a roll of films for the family album and for a fee of one dollar.

[But now] the tourist loses his chance to vie with Edward Curtis, and the Indians lose their feast money."[28]

These measures did not stop tourists from attempting to snap pictures of village inhabitants. In a 1924 article from *Camera Craft* titled "Kodaking the Indians," an unnamed Native woman complained:

> A tourist passing through hops out of his machine with his Kodak and says, "Hey, you, line up! I want to get your picture!" Then he chooses a setting and attempts to back us up against it. I wonder how kindly the white people in Los Angeles or San Francisco would take to the idea of our appearing on their streets with a Kodak and demanding that they line up for their pictures. It seems they overlook the fact entirely that we, too, are human beings.[29]

Despite the justifiable animosity toward visiting photographers, many indigenous people tolerated the intrusions. Some did so simply because they enjoyed photography and liked having duplicate prints from the visitors to hang in their homes.[30] In at least one instance, a Native individual actually demanded that her picture be taken. During a photographing expedition in 1903, George Wharton James claimed that, while taking a Navajo man's photograph, the wife, who "ruled the roost," insisted that "I make a 'sun picture' of her own."[31] Of course, this request could be attributed to the fact that James, like the rest of the Pasadena Eight, made several trips to the Southwest, and locals were undoubtedly familiar with him. Adam Clark Vroman gained trust by always returning with copies in hand for the people.[32] Fellow photographers Ben Wittick and Sumner Matteson were even invited into restricted areas to observe ceremonies. As anthropologist and curator George Horse Capture (A'aninin) remarked, "Sumner Matteson seems to have had a rare ability to gain the confidence and trust of a people in a very short time. . . . he was allowed to enter and photograph ceremonies and events that were previously forbidden to outsiders. His photographs of the Bear Dance and the Sun Dance are examples of this acceptance."[33] Wittick apparently felt so comfortable with Hopis that he attempted, against warnings, to assist in their Snake Dance preparations. A Hopi priest cautioned, "You have not been initiated. Death shall come to you from the fangs of our little brothers."[34] Sure enough, Ben Wittick died after being bitten by a rattlesnake he was collecting for the ritual.

THE GREAT PICTORIALIST ETHNOGRAPHER

At this point it is necessary to introduce the most famous photographer of Native North Americans. Edward Sheriff Curtis (1868–1952) is credited with creating the "vanishing race" trope with his romanticized, sepia-toned images of American Indians. His mammoth undertaking to record "the old time Indian, his dress, his

ceremonies, his life and manners," conducted from 1906 to 1930, resulted in a twenty-volume illustrated text with 1,500 bound photographs, seven hundred additional loose portfolio plates, and a foreword by President Theodore Roosevelt.[35] Overall, he created more than forty thousand images of tribal communities throughout Native North America, spending most of his life (and money) trying to document the indigenous population before they "disappeared." Yet it was his beautifully composed sepia-toned portraits that would nearly vanish. Late in his career, a destitute Curtis sold the rights to his work, and his photographs languished in a Boston basement for decades. After his opus was rediscovered in 1972, it quickly garnered commercial and academic attention.[36] His frontal portraits of tribal elders spawned a thriving cottage industry, and Curtis's photographs can now be found emblazoned on posters, calendars, and various tchotchkes.

Curtis's original intent was to recapture what he conceived to be the authentic Indian—that is, Indians as they lived before the arrival of Europeans. To do so, he carefully removed all evidence of modernity by cropping, retouching, costuming, and employing lighting tricks that gave his photos a distinct hazy, pictorialist composition.[37] But Indian stereotypes and cultural assumptions were so ingrained at the time that, if Curtis had actually provided an accurate image, his customers probably would not have believed it. So, these images must be read as a product of a particular time and place, based on an understanding of the contemporary culture. But what of the people depicted? What did they have to gain from participating in the illusion? "Don't they have any pride?" asks author and curator Paul Chaat Smith (Comanche), who answers his own mischievous question by stating, "I don't know, maybe they dug it. Maybe it was fun."[38] Amusement and enjoyment can certainly be considered reasons for collaborating with Curtis. There is also the monetary factor (since Curtis often paid his models in cash or food), as well as the idea that reenacting battles, recreating ceremonies, and donning regalia maintained a sense of self-worth and cultural affirmation for the Native sitters.[39] Therefore, their assistance in falsifying what could be passed off as historically accurate images can actually be seen as a means of agency for the Native subjects. This is certainly true of our next example.

Apparently, Native people were not always willing to participate in picturing "every phase of Indian life" as Curtis desired.[40] For instance, Curtis sought to record a Navajo Nightway, a sacred nine-night ceremony that calls upon supernatural beings (the Yeibichai) to help heal someone. The dancers refused to wear their ceremonial masks during the day (which the photographer needed for the lighting) to stage the Nightway ceremony (figure 2.4).[41] Instead, they insisted that Curtis make the masks and related costuming for them so that the regalia would not have religious significance. This seems only fair, since Curtis hoped to photograph a winter ceremony in the middle of spring.[42] Furthermore, the participants surreptitiously

secularized the ritual dance by performing it in reverse. They quite clumsily (but ingeniously) danced it backward "and kept bumping into each other" while holding their rattles in the opposite hands—a point made by later Yeibichai dancers who viewed the photos and related film reel in the 1980s.[43] Curtis was probably unaware of the deception. Photographs such as this are important in providing us with information about the relationship between photographer and subject.

FIGURE 2.4

Yeibichai dancers—Navajo,
1904
Photo by Edward Sheriff
Curtis
Library of Congress, Prints
and Photographs Division,
LC-USZ62-96721

PHOTOGRAPHING FRIENDS AND NEIGHBORS

Although many photographers were itinerant and visited tribal communities just long enough to capture the scene they desired, a few lived year-round with them. Understandably, these individuals established long-standing relationships with their neighbors. Lloyd Winter and Edwin Percy Pond, who owned and operated a photography studio in Juneau, Alaska, for almost fifty years from 1894 to 1943, are perfect examples. In that time, they established a good rapport with the Northwest Coast tribes, and Winter learned to speak the Tlingit language. Thanks to their long relationship with the Native communities, they were invited to attend and permitted

to photograph important Native ceremonies, such as potlatches, which they would have been unable to do without consent. After inadvertently witnessing a secret ceremony, Winter and Pond were adopted into a Tlingit clan and given the names Kinda ("Winter") and Kitch-ka ("Crow Man"), respectively. Expressing his ongoing interest in the welfare of the Native population, Winter sought to join the nonprofit Alaska Native Brotherhood in 1928. When he passed away in 1945, six Tlingit men served as his pallbearers.[44]

Perhaps Winter and Pond's most famous, and certainly most reproduced, image was taken inside Chief Klart-Reech's (L-shaadu-xích-x's) house in Chilkat (Klukwan), Alaska, in 1895 (figure 2.5).[45] This image depicts twelve male Tlingits standing among their most prized possessions and displaying what many believe to be the best examples of Northwest Coast art.[46] They are posed in front of the elaborately decorated Rain Screen and between two carved house posts—the Wormwood Post on the left and the Raven Post on the right, both representing crests of the Gaanax-teidi clan.[47] In the foreground is a giant basket known as the "Mother Basket," which was used to serve guests during ceremonies. All of the regalia pictured, including the dance aprons, leather "bird wings," and tunics, would be stored in one of the two carved bentwood boxes on display on the second level. On the far left, a man rests his arm on the long woodworm feast dish that stretches across the upper platform. In addition, he is wearing an apron which, according to oral tradition, was the first Chilkat blanket to come to Klukwan.[48] The only figure identified in this group is Coudahwot, a Chilkat leader, who stands in the center wearing a painted leather tunic and resting his hand on a boy's shoulder. Yeilgooxú (George Shotridge), the hereditary caretaker of the Whale House, does not appear in this picture, although he does appear in other photographs by Winter and Pond. Yeilgooxú and his people were not forced to open their longhouse to the photographers, nor were they coerced to open their storage containers and don their ceremonial regalia. If anything, they were proudly showing off their material culture and taking advantage of the talents of Winter and Pond, who managed to take a beautiful photograph under difficult indoor lighting conditions.

Winter and Pond were neighbors, friends, and not ethnographers by trade, so there was little effort to create "authentic" images of Native life. Unlike Edward Curtis, who eliminated signs of Euro-American contact, Winter and Pond made no such erasures. For example, in the Whale House photograph and in other images of potlatches and dances, Native subjects combine their European-style clothes with their Chilkat blankets and clan hats. As ethnographer Victoria Wyatt points out, "They were not trying to construct literal reenactments of the potlatches of their forebears. Rather, their dances had living meaning to them; they did not need to eliminate evidence of their contemporary dress in order to find that meaning."[49] Winter and Pond

Interior of Chief Klart-Reech's House, Chilkat, Alaska, Indians in old Dancing Costumes, Copyright 1895 by Winter & Pond.

also did not pay the sitters to model for them—though they most likely gave them copies. From all indications, the relationship between these photographers and the Native community within which they lived and worked was one of mutual respect.

It is hard to match the fifty-year residential stay of Winter and Pond, but Kate Cory comes close. In 1905 at the age of forty-four, the self-described "maiden lady" moved to Old Oraibi Pueblo in Arizona with the intent of starting an artist's colony. No one followed the intrepid Cory. So, as she famously stated, "I became the colony."[50] For eight years she lived with the Hopis, photographing everyday life and spiritual practices. Cory never sold her photographs, nor did she create them with the tourist market in mind. Her work is notable for its personable quality, and although the people are aware of her presence there are no stiff poses or awkward glances. Indeed, there is a relaxed quality to the subjects in her pictures (figures 2.6, 2.7, and 2.8).

FIGURE 2.5

Interior of Chief Klart-Reech's house, Chilkat, Alaska, 1895
Photo by Winter and Pond
Alaska State Library, Winter and Pond Photography Collection, PCA-87-10

FIGURE 2.8

Hopi water carrier,

c. 1905–12

Photo by Kate Cory

Museum of Northern Arizona,

Kate Cory Photography

Collection, MS-208 #75.920

In many of her images, the people laugh and smile as if they are conversing with an old friend. They appear comfortable in her presence, and as a result her photographs give the impression of candid depictions of daily life. Unlike itinerant photographers who largely focused on ceremonies and Native regalia, Cory depicted the everyday chores of Hopi existence. In one striking image (figure 2.8), she depicts a woman carrying water—which was no small feat for the subject, since all water had to be carried up to the mesa from a source 600 feet below. Cory empathized with the people and viewed them as human beings, not as curious exotic Others. This is clearly demonstrated in one of her captions, which states, "Mother and twins. Hardly the vanishing race."[51] For her steadfast support of the Native community, the Hopis rewarded Cory by allowing her to enter the kiva—a ceremonial council house traditionally reserved for male initiates. In doing so, she became the first white woman to be permitted into a kiva; she showed respect by not bringing her camera into their sacred space.[52]

Kate Cory, an unmarried woman living among Native Americans during the first decades of the twentieth century, was an anomaly. Yet the fact that she was a female photographer was not all that unusual. In contrast to attending an art academy, it was relatively easy for women to become photographers. They could

learn the medium on their own, or through correspondence classes, and then join camera clubs to hone their skills. At the turn of the twentieth century, many women opened photographic studios, like Gertrude Käsebier and Benedicte Wrensted, and many more traveled the continent taking pictures of its Native inhabitants.[53] Joanna Scherer notes that, since it was a relatively new medium, "photography was not hampered by cultural and social traditions of long apprenticeships and male domination, as was true in other art related fields."[54] In addition, most early photographic studios and developing labs were located in the home. Hence, photography became a socially acceptable profession for Euro-American women.

Women photographed the American Indian population for a multitude of reasons. For example, Jane Gay worked as an assistant for ethnologist Alice Fletcher during the summers of 1889–92 to help document Nez Perce land allotments photographically. Matilda Coxe Stephenson started working for the Bureau of American Ethnology in 1899 and used a camera for her fieldwork among the Pueblo tribes from 1904 to 1910. In the Northwest Territories, Geraldine Moodie started photographing First Nations people and Inuits in the 1890s and became so famous that the prime minister of Canada commissioned her to photograph North-West Rebellion sites. Through 1895–1912, Dutch immigrant Benedicte Wrensted operated a photography studio in the small town of Pocatello, Idaho, where many local Sho-Bans frequented her business.

Some women managed their own studios, and others got their start working for famous photographers. Imogene Cunningham and Ella McBride started out assisting Edward Curtis with his lab work; Grace Nicholson, a photographer of northern California tribes, originally worked as a secretary for George Wharton James. Other women simply traveled around photographing Native populations. For instance, over the course of twenty-five years (1905–30), Mary Schäffer toured the Canadian Rockies photographing the Stoney (or Nakota, as they call themselves). In the American Southwest, Laura Gilpin chronicled the changing landscape and Native peoples from 1916 until her death in 1979. Retired schoolteacher Gladys Knight Harris sold most of her possessions, drove from Los Angeles to Kotzebue, Alaska, and spent the latter half of the 1940s creating almost ten thousand photographs of Inupiat people. These women are just a small sampling of the female photographers who chose to photograph Native North Americans during the first hundred years of the photographic medium, 1840–1940.[55] Despite the large numbers of women practicing photography, art critic Lucy Lippard contends that "the photographers whose names we know are virtually all white men."[56]

It would seem that, by virtue of their gender, women inhabit a social space similar to that of American Indians—that is, a position of inequality within the dominant Euro-American patriarchal society. Many photographic narratives seem to

reinforce the themes of family and domesticity that were traditionally aligned with culturally determined concepts of womanhood. For example, images of the Stoney community photographed by Schäffer (figures 2.9 and 2.10) transcend the visual tropes of the "noble savage" and "vanishing race" by depicting people with human dignity, capable of love and affection for family. The warm smiles and relaxed poses of the sitters attest to a particular level of comfort with the photographer.

Schaffer photographed these families at eye level, thereby giving the impression that the photographer and subjects are "trading gazes."[57] Yet these interactions were much more complicated. Female photographers who traveled to the Native communities were not exactly equals with their indigenous subjects. These women were often well educated and wealthy (or financially comfortable) and took advantage of the mobility their class afforded them. For these women, it was a journey of self-discovery, an adventure, and a chance to escape the last vestiges of Victorian womanhood. Hence, their photographs were not really meant for their American Indian

FIGURE 2.9

Sampson Beaver family, 1906
Photo by Mary Schäffer
Whyte Museum of the Canadian
Rockies, Archives and Library,
Mary Schäffer fonds, V527/NG-125

subjects. Although they sometimes gave copies of the photographs to the sitters, the larger collection of images would be taken with the photographers when they left. In most cases, the pictures were donated to a museum or eventually sold as part of the photographer's estate. If the indigenous people wanted these images, they would have to pay for them. For instance, the Karuk Nation, a northern California tribe, "purchased back" a group of Grace Nicholson's photographs and have since placed them on display in their tribal center.[58]

As more tribes consider photographs part of their cultural patrimony, the desire to have their photographs repatriated and to control the circulation of historic images has grown. A high-profile example is Laura Gilpin's collection of photographs at the Amon Carter Museum in Fort Worth, Texas. In that collection is a 1932 photograph titled *Navaho Madonna* that depicts a Navajo mother and child (not unlike Schaffer's image reproduced here as figure 2.10). Over the years, the image was duplicated repeatedly by the museum and its publishing affiliates. The Navajo descendants of the subject, the Benally family, argued that, although their ancestors did participate in the creation of the photograph, they did not authorize public exhibition or distribution of the image. In addition to the claim of invasion of privacy, the Benally family cited a Navajo belief that considers publicly circulated images to bring "bad effects on the people in the photographs."[59] Eventually the Benallys won their case in a court of appeals, and the image is now restricted to educational use only. This indigenous image-rights case is only one example of a larger movement occurring worldwide, most actively pursued in Australia and New Zealand.[60]

Although descendants' claims and desires with respect to historical photographs are relatively easy to ascertain, it is more difficult to determine the sitters' goals for their own images. One rare exception is the photographs taken in conjunction with the Wanamaker Expedition. Sponsored by department store magnate Rodman Wanamaker, the expedition was a series of three excursions in 1908, 1909, and 1913 to campaign for American Indian citizenship in the United States. This endeavor was part of a larger advocacy movement to "save" Native Americans from cultural extinction. Led by photographer Joseph Kossuth Dixon, the expeditions employed photography, film, and sound recordings to document "the sunset of a dying race" and publicize the plight of American Indians.[61] In 1909 the expedition gathered leaders from approximately fifty reservations, mostly on the northern plains, to meet as the "Last Great Indian Council." They gathered at Crow reservation to tell stories, reminisce about the past, and have their portraits created (figures 2.11 and 2.12).

Although the event was largely intended to evoke nostalgia, the Native participants discussed their hopes for the *future*—especially the future of their images. For instance, Yankton Sioux leader Pretty Voice Eagle (Wabli Ho Waste) stated:

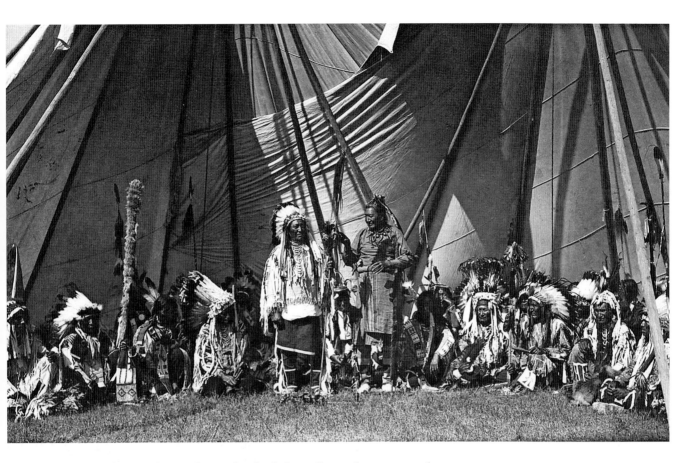

was glad to come here and meet the chiefs from all over the county, and see many whom I have never seen before, and talk to them. . . . we cannot go to Washington; we cannot present ourselves there, but the pictures and the record will be preserved there and in great cities, to speak for us. . . . One great feeling of gratefulness I have about this meeting is that I hope that my grandchildren and their grandchildren will read the speeches I have made here, and will see my pictures.[62]

Pretty Voice Eagle thought that the visual and textual records not only represented but could also act on behalf of the Indian chiefs. For him, these works would have an active (not passive) agency that could mediate social relations and perform an act of diplomacy for the people. At the same time, Pretty Voice Eagle saw these documents as his legacy to leave to his grandchildren and their grandchildren. Such hope and expectations for future descendants does not sound like a person who is anticipating the immediate demise, or "dying," of his race. This is not to say that the chiefs were unaware of their own mortality. All of the participants in this Indian council were respected elders between the ages of fifty and eighty years who recognized that they were making historical documents for their people. As Chief Running Fisher (Atsina/Gros Ventre) stated, "This record and pictures will live when we are all dead."[63]

FIGURE 2.11

Chief Pretty Voice Eagle, 1909

Photo by Joseph Kossuth Dixon

Denver Public Library, Western History Collection, Z-3191

FIGURE 2.12

Chief Two Moons addressing the council, 1909

Photo by Joseph Kossuth Dixon

Denver Public Library, Western History Collection, Z-3163

According to the attendees at the council, the primary beneficiaries of Wanamaker records would be their descendants. As Chief Red Whip (Atsina/Gros Ventre) noted, "The younger generation will read the history of these chiefs and see these pictures." This was echoed by Cheyenne chief Two Moons, who stated that "this record will survive for our children and their children will reap the benefit."[64] Collectively, these elders seemed to consider these records as part of their contribution to the histories of their people and as living memories that would inspire next generations. As visual documents, these photographs were intended by their sitters as messages of endurance and a commitment to cultural survival.

Their descendants have received the message. For Anishinaabe writer Gerald Vizenor these images are a component of "survivance," which he describes as "more than survival, more than endurance or mere response; the stories of survivance are an active presence."[65] Native subjects of photography were not always passive sitters or victims of the colonial gaze. They had (and continue to have) an active engagement with photography as consumers, and as communities who have enforced restrictions on photographers. Native North Americans demonstrated what photography could do for them—from increasing spiritual power to providing visual exposure as propaganda. They proved that they could resist photography as a tool for surveillance by destroying cameras or even altering their rituals to resist visual documentation.

Native author Leslie Marmon Silko (Laguna Pueblo) explains that "Native Americans synthesized, then incorporated, what was alien and new," and therefore it was not long before they would be standing behind the camera instead of in front of it.[66] The next section discusses the practice of photography by Native Americans. Like their roles as subjects, American Indians were not fixed in a single mode of representation. As I demonstrate in the following chapters, their intent and motivations in using photography are as diverse as the number of tribal communities.

PART II | Native
Practitioners

Professional Native Photographers

What is significant about the adoption of alien objects—as alien ideas—is not the fact that they are adopted, but the way they are culturally re-defined and put to use.

—IGOR KOPYTOFF

Most Native involvement in photography has taken place in front of the lens rather than behind it. As curator Gerald McMaster (Plains Cree/Blackfoot) points out, "Native people have had, historically, to play the role of the subject/object, the observed, rather than the observer. Rarely have we been in a position of self-representation."[1] Yet some of the earliest Native photographers straddled the line between being the observed and the observer while working as collaborators in the emerging discipline of anthropology. These pioneering photographers were introduced to and trained in photographic techniques by early anthropologists or ethnographers who visited their communities. Their photographic output is understandably different than that of photographers who started practicing the medium on their own as a hobby. This chapter considers professional Native photographers—individuals who were paid for their photographic work. These people include anthropological informants, field photographers, and studio photographers.

Benjamin Haldane, self-portrait in his studio (detail), c. 1899. Photo by Benjamin Haldane. See figure 3.35, page 85.

A SHAMAN AND ETHNOGRAPHER

The son of a Tlingit mother and British fur trader, George Hunt started his career in 1879 as an interpreter and guide for the Jessup North Pacific Expedition, and ten years later he came to the attention of anthropologist Franz Boas, who was working among the Kwakiutl people (or Kwakwaka'wakw, as they prefer to be called). In both instances, Hunt contributed ethnographic photographs, making him one of the first American Indians to use a camera and perhaps the first ethnographer to employ photography for the purposes of visual anthropology.[2] It was Boas who gave him his first camera, that is, after Hunt complained that he did not have adequate means to record his culture, proclaiming, "Oh if I had your camera with me." Boas then arranged for the Bureau of American Ethnography to pay him two dollars for each photograph.[3] Prior to this exchange, Hunt was trained in the medium by a variety of sources. It is possible that he learned photography directly from the inventor of Kodak himself, George Eastman. The famous inventor often stopped in the Pacific Northwest and reportedly educated the indigenous population on how to operate a camera.[4] Hunt personally stated that he learned photo techniques from his brother-in-law, a studio photographer in Victoria who taught him "how to print the p[h]otograph."[5]

Despite his many influences, Hunt had an unusual approach to photographing his adopted Kwakwaka'wakw community. Unlike other contemporary images of the Pacific Northwest tribes, which focused on material culture such as clan houses and totem poles, Hunt's photographs concentrated overwhelmingly on human activity. Almost all of his photographs depict the Kwakwaka'wakw people of his hometown,

FIGURE 3.1

Kwakiutl shaman and patient, c. 1902

Photo by George Hunt

American Museum of Natural History Library, AMNH 22868

Fort Rupert, or nearby Alert Bay in British Columbia. Although not born into the tribe, Hunt was raised among the Kwakwaka'wakw and took part in their customs, becoming fluent in their language and eventually marrying into the community.[6] His marriages to high-status First Nations women were key to his entry into their culture, especially given that the lines of descent are matrilineal, giving women a greater role in cultural transmission.[7] Thus, despite learning his mother's Tlingit language and his father's European values, Hunt identified more with the Kwak-waka'wakw people. In addition, he trained as a *palaxa* (shaman, or Native healer), which allowed him special access to many Kwakwaka'wakw rites and ceremonies.[8]

In an image taken in 1902, Hunt depicts a Kwakiutl shaman and patient during a healing session (figure 3.1). The healer is featured leaning over, in the process of sucking out the illness from his recumbent patient. The pair are positioned next to a wooden structure and surrounded by spruce trees. Hunt, as the photographer, is in the image as well, throwing a long shadow across one of the baskets in the foreground. At the time he took this photograph, Hunt (known by the name Quesalid) was both a student of shamanism and an ethnographer.[9] That the subjects allowed his attendance at the ceremony, and permitted his photographing it, attests to his status within the tribe.

As with most of his images, Hunt provided a long description for the photograph: "Doctor healing sick man with a basket and sharp pointed stick to drive the evel spirit away and spruce tree for the same."[10] When a relative, Emma Hunt, was asked about such detailed annotations, she said it was the traditional "long way of saying something." Upon further review of his captions, she exclaimed, "He's really speaking Indian now!"[11] Indeed, his indigenous perspective is expressed through both his visual and textual storytelling.

FIGURE 3.2

Hamat'sa initiate being restrained, c. 1902

Photo by George Hunt

American Museum of Natural History Library, AMNH 22866

FIGURE 3.3

Hamat'sa initiate tamed, 1902

Photo by George Hunt

American Museum of Natural History Library, AMNH 22858

Occasionally Hunt created photographs that illustrated the sequence of actions during an event. For instance, in a set of photographs portraying a Hamat'sa (secret "cannibal" society) ritual, he depicts the progress of an initiate returning from seclusion in the woods (figures 3.2 and 3.3). It should be noted that Hunt was previously arrested (in March 1900) for his involvement in the Hamat'sa—one of the many First Nations religious ceremonies banned under Canadian law from 1885 to 1951—so by taking such pictures he was risking persecution.[12]

In figure 3.2, the "wild" dancer is restrained by other participants. Hunt's caption reads, "Hamatsa just caught from the Bush Dress in Hemlock branch, Nakwaxda'xw tribe."[13] With this photograph, he depicts a key part of the ritual, a point at which the initiate has been possessed by a man-eating spirit named Baxbaxwalanuxsiwae. Figure 3.3 depicts the taming of the Hamat'sa initiate, who is seen dancing in a semi-circle of attendants. This stage of the ritual represents control over human emotions and integration back into society. Presumably, Hunt chose to capture these specific moments because he was aware that they were important steps in the ritual. After all, his son, David, was once a Hamat'sa initiate and eventually became a senior member and chief of all secret societies within the community (known collectively as Seals), so Hunt had a close personal connection to the ceremony.[14] Furthermore, Hunt had previously arranged for a troupe—including his son—to attend the 1893 Chicago World's Fair, where they danced the Hamat'sa.[15] In other words, he had a long-standing interest in representing this particular ceremony, and he brings his own intimate indigenous knowledge to bear on the photographs.[16]

Hunt's approach to photography can be extended beyond his own work. He also had strong feelings about how his culture should be photographed by others. When Edward Curtis was in the Pacific Northwest between 1910 and 1914 to create his film *In the Land of Headhunters* (1914) and to shoot photos for volume 10 of *The North American Indian,* Hunt served as his principal assistant for both filming and photography.[17] He helped Curtis scout for locations, recruit actors and models, and procure costumes and props, and he provided text and translations.[18] In an image taken for Curtis's book project, Hunt's wife Francine (Tsukwani) modeled as a bride for a traditional Kwakwaka'wakw wedding (figure 3.4). But Francine was not just a model; she was also an influential collaborator in the making of Curtis's Kwakwaka'wakw imagery. Scholars Bill Holm and George Quimby detailed her contributions, which included creating traditional attire, advising on details, and playing several roles in both the film and still photography.[19]

The image starring Francine, which Curtis simply titled *A Bridal Group,* features six people posed on a platform of a clan house and framed by a pair of totem poles. The bride is positioned in the center between two dancers, with her "father" on the

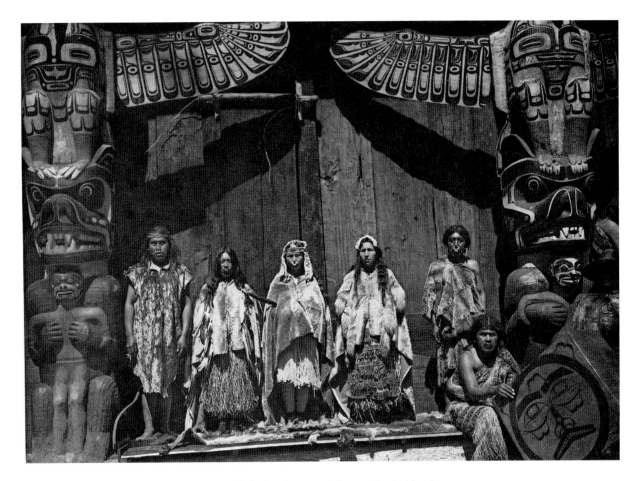

far left and the "bridegroom" to the far right behind a seated figure who holds a box drum.[20] To focus on the bridal party, Curtis moved in close with his camera, which effectively cropped out some of the totem poles and architecture.

Hunt had strong words regarding Curtis's aesthetics and was exceptionally frustrated with the framing. He wrote to Boas exclaiming, "About the photo of my wife there is story belong to it. But Mr. Curtice did not take the story or did not care as long as he get the picture taken. . . . he Don't know what all the meaning and the story of it. for on that Picture you cant see the four carved Post under it."[21] If this statement is any indication, Hunt had specific ideas of what should be included in the photographic compositions of his people. For him, photography was much more than just capturing an aesthetically pleasing image—it was a means of facilitating storytelling and expressing Native ways of life. In other words, Hunt would not have cropped this scene in such a way because the details provide an important context for relationships among the community, ancestors, and spirits. Still, the impetus for much of Hunt's own image-making can be attributed to his ongoing collaboration with Boas, who often requested that specific items be photographed.

FIGURE 3.4
A bridal group, 1914
Photo by Edward Curtis
The North American Indian,
vol. 10, pl. 361
Library of Congress, Prints
and Photographs Division,
LC-USZ62-52209

Their combined efforts would come to be known as "salvage ethnography" (the documentation of cultures threatened with extinction), which is readily apparent in the photography by Hunt.[22]

Hunt's most reproduced images are also his most controversial. The photographs in question were taken in 1903–4 of the Nuu-chah-nulth (formerly known as Nootka) Whalers' Shrine located in the village of Yuquot on Vancouver Island (figure 3.5). Rituals to ensure a good whale hunt and to lure dead whales to wash up on shore were enacted at the site. Only high-ranking Nuu-chah-nulth families could hunt whales, so the shrine was used exclusively by people who were members of chiefly lineages.[23] The two chiefs who claimed to be co-owners of the shrine required proof that Hunt was worthy of admittance. By putting on a demonstration of his shamanistic skills, Quesalid (as he was known to them) was permitted to view and photograph the site.

The Whalers' Shrine consists of four carved whales, eighty-eight carved human figures, and sixteen human skulls—two of which were fixed on stakes at either end of a large wooden canopy. Upon seeing Hunt's photographs of the shrine, Boas insisted that he acquire it for the American Museum of Natural History. In a subversive agreement with the chiefs, Hunt negotiated a price of $500 and ten Hamat'sa songs, but the chiefs stipulated that Hunt could not remove the shrine until the people were out fishing. As he stated, "They Made me Promes to leave the House alon ontill all

the People go to the Bearing sea and to New Westminster. then they will ship it on the steamer."[24] Before the shrine was packed for shipping, Hunt took several more photographs of the site. They are the last remaining documents of the complete shrine, because after the American Museum of Natural History acquired it the shrine was never assembled or placed on display. For over a century the shrine has remained in storage and, to date, it is embroiled in controversy and subject to ongoing claims of repatriation.

Ever since its dismantling, the shrine has been represented exclusively through Hunt's photographs, reproduced in publications, documentaries, and at the museum. And, just like Boas, the public has responded with curiosity and awe to the photographs of the Whalers' Shrine. "The photographs," states anthropologist Aldona Jonaitis, "for most people *are* the shrine."[25] Hunt's images have essentially become artifacts that retain the essence of the original objects. Yet there is still a sense of loss regarding the shrine—especially for the Mowachaht people, the original owners of the shrine. The documentary film *The Washing of Tears* (1994) highlights their struggles to reclaim the shrine and features many of Hunt's photographs. In effect, the images signify the presence and existence of the shrine while making us aware of its absence in the world.

A TLINGIT COLLECTOR AND VISUAL ANTHROPOLOGIST

Although George Hunt is allegedly responsible for collecting approximately 80 percent of the Pacific Northwest Coast objects found in museums today, he was just one factor in anthropological efforts at salvage ethnography.[26] Another Native figure who was actively involved in early anthropology and photography was Louis Shotridge. Born into the high-ranking Kaagwaantaan clan, Louis Shotridge (Stoowukháa) was the son of Kudeit.sáakw and George Shotridge (Yeilgooxu)—the hereditary chief of the Whale House of Klukwan (photographed by Winter and Pond, see figure 2.5). He inherited the position of Klukwan clan chief, and later in life he would serve as the chief president of the Alaska Native Brotherhood. Ambitious and highly educated, Shotridge studied anthropology (informally) under Franz Boas at Columbia University. For twenty years (1912–32) Shotridge worked as an assistant curator at the University of Pennsylvania's Museum of Archaeology and Anthropology—making him the first Native North American to serve as a curator at a museum.[27] In addition to his curatorial duties, he worked as a field ethnographer collecting ethnological specimens for the museum and for private interests such as the Wanamaker expeditions.[28] For several years Shotridge attempted to remove artifacts from the Klukwan Whale House by claiming, under U.S. laws of inheritance, that he was the rightful heir to the collection.[29] His repeated efforts to obtain the objects ruined his reputation among his people and led to increasing factionalism within the community. In

FIGURE 3.6

Killer Whale hat, 1916

Photo by Louis Shotridge

University of Pennsylvania

Museum of Archaeology and

Anthropology, Louis Shotridge

Digital Collection ID: 14812

1937 he died from a fall off a ladder, but according to the archives "some believed his mortal injury was made to seem accidental by Klukwan Natives."[30]

During his collecting ventures, Shotridge took approximately five hundred photographs of objects, people, and landscapes of the Pacific Northwest. Like George Hunt, he provided a detailed description of the artifacts, including their related myths, stories, and genealogy. For example, his field photograph of the Killer Whale hat (Krt-sa xu) (figure 3.6) was followed by an article written for the *Museum Journal* in which he stated: "When Daqu-tonk died, Gahi succeeded his maternal uncle. It was for him that the Killer-Whale Hat was made. The crest had been originally claimed by a Tsimshian clan, but after they were defeated in a war, it was taken as a spoil by the Nani-ya-ayi clan, the victors, who have used it since as an emblem of courage."[31]

This object was one of three highly regarded crest hats that Shotridge collected in 1916, and according to his correspondence the hats were extremely difficult to obtain. As he wrote, "Taking these out from the Drum-house was something like juggling a hornet's nest."[32]

If a group was unwilling to sell an item, Shotridge photographed it instead. For him, photography was a means to obtain otherwise unobtainable objects. He used photography to "acquire" villages and landscapes (especially sites of sacred significance) that were physically unable to be collected in whole.[33] In at least one case, he took photographs against the will of a community—confessing that "while the Indians were attending a feast I had an opportunity of making some photographs of the old section of the town which is strictly prohibited, as I was informed by my host."[34]

Louis Shotridge did not always acquire objects surreptitiously. In some cases, the elders felt that the next generation would not take care of the items so they willingly gave objects over for safekeeping. In other instances, the original owners had converted to Christianity and no longer wanted what they now considered to be idolatrous images.[35] Economic need, especially during the Great Depression, was another reason that many families liquidated their prized possessions. Shotridge once bragged to George Byron Gordon, curator of American archaeology, that "I know where most of the important things are, and my only obstacle is the everlasting esteem of the native owner for them."[36] Despite being a full-blooded Tlingit and spending most of his time in the field collecting—reportedly fifteen of the twenty years he was employed at the museum were spent in the field—Shotridge was unable to convince many people to part with their material culture.[37]

A prime example occurred in 1918, when he attempted to collect a Stone Eagle crest from the Tlingit chief Gago-gam-dzi-wust, who effectively stated, "over my dead body." Shotridge described this exchange in an article for the *Museum Journal*:

> After I photographed it I suggested to the chief that it would be a good thing for a museum, where people from all parts of the world may see and study it. He hesitated for a moment and then said: "I like to do that, if only I have something besides this piece by which to keep memories of my uncles and grandfathers, but this is the only thing I have left from all the fine things my family used to have, and I feel as if might die first before this piece of rock leaves this last place."[38]

Shotridge illustrated the article with his photograph of the chief and the Stone Eagle crest (figure 3.7). In the image, Gago-gam-dzi-wust stands proudly and resolutely behind his cultural heritage. He seems to have a smile of satisfaction—as if he has bested the aggressive collector. The object of his "everlasting esteem" is in the foreground—close to the photographer who wished to possess it, but well out of reach.

FIGURE 3.7

Gago-gam-dzi-wust with the Stone Eagle, the main crest of his ancestors, 1918

Photo by Louis Shotridge

University of Pennsylvania Museum of Archaeology and Anthropology, Louis Shotridge Digital Collection ID: 14931

During a collecting trip along the Naas and Skeena rivers in 1918, Shotridge claimed that he made "over a hundred fine photographs . . . most of which are taken of leading old families of each town."[39] These photographs range from formally posed portraits to casual snapshots (figures 3.8–3.10), and he pictured Native men, women, and children of all ages, either alone or with family and friends, all dressed in popular, contemporary clothing. Unfortunately, many of the sitters are unnamed or simply identified by their tribal affiliation.[40] For example, in figure 3.8 the individual is described as a "Git-k-cn man," but his plain white shirt and dark trousers do not give any indication of his status or rank within the Gitxsan community. Another photograph (figure 3.9) is captioned "A new Tlingit couple," but it should be a "Tlingit family," because a child, presumably theirs, stands between the fashionably dressed pair. Yet another caption (for figure 3.10) does not even indicate the tribal community or location, but merely notes that the people are en route to the fishing camps. Despite his long descriptions of artifacts, Shotridge clearly did not offer the same level of identification to the people he photographed. This was not because he lacked the ability to keep records. Quite the contrary, he had an extensive note-taking system. He meticulously numbered every roll of film and as well as each individual shot. For every photograph, Shotridge provided a subject or object title, place, and date. But for some reason he did not always record the names of his subjects.[41]

Shotridge's notes do offer other insights into his photographic methods. One notecard indicates "color screen used in heavy shadows," and another states that the shot was "taken [with] camera almost pointing at the setting sun."[42] Shotridge also accounted for his poorly composed "test shots" when he described one photograph as "exposure made to make sure of a picture." Furthermore, he used his camera for personal projects, noting that "the other 3 exposures are made with personal pictures." Ultimately his photographs and corresponding notes were used as a type of visual field diary of his collecting trips.

Both Louis Shotridge and George Hunt spent most of their careers as anthropological informants and field ethnographers for their respective cultural institutions. Their photographs were largely conceived of as anthropological "specimens" to be collected and saved in museums along with the material culture the two amassed. Working between the two worlds—the urban museum and the tribal communities— was not without ethical concerns for these indigenous visual ethnographers. As Shotridge professed, "The modernized part of me rejoiced over the success in obtaining this important ethnological specimen for the museum, but . . . in my heart I cannot help but have the feeling of a traitor who has betrayed confidence."[43] Shotridge and Hunt may have started to believe the dominant viewpoint that Native North Americans were a "vanishing race" and that tribal material culture is best preserved in museums. After all, the early twentieth century saw an active effort on behalf of the U.S. and Canadian governments to assimilate Native peoples.

FIGURE 3.8

Git-k-cn man, September 1918

Photo by Louis Shotridge

University of Pennsylvania Museum
of Archaeology and Anthropology,
Louis Shotridge Digital Collection
ID: 14949

FIGURE 3.9

A new Tlingit couple, c. 1918

Photo by Louis Shotridge

University of Pennsylvania Museum
of Archaeology and Anthropology,
Louis Shotridge Digital Collection
ID: 14867

FIGURE 3.10

People on a boat deck during
a visit to the fishing camps,
August 1918

Photo by Louis Shotridge

University of Pennsylvania Museum
of Archaeology and Anthropology,
Louis Shotridge Digital Collection
ID: 14899

PHOTOGRAPHING FOR THE GOVERNMENT

Unlike salvage ethnography, which attempted to depict traditional ways of life, government assimilation programs hoped to produce records showing American Indians adopting Western lifestyles. One Native photographer, Richard Throssel (1882–1933), worked on the Crow reservation for the BIA's Indian Service. Part of his job was to document the daily lives of the Native population to ensure that they were acclimating to a Western style of life.

Born of mixed Canadian Cree and European heritage, Throssel followed his brother from Puget Sound in Washington to the Crow reservation in Montana to work for the BIA. From 1902 to 1911 he was employed as a clerk and field photographer for the Indian Service. Early in his stay, the Crow tribe adopted him and thereby gave him legal status, tribal identity (at the time, the Cree Nation did not have federal recognition or a reservation), and land.[44] The tribe benefited from the adoption of Throssel and other non-Native locals because it enlarged the amount of land owned by the tribal community and decreased the acreage available for sale. During the decade that he lived with his adopted community, Throssel (who is also known by his Crow name, Esh Quon Dupahs, meaning "Kills Inside the Camp") created more than a thousand images of the people and conditions on the Crow reservation.

In 1910 the Indian Service commissioned Throssel to take pictures as part of a nationwide campaign to fight the spread of tuberculosis and trachoma (an infectious eye disease) on reservations. Under the direction of field physician Dr. Ferdinand Shoemaker, Throssel produced a series of "Photographs of Diseased Indians" that illustrated the "unhealthy activities" the government hoped to discourage, including poor personal hygiene, unsanitary housekeeping, and general group behavior like sitting on the ground and sharing items that could spread germs. One of these "Diseased Indian" photographs (figure 3.11) was taken at a sacred event, the Crow Tobacco Society ceremony, and depicts the participants sharing a pipe. Seated on the "dirty" ground and partaking in a ritual that could conceivably spread infection, these people signified the behaviors that put the indigenous population at risk. This type of "before" photograph would have been juxtaposed against images that showed the "pleasant, healthful homes of Indians who have taken advantage of the opportunities the Government has given."[45]

Throssel also took the "after" photographs that illustrated these "good" behaviors. In one titled *Interior of the best Indian kitchen on the Crow Reservation* (figure 3.12), Throssel presents the ideal Native household. In this image, a family is seated at a formal dining table in a well-furnished home. Using a silver teapot, the head of the household pours tea while his wife and son sit patiently. In the left foreground, bright porcelain wash basins punctuate the scene and remind the viewer of the cleanliness of the people pictured. Unlike indigenous spiritual practices that are associated with

unsanitary behaviors and disease, this image is intended to portray acculturation as a healthy and beneficial lifestyle change. Taken together, these images are illustrative of late Victorian Euro-American ideologies at work—namely, the belief that "cleanliness is next to Godliness," which places notions of good hygiene against degeneration. Thus, images that show aesthetic sanitation were vital for both modeling behaviors and conforming to Western values.

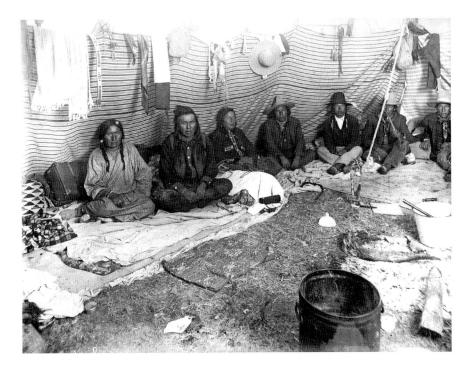

FIGURE 3.11

Interior of Indian teepee, showing the passing of the pipe, from the "Photographs of Diseased Indians" series, 1910
Photo by Richard Throssel
National Anthropological Archives, Smithsonian Institution, BAE GN 04635 06627300

FIGURE 3.12

Interior of the best Indian kitchen on the Crow Reservation, from the "Photographs of Diseased Indians" series, 1910
Photo by Richard Throssel
National Anthropological Archives, Smithsonian Institution, NAA INV 00486700

The before-and-after photographs were shown to Native audiences nationwide as part of the Indian Agency's public health lecture circuit.[46] Like nineteenth-century photographs of "hysterical" patients taken by French and English psychologists, these images were instrumental in defining health and illness.[47] Such measures taken to illustrate, regulate, and control public health are manifestations of what Michel Foucault would call "the birth of biopolitics."[48] Whether Throssel's images were an effective tool for changing the public health of indigenous people is not known. We do know, though, that his photographs were widely circulated, for according to the *1911 Annual Report of the Indian Commissioner* Throssel's images, which "illustrate in juxtaposition the ordinary habitations of careless Indians and the pleasant, healthful homes of Indians who have taken advantage of the opportunities the government has given," were shown on fifty-two occasions "before audiences of Indians and employees aggregating more than 10,000."[49]

By the time the public health images were disseminated 1911, Throssel was already an established photographer. Early in his career, he was mentored by Edward Curtis. Throssel met him in 1905 when Curtis visited the Crow reservation to collect images for *The North American Indian* project. Throssel wrote in his diary: "Mr. Curtis came to the reservation . . . and here I saw some real work. . . . [his technique] was in the finishing and getting the light. Became quite well acquainted with him, and was invited to his studio in Seattle and to go through the Portland Fair together a month or so later."[50] Throssel took Curtis up on the offer, becoming an informal apprentice. The two men would photograph many of the same individuals (mostly chiefs and elders) in the same romantic, pictorialist style pioneered by Curtis. For example, their photographs of the Crow medicine man Bull Goes Hunting (figures 3.13 and 3.14) are both bust-length portraits using dramatic lighting and soft-focus imagery to emphasize the aged and weathered condition of the sitter's skin. Close-up portraits of Native elders in this manner are a typical Curtisian conceit, the implication being that the elderly individual is the part of a disappearing race.

Because Curtis was so invested in the myth of the vanishing race, it is tempting to conclude that the techniques, aesthetics, and themes adopted by Throssel speak more to this myth than to an authentic indigenous visual voice. Yet there are some subtle distinctions between the two photographers. Throssel worked with the standard, black-and-white photographic print rather than toning it in sepia. He also seemed to prefer a variety of poses—especially the three-quarter view—whereas Curtis frequently employed a frontal view of his sitters. And Curtis almost exclusively pictured his Native subjects in traditional dress or in body paint and had little interest in depicting reservation life, whereas Throssel's subjects often wear contemporary Western-style clothing in various settings. Finally, as historian Shamoon Zamir points out, Curtis was not Throssel's only influence, and the representation of

people in Plains ledger drawings could have had just as much impact on Throssel's compositions as Curtis's pictorialism.[51]

Building on what he learned from Curtis, Throssel would create a vast collection of photographs documenting the everyday lives of the Crow community. As he refined his craft, he contrasted his own achievements with those of his mentor. "Since then," Throssel stated, "for this was really the starting point in my work . . . [I] worked to the extent that others thought me a little off. Many times going without meals for want of time just to shoot pictures. . . . Curtis has great stuff but he did not learn his profession nights and make the collection in four years, working only Sundays and after hours."[52]

Throssel's energy and determination to photograph the Crow people resulted in a distinctive body of work. Most of his photographs (including those created for the Indian Service) exhibit a casual intimacy with his adopted tribe. For instance, one of Throssel's most frequently reproduced images, *Crow Indian Camp* (figure 3.15), depicts an intimate and personal moment—the naming ceremony of a new child. In this photograph the father, Bear Ground, stands outside a tipi with his new child in his arms, while his little daughter, Mary, stands at the edge of a finished picnic

FIGURE 3.13

Bull Goes Hunting (Apsaroke), 1909
Photo by Edward Curtis
The North American Indian, vol. 4, plate facing 188
Northwestern University Library, Edward S. Curtis, *The North American Indian*, Digital ID: ct04043

FIGURE 3.14

Bull Goes Hunting, the Old Historian, 1909, in the pamphlet *Western Classics from The Land of the Indian*
Photo by Richard Throssel
Richard Throssel Papers, American Heritage Center, University of Wyoming, ah02394_0729

FIGURE 3.15

Crow Indian camp, c. 1910

Photo by Richard Throssel

National Anthropological

Archives, Smithsonian

Institution, NAA INV 00486800

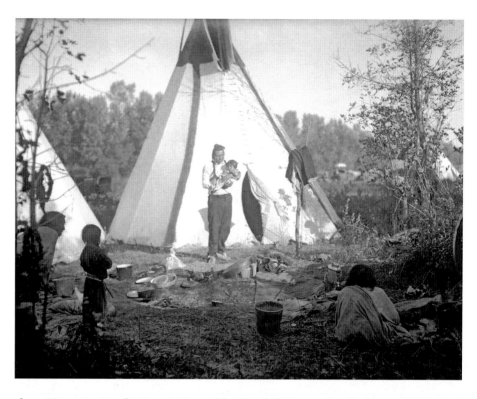

feast. Upon viewing this image, Crow elder Mardell Hogan Plainfeather stated, "It has to do with the strong parental love for a child, the sharing of food, the giving of gifts to the namers, the prayers offered for the future of the child, dream sharing, and the clan system, all of which strengthen the ties that still bind the tribe."[53] This image was sent to the Indian Service as part of Throssel's duties as a field photographer—perhaps to show that Crow families were healthy and thriving. In another photograph featuring Crow youth (figure 3.16), toddler girls eat snacks while playing with a dog and puppy. Framed by a tipi in the background, two of the girls wear Crow dresses decorated with elk's teeth, or "ivories." These dresses would have been worn only for special occasions, so this photo must have been taken before, after, or during a break from an event.

Throssel supplied forty-two images to the Wanamaker photographic expeditions when Joseph Dixon came to the Crow reservation in 1908. He took advantage of the Wanamaker events, such as the Last Great Indian Council, to photograph the various chiefs and elders who gathered on the reservation. Nevertheless, many of Throssel's photographs are not formal portraits and exhibit a snapshot quality, like that of an unidentified couple sitting in a tipi (figure 3.17). In this image, a couple appears to be having a friendly conversation and, as the photographer enters the space, the woman flashes a dazzling smile. This is one of the many images Throssel would take with him when he left the reservation to start his own studio.

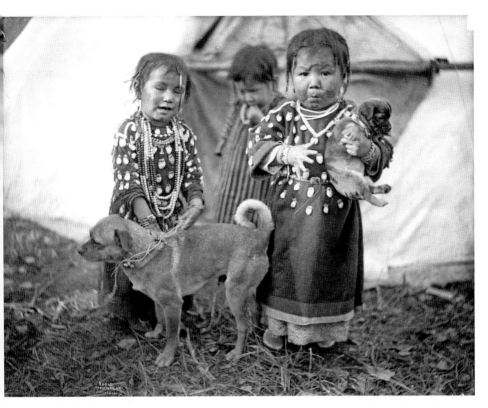

FIGURE 3.16

Three girls and dogs, 1908
Photo by Richard Throssel
Richard Throssel Papers, American
Heritage Center, University of
Wyoming, ah02394_0896

❧ *Collecting and displaying
elk teeth is a long-standing
tradition within many indigenous
communities, not just the Crow
people. Only the two canine
teeth from each elk are desired
for ornamentation. Therefore,
such dresses represent years of
successful hunting, hard work,
and family status within the
society.*

FIGURE 3.17

*Unidentified Crow couple sitting
in a tipi,* c. 1905–11
Photo by Richard Throssel
Richard Throssel Papers, American
Heritage Center, University of
Wyoming, ah02394_2057

FIGURE 3.18

*Western Classics from the
Land of the Indian* (photo
brochure), 1925
Creator: Richard Throssel

Richard Throssel Papers,
American Heritage Center,
University of Wyoming,
ah02394_1548

FIGURE 3.19

Richard Throssel, self-
portrait, 1916
Photo by Richard Throssel

Richard Throssel Papers,
American Heritage Center,
University of Wyoming,
ah02394_1899

In 1912, Richard Throssel left the Crow reservation for Billings, Montana, to start
a photography business—the Throssel Photocraft Company. Using a Thunderbird
as his logo, he emphasized his Native heritage and aggressively marketed himself
as an indigenous photographer. His logo appeared prominently on the cover of his
best-selling product, the *Western Classics from the Land of the Indian* (1925, figure
3.18). Featuring thirty-nine photographs from his personal collection (including
his portrait of Bull Goes Hunting, figure 3.14, discussed previously), this illustrated
booklet describes himself and his work in the following terms:

> Richard Throssel is an Indian, Crow allottee No. 2358, Esh Quon Dupahs
> as the Indian knows him. He belongs to them. His home is among them.
> Their lives he knows, their traditions and folklore. Because these are shown
> throughout his work, whitemen look upon him as an artist. And too, they
> think his pictures are taken from paintings. They are not. They are taken from
> Indians, real Indians in Indian country. Therefore we know they are more
> than just pretty pictures. They are genuine WESTERN CLASSICS.[54]

With such language, Throssel sought to market his product to non-Native customers.
Clearly he was exploiting the popularity of American Indian imagery by promoting
his product as coming from an authentic source.

His self-portrait (figure 3.19), along with his frequent public appearances as a
politician (in the Montana state legislature) and as an Indian activist, helped fashion
his image as a modern American Indian and self-made businessman.[55] Throssel

actively publicized his indigenous identity in relation to his photography business, which would have presumably attracted clients from the local Native population. They must have patronized his Billings studio to have their portraits made. However, these photos are not located in the Throssel archives, so if they still exist they may be in his customers' family albums.

BENJAMIN HALDANE, SCENIC AND PORTRAIT PHOTOGRAPHER

It is rare to find indigenous photographers owning and operating photography studios during the first decades of the twentieth century. Because of the lack of resources and opportunities, most individuals—and not just American Indians—lacked the financial means to open a business and purchase photographic equipment. And if they did, the requisite materials including glass plates, chemicals, and print stock may not have been readily available in their region. These are not the only limiting factors, for social circumstances may have also come into play. Native artist and scholar Hulleah Tsinhnahjinnie (Taskigi/Diné) argues that "Native people dealt with forced assimilation, land allotment procedures, and religious persecution . . . so when photography celebrated its 100th year anniversary in 1939, Native people were concentrating on survival."[56] Still, there are exceptions. One of the earliest Native North Americans to open a photography studio, Benjamin Haldane, did so before the turn of the twentieth century.

In 1899, Tsimshian photographer Benjamin Alfred Haldane (1874–1941)—B. A. Haldane as he was commonly known—opened a portrait studio in the village of Metlakatla on Annette Island in southeastern Alaska. Haldane migrated to the island from Old Metlakatla in British Columbia, roughly thirty miles away, as one of the approximately eight hundred Tsimshian followers of missionary William Duncan. In 1891, under Duncan's leadership, the group gained federal recognition and established their new home as Alaska's only Indian reservation—the Annette Island Reserve.[57] With a busy cannery and logging operations, the settlement prospered and could support Haldane as a "Scenic and Portrait Photo-Grapher" (figure 3.20).

In 1904, American journalist George T. B. Davis wrote a brief history of Metlakatla, in which he noted: "The village photographer, Benjamin A. Haldane, does not hesitate to work in the cannery when it is running and looks after his picture-making and developing after or before working hours. Mr. Haldane is a versatile and talented young man. In addition to being an excellent photographer, he is leader of the village band, and plays the pipe organ in the church."[58] Benjamin reportedly learned photography from his cousin, Henry Haldane.[59] But according to Metlakatla resident and art historian Mique'l (Askren) Dangeli, her community remembers B. A. Haldane more as a talented musician, composer, and band director than as a photographer—that is, until they (re)discovered his work in 2003 when 162 glass-plate

FIGURE 3.20

Three unidentified men in
front of Benjamin Haldane's
studio, c. 1900

Photo by Benjamin Haldane

National Archives, Sir Henry
Wellcome Collection, 297541

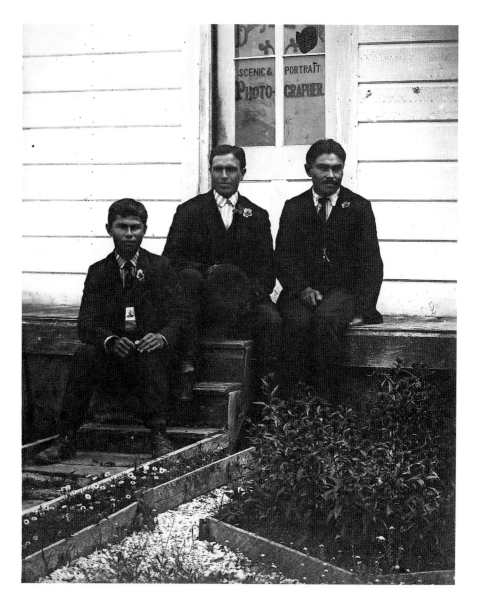

negatives were salvaged from the furnace at the Metlakatla waste facility.[60] Almost
all of the images recovered were taken at his studio in Metlakatla or elsewhere in the
village. Until evidence to the contrary is found, Benjamin Haldane is the first indige-
nous photographer to open a portrait studio on a reservation.

Before he opened his studio, Haldane photographed his patrons outside, usually
on the porches of Metlakatla homes (figures 3.21–3.23). He typically composed these
shots with a front door centered in the background, his subjects seated or standing,
often without props. There is little in these photographs, other than the subjects
themselves, to give the images any distinctive context, but in two instances the sit-
ters have remarkable identifying items. In one potrait (figure 3.21), a pair of Native

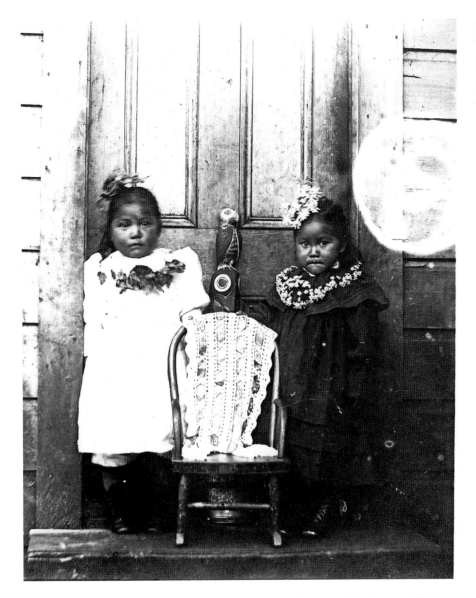

FIGURE 3.21

Two indigenous girls, c. 1897

Photo by Benjamin Haldane

National Archives, Sir Henry

Wellcome Collection, 297489

girls stand flanking a small, model totem pole, the inclusion of which most likely indicates their clan affiliation. Writing specifically about the Tsimshians of Metlakatla, anthropologist William Benyon claimed that by this time "clan obligations and tribal divisions were done away with."[61] This image is evidence to the contrary. The totem pole is partially obscured with lace, perhaps in an attempt to bring attention to the Eagle crest at the top.[62]

The four major Tsimshian clan crests are Eagle, Killer Whale, Raven, and Wolf. Beaver is sometimes used as an alternate crest for Eagle. A local anecdote tells that Duncan and the Tsimshians often substituted Beaver because, as good businesspeople, they recognized that beavers provided wealth during the fur trade era.[63]

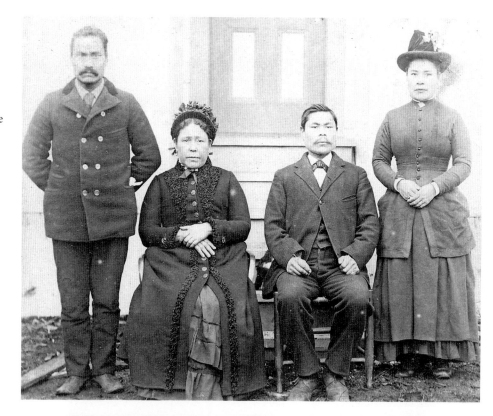

Still, the very presence and central placement of the crest pole reminds us of the continued importance of clan lineage and cultural heritage at this time. In another portrait (figure 3.23), three children pose on a set of stairs, with one child prominently displaying the Canadian flag from the era. Although it impossible to know the significance of the flag for these subjects (perhaps speaking to the residency of the sitters in old Metlakatla, or maybe representing kinship ties to the mainland, since many locals still had family members living in British Columbia), the flag, like the crest pole, operates as a symbol of identity. In contrast to the crest pole, however, the flag is suggestive of national, rather than tribal, identity. The juxtaposition of the two images is evocative of the layering of forms of identity experienced by peoples like the Tsimshians who straddle national boundaries.

As his business expanded, Haldane invested in backdrops. His early photographs employed the use of a plain black curtain, set up outside to serve as a makeshift studio. He brought it with him as he traveled around Alaska and British Columbia taking pictures of the local inhabitants. It can be seen in a portrait of the medicine man Hah-lil-git (figure 3.24) at Nass River, where Haldane spent an entire winter teaching music and taking photographs.[64] In addition to the plain curtain, Haldane would have at least four different studio backdrops. He probably made business purchases incrementally, accumulating the necessary items to bring his operations indoors. This is suggested by an image (figure 3.25) taken outside with a large-scale backdrop, one that would ultimately become a prominent fixture in his studio. In the picture, the backdrop is tacked up to the front of a house and the bottom piles up, spilling over the sides of the steps. The hammer used to mount it rests on the stairs in the foreground, in front of the portrait subject, a young indigenous woman. Perhaps Haldane was still working outside to take advantage of the natural light before he acquired the necessary studio lightening. Once he did move his practice inside, however, his photography became more sophisticated. For example, in a triple portrait (figure 3.26) locals Fred and Mary Eaton (standing and seated, respectively) are accompanied by a third, unidentified woman whose mirror reflection is captured off to the side. It is a beautifully composed image, and he has clearly refined his craft.

Haldane's existing photographs indicate that Native customers traveled from communities across the region, including Saxman, Juneau, and Ketchikan, to visit his studio (figures 3.27–3.32). In every case, the subjects appear modern and refined—the very antithesis of Native American photographs being produced by contemporary commercial photographers like Curtis. It was—and one could argue that it still is—exceedingly rare for Euro-Americans to see images of indigenous people who appear to be thriving and successful in Western terms.

By fashioning themselves as wealthy and sophisticated, Native consumers
actively subverted the prevailing images of indigenous people as universally impov-
erished (and disappearing). Haldane catered to the needs and desires of his clientele
by co-opting portrait conventions commonly found in Victorian photographic
parlors, such as painted backdrops and elegant furnishings. In this manner, Native
customers could commission portraits to depict themselves as upwardly mobile
equals of non-Natives—not as exotic Others.[65] Nevertheless, Haldane's images (par-
ticularly those of the local Metlakatla population) may be illustrating a much more
complicated sociopolitical situation.

FIGURE 3.26

Fred Eaton, Mary Eaton
(seated), and unidentified
woman, c. 1900
Photo by Benjamin Haldane
National Archives, Sir Henry
Wellcome Collection, 297587

FIGURE 3.27

George McKay, Thlinket
Indian of Ketchikan, Alaska,
1899
Photo by Benjamin Haldane
National Archives, Sir Henry
Wellcome Collection, 297519

FIGURE 3.28

David Kininnook of
Saxman, Alaska, 1907

Photo by Benjamin Haldane

National Archives, Sir Henry

Wellcome Collection, 297521

FIGURE 3.29

Unidentified First Nations
woman, c. 1899–1910

Photo by Benjamin Haldane

Ketchikan Museums,

Benjamin Haldane collection,

KM 2018.2.30.131

FIGURE 3.30

Two indigenous couples,
c. 1900

Photo by Benjamin Haldane

National Archives, Sir Henry
Wellcome Collection, 297559

FIGURE 3.31

Four First Nations girls,
c. 1910s

Photo by Benjamin Haldane

National Archives, Sir Henry
Wellcome Collection, 297572

*❧ Benjamin Haldane
operated his studio for
the first four decades of
the twentieth century.
His photographs record
the changing fashions—
especially in women. Sitters
can be seen wearing leg-of-
mutton sleeves popular at the
turn of the twentieth century,
then the tailored suit jackets
and boater hats of the 1910s,
then the casual flapper style
of the 1920s.*

FIGURE 3.32

Two indigenous women,
c. 1920s

Photo by Benjamin Haldane

Ketchikan Museums,
Benjamin Haldane collection,
KM 2018.2.30.159

William Duncan, the religious leader and founder of Metlakatla, attempted to create an economically self-sufficient community with Christian guidelines for living. To enforce this model society, he required the people to adhere to a "Declaration of Residents" (1887), a collection of rules stating what one would expect of a Progressive-era village: observing the sabbath, adhering to U.S. laws, partaking in local government, educating children, abstaining from vices including never attending heathen festivities, being sanitary, using the land, and never giving away property.[66] Obviously, two of the rules (prohibition of attendance at heathen festivities and distributing one's personal property) specifically target Native ceremonies like potlatching. These rules were somewhat redundant, since both the U.S. and Canadian governments already had laws criminalizing indigenous spiritual practices. Duncan ensured that his flock did not break any laws, or commandments, by requiring them to give up their ceremonial objects and regalia upon being baptized.[67] Apparently, his efforts were in vain.

FIGURE 3.33
Unknown family in regalia,
c. 1899–1910
Photo by Benjamin Haldane
Ketchikan Museums,
Benjamin Haldane
collection, KM 2018.2.30.54

Sometimes people patronized Haldane's business to depict themselves and their family members wearing traditional regalia. In one image, an unknown family stands on the porch of a building, with each figure wearing a cedar bark neck ring, or 'yootsihg (figure 3.33). Both the man and child wear bearskin robes, and the mother is clad in a *gwishalaayt,* or what is commonly known as a Chilkat blanket. Damaged film makes it difficult to discern some of details, but the male figure is dressed in full regalia, including a tunic and leggings, holding what appears to be a dance rattle, and his family members are wearing a mix of wool dress and traditional Tsimshian ceremonial regalia. Whatever the case may be, they are certainly outfitted formally as if they are going to partake in a potlach.

In another photograph by Haldane, a young Tsimshian boy is portrayed in full regalia (figure 3.34). Standing on a porch and wearing an oversized button blanket, the boy awkwardly holds a large dance paddle. Because these are adult-sized objects, Dangeli believes that they were being passed down to him, "probably by a matrilineal uncle as is inheritance protocol for Tsimshian men."[68] As is common practice now among both Native and non-Native communities, Tsimshian people were using photography to record milestones in the lives of their children. The photograph not only documents the event but provides evidence that material culture was being

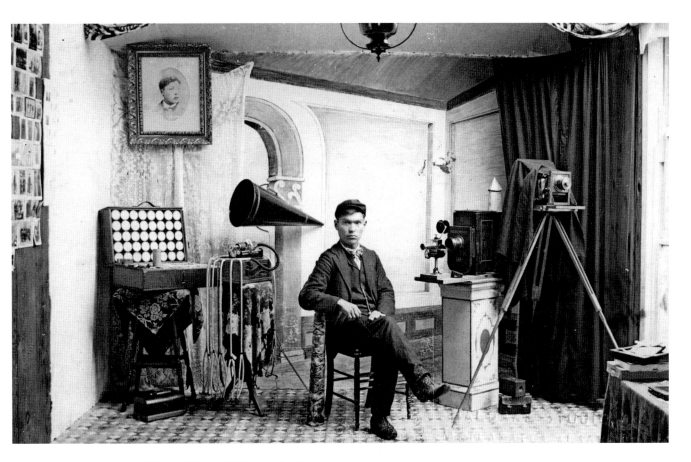

bestowed to its rightful heir. This solidifies the boy's acceptance into the group or, as sociologist Pierre Bourdieu states, "It supplies the means of solemnizing those climactic moments of social life in which the group solemnly reaffirms its unity. . . . by means of photographs, the new arrival is introduced to the group as a whole, which must 'recognize' the child."[69] If this particular photograph was circulated within the community, as Dangeli argues, then it could have performed as a surrogate for the potlach where such kinship roles were publicly acknowledged. Regardless, the image does indicate that the parents were still honoring Tsimshian customs in spite of regulations that restricted aspects of their cultural traditions.

I would like to say that everyone who patronized Haldane's business was enacting a form of resistance by including some form of traditional material culture, but unfortunately this is not the case. Of the approximately four hundred images attributed to Haldane, less than 5 percent depict individuals with carvings or regalia.[70] Haldane's First Nations customers simply did not hint at tribal heritage through dress or material culture in their formal studio portraits. In fact, I could not find a single example of expressed indigeneity within his portrait studio—that is, except for his own self-portrait.

FIGURE 3.34

Indigenous boy wearing a button blanket and holding a dance paddle, c. 1900
Photo by Benjamin Haldane
National Archives, Sir Henry Wellcome Collection, 297482

FIGURE 3.35

Benjamin Haldane, self-portrait in his studio, c. 1899
Photo by Benjamin Haldane
Ketchikan Museums, Benjamin Haldane collection, KM 89.2.14.21

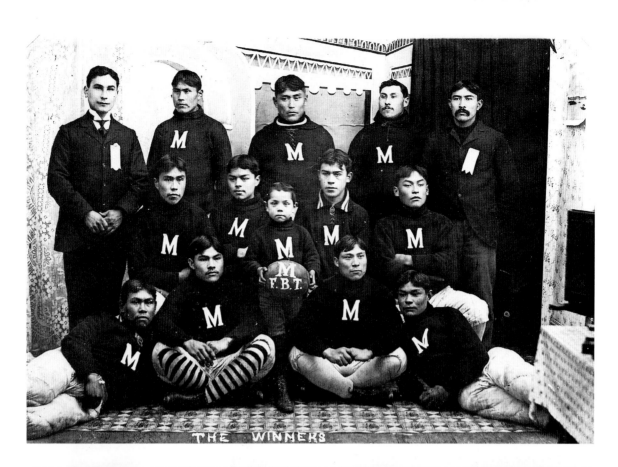

THE WINNERS

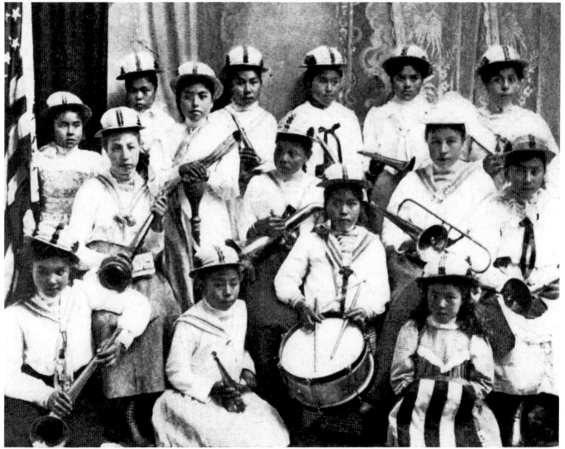

In his self-portrait (figure 3.35), Haldane pictures himself seated in his studio surrounded by his personal interests and tools of his trade. On his left he has placed his photography equipment, including a large camera on a tripod, a Kodak Brownie, and a pair of slide lanterns. To his right he displays his love for music, including a megaphone, a gramophone, several pairs of headphones, and an open box full of wax cylinders. One item is literally propping him up—a small model totem pole on which he rests his right arm. As Askren notes, "B.A. confidently positions himself as physically and metaphorically supported by our cultural values and beliefs and looks directly at the viewer to assert its importance." Askren identifies the bottom figure on the pole as Lax Gibou, the Wolf Clan, which is his clan crest.[71] Haldane thereby combines his lineage, personal, and professional lives in a single photograph. We must remember that this image, and the images he created for his clients, were made during the Progressive era (1887–1933), or the Assimilation era, as it also known, and yet still indigenous practices, beliefs, and customs persevere.

This is not to say that Haldane's clients did not enjoy or take pride in non-Native events and customs. Haldane photographed the local athletic clubs, brass bands, and many weddings and funerals. For instance, the Metlakatla football team used his photographic services to record their winning season (figure 3.36). Interestingly, the team is pictured not outdoors on their field (like the baseball team, not shown) but inside the studio, all squeezed together in the tight space. It is a conventional portrait with the coaches flanking the team and a ballboy in the center. Another community club, the girls zobo band, is pictured in much the same manner (figure 3.37), but with U.S. flags instead of coaches. This photograph was probably taken around the Fourth of July, when many towns and villages celebrated the national holiday. We can see that each member of the band holds a musical instrument, mostly zobos, but there is one drummer and a trombone player as well. Such participation in all-American pastimes paired with the conversion to Christianity has been used as evidence of successful assimilation by earlier scholars.[72] This is not, however, necessarily the case. As historian Victoria Wyatt so aptly put it, "The extent to which they adopted aspects of the foreign culture is not a reliable measure of the degree to which they abandoned their own."[73]

FIGURE 3.36

Metlakatla football team
Photo by Benjamin Haldane
National Archives, Sir Henry
Wellcome Collection, 297985

❧ *By the time this photograph was taken, the Metlakatla community had been fielding football teams for at least thirty years. Duncan introduced football to the Tsimshians at Old Metlakatla in December 1864. He noted in his journal on December 26 that "they had never seen the game before. The village is in two wings east and west, so it was easy to get sides."*

FIGURE 3.37

Girls' zobo band
Photo by Benjamin Haldane
National Archives, Sir Henry
Wellcome Collection, 297652

❧ *The zobo, also known as a songophone, was invented in 1895 by W. H. Frost, also inventor of the kazoo. It was a novelty instrument, made of brass and based on the cornet. Until about 1915, when the fad ended, many small towns (like Metlakatla), colleges, and clubs formed zobo bands, which marched or paraded on bicycles.*

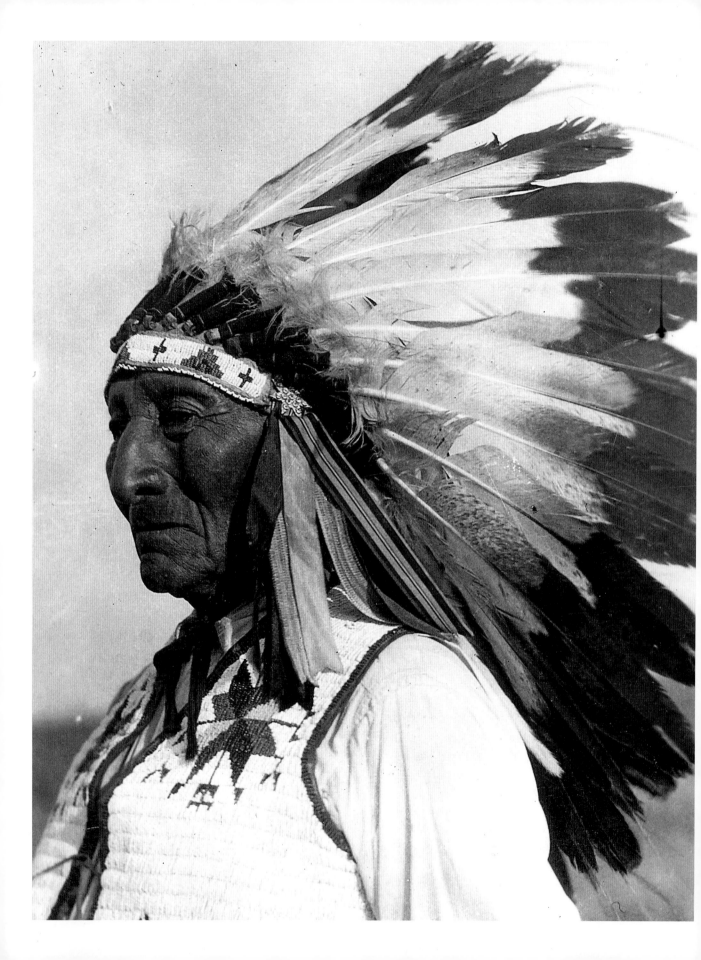

Semiprofessional Native Photographers

> *The instances of native eyes in the aperture are continuous narratives that counter the closure of discoveries and cultural evidence in photographs.*
>
> —**GERALD VIZENOR** (Anishinaabe)

While conducting research for this book, I identified two Native photographers who wanted to earn a living doing what they loved but were unable to break into the profession. They had formal training in the medium, which set them apart from amateur photographers. This brief chapter is devoted to them. One, Horace Poolaw (Kiowa), apprenticed under a studio photographer, then learned aerial photography in the army. He became known as the unofficial photographer of Kiowa community events. The other, John Leslie (Squaxin Island), studied photography at Carlisle Indian Industrial School and reportedly continued publishing his pictures after leaving school. Leslie's work is not well documented, but Poolaw has been extensively studied and exhibited—recently in a solo show at the National Museum of the American Indian.[1]

PHOTOGRAPHING FOR THE ARMY AND THE INDIAN FAIR

Horace Poolaw (1906–84) adopted photography in his teenage years and showed an interest in receiving a formal education in the medium. In 1926 he persuaded a studio photographer to accept him as an apprentice, and around this same time he enrolled in a correspondence course on hand-coloring photographs.[2] So by 1943,

Heap of Bears (detail), c. 1930. Photo by Horace Poolaw. See figure 4.3, page 93.

when he decided to enlist in the army, Poolaw was well versed in photography. The military sent him to school in Denver for technical training in aerial photography, and for three years in the army air corps Poolaw trained bomber crews on how to use a camera to document enemy targets.

"Because young Kiowa men were expected to become warriors," stated his daughter Linda Poolaw, "many of Poolaw's contemporaries joined the armed forces feeling that this was not only their patriotic duty as Americans, but an opportunity to fulfill traditional roles."[3] In a self-portrait created on-site at MacDill Air Force Base in Florida, Horace Poolaw and Kiowa friend Gus Palmer are depicted in a fuselage of a military plane (figure 4.1). Poolaw is in the foreground holding his camera while Palmer hunches in the rear grasping the controls of the machine gun. Both men wear brilliant feathered headdresses along with their regulation military uniforms. Their Plains warbonnets may dominate the photograph, but it is their intense stares and eagerness to "shoot" that enhances the drama of the scene.

This photograph is one of many theatrical-style poses that appear throughout Poolaw's work.[4] Such dramatically composed images seem very much like film stills, so it is natural to assume that Poolaw was influenced by the Westerns being filmed near his home as a boy.[5] But he was exposed to this style by his older brother's wife, Lucy (a Penobscot), who performed in the vaudeville circuit as "Princess Watahwaso."[6] When teaching him how to stage photographs, she thought that his photos would be more entertaining if he added to his style by learning to imitate the movies and the vaudeville stage.[7] Regardless of the influence, he enjoyed directing his subjects and carefully composing his photographs. "He would meticulously place people in as perfect a setting as possible," said his daughter, and "then he took ever so long to make just one or two exposures. Years later, I finally realized that he took such special pains because he didn't have the means to use expensive film. His few exposures had to be perfect."[8]

Poolaw developed his pictures at home, but the expense of paper and chemicals prohibited him from printing all of his images. So he stored the (highly flammable) nitrite negatives in cardboard boxes in a closet; his daughter remembers that "dad had a gas stove back there for heating, they could've blown us all up!"[9] It was not until the 1990s that the family, spearheaded by Linda Poolaw, arranged to print, catalogue, and archive his photographic legacy. Then it was learned that over the course of his photographic career, from the 1920s–1970s, Horace Poolaw had taken more than two thousand pictures of people and places near his hometown in Mountain View, Oklahoma.

Although a prolific photographer, Poolaw was never able to make a living through photography—though not for lack of trying, since he enlarged some pictures and sold them to local restaurants and individuals. He also printed postcards

FIGURE 4.1

Aerial photographer Horace

Poolaw, with Gus Palmer,

1944

Photo by Horace Poolaw

Horace Poolaw Collection,

University of Science and

Arts Oklahoma, Nash Library

Archives, SAO 45UFL12.

Reproduced with permission from

the Estate of Horace Poolaw

of Kiowa leaders to be sold at Indian expositions and at the Anadarko bus station.[10] Regrettably, little else, such as the date or people pictured, was added to the photographs. Identification of the sitters and locations has been problematic because of the general absence of documentation, and information regarding his images has had to be reconstructed some sixty years after many of the images were made.

One of Poolaw's postcards, created around 1930 (figure 4.2), features his relative, Kiowa elder Harry A-hote (Kau-tau-a-hote-tau, meaning "Buffalo Killer"). Although not much is known about the portrait session, Harry A-hote served in the military

and was a member of the elite O-ho-mah War Dance Society, one of the oldest Kiowa dance lodges.[11]

The postcard was not intended to cheapen or lessen the importance of this figure. Poolaw biographer and art historian Laura Smith considers that "among the Kiowa, the possession of a picture postcard of a leader could have served as an affordable way to honor his heroic efforts, as well as a sign of Kiowa strength and determination in the on-going fight for control over their lives."[12] The iconography helps support such a claim. Harry A-hote wears his hair braided and wrapped in otter skin, identifying him as a peyotist—a member of the Native American Church, a religious and resistance movement which, since its incorporation in 1918, has faced legal battles over the use of peyote as a sacrament.[13] Postcards featuring A-hote's steely-eyed gaze along with the peyotist symbolism undoubtedly found a fan base among the Kiowas and other local indigenous communities.

Yet to be truly marketable, Poolaw's postcards also had to interest non-Natives who might not be familiar with the iconography or the status of the individual pictured. To conform to popular images of American Indians, Poolaw often loaned clothing to his sitters. For instance, Harry A-hote wears a beaded vest that can be seen in other photographs by Poolaw, including images of his brother Bruce (or "Chief Poolaw," as he was known on the vaudeville stage), and in a picture of Kiowa elder Heap of Bears (figure 4.3). Ironically, the Kiowas did not traditionally make such fully beaded vests, instead often limiting their beadwork to the edging, although they could have acquired vests like this from other tribes as gifts or in trade.[14]

Given the type of performed Indian identity being depicted, these pictures could be misunderstood as simply reinforcing stereotypes, or playing "white man's Indian." After all, such costuming recalls the work of Edward Curtis, who provided Indian clothing and props to help support his concept of the vanishing race. On the other hand, for Kiowas and other Native communities, wearing Native attire was (and still is) an important means of resistance and expressing indigenous identity. As Kiowa

artist Vanessa Jennings recalled, "The 1920s was a time of defiance. After many years of the Indian agents and some missionaries forbidding Kiowas and other Indians to dress in traditional clothing . . . putting on those [garments] was a way to defy those orders and affirm your right to dress and express your pride in being Kiowa/Indian."[15]

Before the American Indian Religious Freedom Act was passed in 1978, the federal government made several attempts to outlaw indigenous ceremonies and performing arts. As a result, Indian fairs and their current incarnations, powwows, became important instruments of cultural pride and resistance. Modeled after the popular Wild West shows, these events included the Craterville Indian fair and the Medicine Lodge Peace Treaty reenactment. According to Linda Poolaw: "Although Craterville and Medicine Lodge were run by white people, they provided the opportunity for Indians from several tribes to dance and celebrate their traditional lifestyle. So when Craterville closed in 1929, Indians from the Anadarko area decided to start a fair of their own. The next year the American Indian Exposition opened in Anadarko where it remains an annual event to this day. From the beginning, Poolaw was the official photographer."[16]

FIGURE 4.3

Heap of Bears, c. 1930

Photo by Horace Poolaw

Oklahoma Historical Society, Virgil Robbins Postcard Collection, 16445. Reproduced with permission from the Estate of Horace Poolaw

Much of what Horace Poolaw photographed at these events was indigenous pride in cultural heritage and the (re)claiming of space. For instance, in a photograph taken at the Medicine Lodge Treaty reenactment of 1928 (figure 4.4), Jeanette Berry-Mopope and her daughter Vanette wear traditional hideskin dresses while standing in front of a tipi. Even though they are no longer used as housing, tipis continued to be an important visual link to the Kiowa past. Women were the traditional makers and owners of these iconic dwellings, and it was an honor for a girl to learn this skill passed down from her ancestors. Fair attendees like the Mopopes would erect tipis on-site, and the tribal groups would cluster in their respective areas.[17] Not only did the tribal communities assemble in camps, some individuals embellished their tipis with clan and family imagery, and one such symbol (a medicine wheel) can be seen in the photo on the tipi next to little Vanette. Therefore, these tipis, and the camps

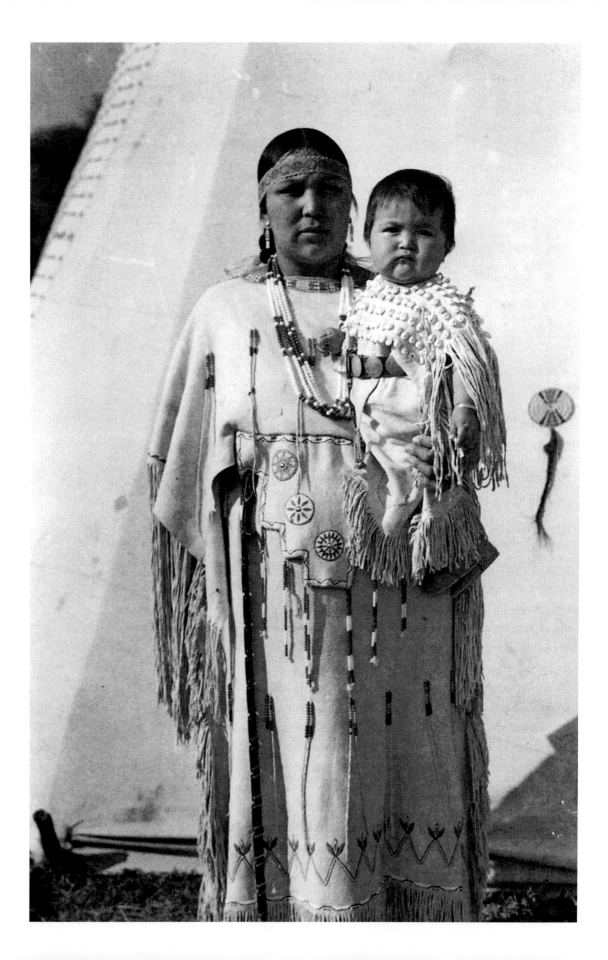

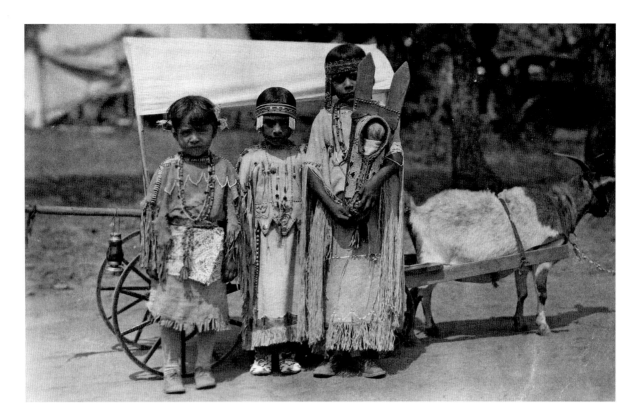

as a whole, served as an important way for the indigenous groups to carve out and claim a piece of the landscape.

Poolaw often sold postcards of Kiowa elders, but in at least one case he created a postcard of children (figure 4.5). They are unidentified, except for the middle child, who is Rachel Two-Hatchet Bosin. The image is undated, but Rachel was born in 1924, so this picture must have been created around 1928. What strikes me about this postcard is that, instead of marketing the same old warrior image that was popular at the time, here we have the next generation. This is at the height of the disappearing-race mentality, so picturing a group of youth taking part in their cultural traditions—wearing buckskin dresses and playing with a cradleboard—subverts the hackneyed vanishing-race trope. Also, Poolaw made no attempt to crop (or otherwise erase) the car in the background, so this is not a melancholic image of days gone by; rather, it is an optimistic vision at a people living very much in the present and looking forward to the future.

Although a great number of individuals pictured by Poolaw are yet to be identified, he did photograph some Kiowa celebrities, such as Silver Horn and Belo Cozad (figures 4.6 and 4.7, respectively). Silver Horn (1860–1940), also known as Haungooah, is one of the most prolific and respected Native artists of the twentieth century. His ledger-style paintings, created in a variety of media, number in the thousands and can be found in most major metropolitan museum collections. Silver Horn would mentor and greatly influence the next generation of Plains artists,

FIGURE 4.4

Jeanette and Vanette Mopope, c. 1928

Photo by Horace Poolaw

Horace Poolaw Collection, University of Science and Arts Oklahoma, Nash Library Archives, P26502. Reproduced with permission from the Estate of Horace Poolaw

FIGURE 4.5

Postcard with Rachel Two-Hatchet Bosin (*center*) and two unidentified children, c. 1928

Photo by Horace Poolaw

Oklahoma Historical Society, Virgil Robbins Postcard Collection 19344.46.10. Reproduced with permission from the Estate of Horace Poolaw

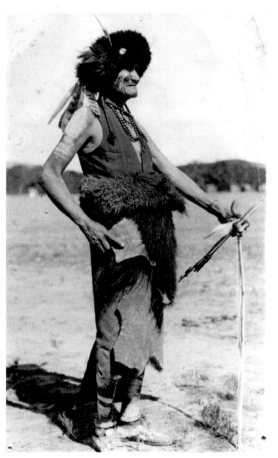 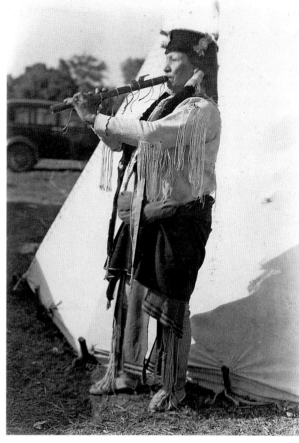

FIGURE 4.6

Silver Horn, Kiowa artist, c. 1928

Photo by Horace Poolaw

Oklahoma Historical Society, Virgil

Robbins Postcard Collection, 16130.

Reproduced with permission from the

Estate of Horace Poolaw

FIGURE 4.7

Belo Cozad, Kiowa flute player,

c. 1927

Photo by Horace Poolaw

Oklahoma Historical Society,

Virgil Robbins Postcard Collection,

19344.64.3. Reproduced with

permission from the Estate of Horace

Poolaw

including Stephen Mopope of the famous Kiowa Six (whose wife and daughter are pictured in figure 4.4), but it is not known if he had any specific impact on Poolaw's aesthetics.[18] Poolaw photographed the artist on the grounds of Craterville Indian fair in 1928. He is dressed in the "old style," not in a reservation blanket but with a head-dress and apron fashioned out of real buffalo hides (which, by this time, had been largely extinct in the Plains).[19] With his right index finger outstretched, he seems to be pointing at the hide, and thus bringing more attention to his historic dress. Around his neck he wears mescal beads—a symbol of peyotists—and a potent hallucinogen used in early Native American rituals before it was replaced by the safer peyote bud. Taken collectively, his dress honors pre-reservation Indian life and symbolizes resis-tance, despite the fact that the only safe place to practice their customs at the time was at an Indian fair.

One year earlier, in 1927, at the same fair in Craterville, Poolaw photographed the famous Kiowa flute player Belo Cozad (1864–1950). Cozad, keeper of the sacred flute, spent his life tirelessly promoting the preservation of Kiowa music. His 1941 recording for the Library of Congress influenced several different genres of music

and musicians, including classical composer Aaron Copeland and the American rock group Jefferson Airplane.[20] In Poolaw's photograph, Cozad is wearing fringed buckskin and playing his instrument in front of a tipi. Nevertheless, our eyes are drawn to a solitary car parked in the background. Unlike Edward Curtis, who literally erased any evidence of Western modernity in an effort to show a "pure" indigenous culture, Poolaw depicted Cozad as a contemporary figure who is continuing traditions while participating in a dynamic world. As Kiowa contemporary Parker McKenzie remarked, "Back when Horace took his pictures, most Kiowa . . . took what they wanted from each culture, and left the rest alone. It wasn't easy, but they did it."[21] Indeed, the Kiowas were a "culture in transition," and Poolaw brilliantly captured the changes that his community was undergoing.[22] He purposefully chose a point of view that would allow the car to be seen within the shot. In fact, the image is visually constructed so that the form of the car touches both the tipi and the Native man, linking them together in space. By depicting both traditional and modern elements in the same image, Poolaw rejected the reductive dichotomy that implies that there were only two choices for American Indians: either follow traditional ways of life or join the Western world and assimilate.[23]

In recent years, Horace Poolaw's photographs have gained wide acclaim through traveling exhibitions and a solo retrospective at the National Museum of the American Indian in late 2014. Within the Kiowa community, he is a well-regarded individual who continually garners pride for his pictorial record of his people. Fellow Kiowa and Pulitzer Prize–winning author N. Scott Momaday states:

> Horace Poolaw was a photographer of the first rank. He knew, from the time he took up a camera in his hands, how to draw with light. His sense of composition, proportion, and symmetry were natural and altogether trustworthy. His vision of his world, perceived through the lens of a camera, was touched with genius. Looking at this life's work, we see that he was the equal of such frontier photographers as Edward Curtis, Charles Lummis, and William Soule; and in his native intelligence and understanding of the indigenous world, he surpassed them. He was an artist of exceptional range and accomplishment, and he has given us a unique vision of American Life.[24]

Yet Poolaw was a humble man who never sought celebrity status. According to his daughter, "He always said that he did not want to be remembered himself; he wanted his people to remember themselves through his pictures."[25] In a way, Poolaw continued the Kiowa tradition as keeper of the calendar—a visual record that told the history of the people through small drawings.

A NATIVE PHOTOGRAPHY STUDENT

At the turn of the twentieth century, almost all Native children in the United States and Canada were educated at Indian boarding schools. One of the first such institutions, the Carlisle Indian Industrial School in Pennsylvania, opened its doors in 1879 and served as a model for the more than twenty-five other federally funded schools scattered across the nation.[26] Canada had a similar system called "Residential Schools" that started in the 1840s. Operating with a gender-specific curriculum that emphasized Euro-American conventions, these schools offered female students classes in sewing, laundry, gardening, baking, and child care, and male students learned farming, blacksmithing, carpentry, and other trades.[27] Interestingly, Carlisle Indian School also included photography among its courses. In 1907 the school newspaper boasted that the institution had built "one of the finest and best equipped photographic studios in the state."[28] After learning of this studio, I assumed there would be a large collection of student work readily available, yet I was wrong. Only one student has been identified as a photographer at Carlisle—John Leslie (Squaxin Island)—and he attended more than a decade before the studio was completed.

Little is known about John Leslie. School records indicate that he was twenty-one years old when he left Carlisle on March 5, 1896. His father was listed as deceased, and his mother was living in Squaxin Island, Washington. Leslie apparently hailed from that small island in southern Puget Sound, where several clans of Coast Salish live. The best source of his biographical information comes to us from Quakers who featured a story about him in their weekly publication *The Friend*. In their October 24, 1903, issue, they describe Leslie as having

> no unusual advantages, but he always made good use of such advantages as he had. He was always ambitious to learn, and was never afraid of work. Years ago, he attended the boarding school on the Chehalis reservation; later he came to Puyallup and, in time, accepted an offer to transfer to the large school at Carlisle, Pennsylvania. At Carlisle he studied hard and soon completed the regular course and in addition thereto studied photography, becoming quite proficient in that art.[29]

Leslie learned photography by participating in the outing system (a type of internship, usually off-campus) with the campus photographer, John Choate.

John Nicholas Choate is best known for his photographs depicting Carlisle students "before and after" entering school to demonstrate the "civilizing" transformation (figures 4.8 and 4.9). He served as the official school photographer for nearly twenty-five years—from its establishment in 1879 until his death in 1902.[30] Through hundreds of pictures, Choate attempted to provide visual evidence for

Superintendent Pratt's infamous declaration, "Kill the Indian, Save the Man." His images would effectively serve to illustrate the purported benefits of the forced assimilation practices at the American Indian boarding schools.[31]

On June 1, 1894, Carlisle's school newspaper, *The Indian Helper,* described John Leslie as the "right hand Indian man" to Choate.[32] The young apprentice used this association to sell his photographs, which "could be purchased at the school or by mail through the Indian School newsletters."[33] Yet no record of sales exists, and few photos are credited to him in the two years that he worked with Choate, 1894–96. Nonetheless, *The Indian Helper* advertised the 1895 souvenir catalogue as including photographs by Leslie, announcing, "Remember this is Indian work and the first sent out from Carlisle school."[34] The publication was not an exclusively student-produced work, since the catalogue's cover art (figure 4.10) bears the characteristic "before-and-after" hallmark of John Choate.

FIGURE 4.10

United States Indian School,
Carlisle, Penna. souvenir
catalogue cover, 1895
Richard Henry Pratt Papers,
Yale Collection of Western
Americana, Beinecke Rare Book
and Manuscript Library

The 1895 souvenir catalogue features sixty-one pages of text and photographs, including both interior and exterior scenes of the campus. It also contains a selection of group portraits picturing the first graduating class in 1889 through the seventh in 1895. Leslie did not start Carlisle until 1892 and began his photographic training only in 1894, so the formal graduation portraits are likely the work of Choate. Attribution is difficult because the photographs are not credited, and many images are just assumed to be the work of the lead photographer.[35] Those photographs attributed to Leslie are largely scenic views of the campus.

Statioinary subjects (such as buildings) would provide easy material for a novice photographer, so the exterior scenes are probably by John Leslie. Two photographs attributed to him are an establishing shot of Entrance Avenue (figure 4.11) and the Farm House (figure 4.12). Both images feature foliage blocking the structure and appear to be taken by someone with a more amateur eye. In recent years, a movement to save the Farm House from demolition has revealed an interesting history regarding the structure. It served as barracks, classrooms, and most notably the site where athlete Jim Thorpe was working immediately before he did an impromptu high jump in his overalls and boots, thus causing Glenn "Pop" Warner to take notice of his talents.[36] The Farm House photograph has since been used as an illustration to save the structure—and it continues to be credited to John Leslie.

Leslie photographed classmates as well as buildings. In two photos, for instance, he pictured his peers enjoying the outdoors (figures 4.13 and 4.14). Both images seem to be taken by the same hand and employ a similar depth of field. In each case, the

FIGURE 4.11

Entrance Avenue, from
the Carlisle Indian School
souvenir catalogue, 1895
Photo by John Leslie
Richard Henry Pratt Papers, Yale
Collection of Western Americana,
Beinecke Rare Book and
Manuscript Library

FIGURE 4.12

The Farm House, from
the Carlisle Indian School
souvenir catalogue, 1895
Photo by John Leslie
Richard Henry Pratt Papers, Yale
Collection of Western Americana,
Beinecke Rare Book and
Manuscript Library

human subjects almost appear as ants in the frame, reflecting how the photographer positioned himself to attain the shot. According to a photo history of the Carlisle Barracks, "In June 1894, Carlisle photographer John Leslie photographed the Native American students at play on the parade ground from the second-story porch of barracks 2, the large boys' dormitory."[37]

In addition to photographing the campus and its student population, Leslie exhibited his images at the 1895 world's fair in Atlanta (or Cotton States and International Exposition, as it was officially called). Unfortunately, lacking documentation, we do not know which images or how many were exhibited. In the 1895 souvenir catalogue, there is a photo of a world's fair exhibit (figure 4.15) that could shed some light on this issue, but to no avail; it is difficult to see what is in the cases, and the

FIGURE 4.15

World's fair exhibit, from
the Carlisle Indian School
souvenir catalogue, 1895
Photographer unknown
Richard Henry Pratt Papers, Yale
Collection of Western Americana,
Beinecke Rare Book and
Manuscript Library

date of the image is unsettled. One archive dates this image to 1879 (which would be
the Sydney World's Fair) and another to 1893 (Chicago World's Fair).[38] If it does, in
fact, show the 1895 Atlanta World's Fair, then it must have been one of the very last
images added to the Carlisle souvenir catalogue, because that fair ran from Septem-
ber to December of that year.

Regardless, John Leslie was quite busy in 1895. In addition to producing the
souvenir catalogue and showing his work at the world's fair, the school newspaper
reported that he traveled to New York to "take snap-shots of the football game," and
he took a group portrait of his own teachers.[39] The now-faded image (figure 4.16)
pictures sixteen faculty on the porch of a building and an additional figure peek-
ing out of a window on the right. In the center is a Native man seated in an erect,
frontal-facing pose. This is Dr. Carlos Montezuma (or Wassaja), a Yavapai Apache
university-educated physician, political leader, and activist who had a brief tenure at
Carlisle.

The back of the image (figure 4.17) credits John Leslie and is one of the only
existing images with his stamp.[40] The portrait itself is rather conventional. Without
the stamp, we would assume that it is just another group image by the official school

photographer. As art historian Hayes Mauro stated, "[Leslie's] images bear a notice-able imprint of Choate's compositional influence."[41] In other words, it appears that he was directed to take certain pictures and did not have much artistic license while practicing photography at school.

According to Carlisle student records, John Leslie was "discharged" on March 5, 1896, but there are conflicting accounts about his departure. The records indicate that the reason for leaving was "graduated," but the school newspaper reported differently. It stated that "he went without saying good-by to some of his best friends who awoke on Friday morning and found him gone. It was not a run-a-way, but only sudden ending of a plan contemplated for several weeks." John Hiram Andrews (Choate's official assistant) declared, "There was gloom all day in the gallery."[42] Regardless of the reason for his departure, Leslie had been at Carlisle for five years, so he probably satisfied the requirements for graduation.

Leslie's career after school is further marked by contradictory accounts. We know that he returned to Washington to start a career as a photographer, but whether he actually practiced is uncertain. Locals on Squaxin Island remembered him purchasing a bike and using it to ride to the mainland to take and develop photographs.[43] His efforts at professional photography are further acknowledged in a 1926 newspaper account which relates, "Having completed his education, he began work as a photographer in and about Olympia."[44] The Carlisle school newspaper corroborates these stories, reporting that the alumnus was "doing well in the photography business. In three weeks, he took in $40."[45] Earning that sum of money in the late 1890s was no small feat, and it would indicate that his business was doing well. Yet, despite all of this documentation, there are no photographs attributed to John Leslie while he lived in Washington.

FIGURE 4.17

Verso of figure 4.16, showing John Leslie's professional stamp

Photo by John Leslie

Richard Henry Pratt Papers, Yale Collection of Western Americana, Beinecke Rare Book and Manuscript Library

Perhaps the competition with itinerant photographers and the cost of operating a studio made photography less than lucrative for Leslie. The Quakers testified that "upon his return home and not finding a suitable opening for photography, he went to work industriously at whatever he could find to do. He finally hired as deck hand on one of the Puget Sound steamers."[46] This account is supported by Edwin Chalcraft, a former superintendent for the Indian boarding schools in the Pacific Northwest, who stated that, "after he graduated from Carlisle, he [John Leslie] returned to Seattle and I helped him to get a job as a fireman on a steamer." Over the years, Leslie apparently worked his way up from fireman to chief engineer. As Chalcraft noted: "Sometime after this, I received through the mail a marine magazine published in Seattle, in which there was a picture of a new steamer named 'City of Shelton.' In the description of the boat was the following caption: 'Captain Gustavenson is going on her as Master, and John Leslie as Chief Engineer, two of our well-known steamboat men on Puget Sound.'"[47] Since the *City of Shelton* was new in 1895 when Leslie was still in school, the photograph Chalcraft described is most likely an image of the sternwheeler *S. G. Simpson* (figure 4.18), which went into service in 1907. In this image, John Leslie can be seen standing on the far right of the upper deck.

Despite his career as a marine engineer, John Leslie would not give up photography. Friends remembered him taking his camera everywhere and shooting pictures.[48] After working as an engineer on Puget Sound for almost thirty years, he retired to Squaxin Island, where he took care of his older sister. He passed away in 1956 at the age of eighty-two, unmarried with no children, but with lots of friends who had enjoyed his clambakes and salmon barbeques.

FIGURE 4.18

John Leslie (*upper deck, far right*) and crew of the steamer *S. G. Simpson* of Shelton, c. 1907

Photographer unknown

Courtesy of Mason County Historical Society, 89-45.1

Amateur Native Photographers

> *We don't look very interesting if you are interested*
> *in feathers. Historical photographs and paintings in*
> *certain time periods do not include us, because we did*
> *not look like what they wanted us to look like.*
>
> —**RAYNA GREEN** (Cherokee)

With this chapter I introduce a broad cross-section of amateur Native photographers as well as their vast range of practices. The four photographers discussed hail from different parts of Native North America, from Yukon Territory and the Great Basin to Indian Territory in Oklahoma. Picking up where we left off in the previous chapter with student photography in Indian boarding schools, the first photographer, Parker McKenzie, took snapshots of his classmates at Phoenix Indian School during the 1910s. A second photographer, Jennie Ross Cobb, also took photographs at school—the Cherokee Female Seminary School—but her collection focuses primarily on the domestic sphere. Harry Sampson took snapshots of his Northern Paiute community and of other Great Basin tribes. Like Sampson, George Johnston photographed his people of the southern Yukon. As a whole, this chapter examines the experiences that inform the image-making of early Native photographers.

Lucy Sumpty, posing on the bed (detail), c. 1915. Photo by Nettie Odlety. See figure 5.10, page 117.

STUDENT SNAPSHOOTER

His Kiowa name was San-Tau-Koy, but everyone knew him as Parker McKenzie (1897–1999). He would become a linguist whose work on the Kiowa writing system resulted in two books, several papers, and an honorary doctorate.[1] McKenzie

FIGURE 5.1

Nettie Odlety (Kiowa) and
Francis Ross (Wichita),
Phoenix Indian School,
c. 1915
Photo by Parker McKenzie
Oklahoma Historical Society,
Parker McKenzie Collection,
19650.102

FIGURE 5.2

Doye Cleveland and Nettie
Odlety, c. 1916
Photo by Parker McKenzie
Oklahoma Historical Society,
Parker McKenzie Collection,
19650.226

attended boarding schools both on and off the reservation, and it was at school that
he started photographing. From 1904 to 1914 he was enrolled in Rainy Mountain
Boarding School on the joint Kiowa-Comanche-Apache reservation in southwest
Oklahoma.[2] By his own account, he did not take any photographs while there:

> At Rainy Mountain, we had no knowledge of picture taking with kodaks.
> On an occasion[al] Sunday visitors from Gotebo would show and took a few
> pictures of the students. None of the employees or their family members
> had kodaks, so they were new things to us when we arrived in Phoenix in
> September 1914. We soon learned that a few of the students were taking
> pictures and in no time, some of us Okies began the practice, and after
> "learning the ropes," we were snapping many pictures.[3]

McKenzie's photographic collection consists of over three hundred images taken
with a Kodak Brownie during his time at the Phoenix Indian Boarding School (1914–
19). It is remarkable that he was able to create so many photographs, since boarding
school life was so regimented. As historian David Wallace Adams claims, "Nearly
every aspect of his day-to-day existence—eating, sleeping, working, learning, pray-
ing—would be rigidly scheduled, the hours of the day intermittently punctuated by
a seemingly endless number of bugles and bells demanding this or that response."[4]
The official boarding school images seem to back up this statement and often depict
students in class, marching, or doing chores.

Overall, there are relatively few photographs of American Indian boarding
school students relaxing during break. McKenzie's collection is an exception to
this fact. In one photograph, two girls, Nettie Odlety (Kiowa) and Francis Ross
(Wichita), lounge on the grass, propped up on their elbows, smiling at the camera
(figure 5.1). Both girls have bows in their hair and appear to be dressed in casual,
white sundresses. It is an image of relaxed, carefree youth, enjoying their teenage
years. With a smile, they welcome the photographer whose only agenda is to show
affection by taking a snapshot.

In a similar photograph created following year (1916), Doye Cleveland and Nettie
Odlety are pictured in their school uniforms and seated on the campus grounds (fig-
ure 5.2). They appear to be caught in the act of studying, their books scattered about
them. Once again, Parker McKenzie has found his sweetheart and persuaded her and
her friend to have their pictures taken. These photographs are just two of the hun-
dreds of images created by McKenzie as he roamed the campus taking pictures of his
classmates during break. Most of them depict Odlety alone or with classmates, lead-
ing us to believe that McKenzie spent most of his breaks seeking out his girlfriend.

American Indian boarding schools prohibited physical contact between the sexes
as much as possible. Dorms were segregated and administration kept a watchful eye

FIGURE 5.3

Nettie Odlety and Parker
McKenzie in front of the
Phoenix Indian School
administration building,
March 1916

Photographer unknown

Oklahoma Historical Society,
Parker McKenzie Collection,
19650.223

on the students. Classrooms and common areas gave students the opportunity to
fraternize and flirt. This was certainly true of the relationship of Parker McKenzie
and Nettie Odlety, which began with notes passed in class, written in phonetic Kiowa.
They created this secretive method, as McKenzie recalled, "to foil our teachers in the
event one of our notes fell into their hands."[5] One photograph dated March 1916 (fig-
ure 5.3) shows the couple together on campus, in front of the administration building.

The administration building, a neutral area (as far as proctors were concerned),
was the perfect setting for an innocent meeting between school sweethearts. They
stand in their own space, not touching or even looking at each other; in fact, while
Nettie gladly smiles at the camera, Parker looks off-camera. Their body language
seems almost uncomfortable, perhaps shy, as they stand stiffly with their hands
shoved in their pockets. Of course, this could be a reaction to being observed by the
faculty; they are, after all, posed directly in front of the administration building.
McKenzie complained that "keeping the sexes apart was routinely strict. . . . we
were under strict discipline, we were never free."[6] Contrary to this statement, he and
Nettie were still able to create this portrait directly under the collective noses of the
administration. This image is probably one of the only visual examples of an actively
courting couple at an American Indian boarding school. Although there are images

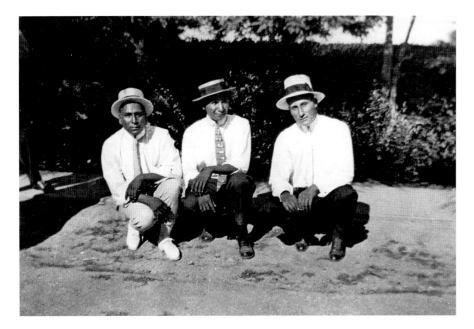

FIGURE 5.4

Easchief Clark (pro wrestler),
Ross Shaw (Pima), Andrew
Ahhaitty (Kiowa), c. 1916
Photo by Parker McKenzie

Oklahoma Historical Society,
Parker McKenzie Collection,
19650.250

of couples at school-sanctioned activities such as school dances or picnics, there are few, if any, focusing on one specific couple as this image does.

Judging from the casual dress of Odlety and McKenzie, the photograph was most likely taken on a Saturday. Saturdays were the one day of the week that students were free to choose their own schedule. They could participate in an extracurricular activity, study, relax, or sign up for a position with the outing system. The outing system (a type of paid vocational training that was met with mixed reviews) allowed students to earn some extra spending money, $10–$40 per month. Considering the times, this was a lot of money for a teenager, and these students were often the only breadwinners in their household. The school established banking accounts for students so that they could save, send the money back home, or spend it on "town day."[7] On select Saturdays, students were allowed off campus to visit the downtown Phoenix area. Although he did not specifically mention it, McKenzie most likely had his film developed and purchased new film on these shopping days. Furthermore, some of the more fashionable hats and dresses seen in his pictures can probably be traced to purchases made on these Saturdays.

The clothing worn on town days is perhaps best illustrated in a photograph (figure 5.4) taken by McKenzie sometime between 1914 and 1917. On the back of the photo he identifies the three classmates pictured as "Easchief Clark (Pro-Wrestler), Ross Shaw (Pima), and Andrew Ahhaitty (Kiowa)." The three men are posed on a walkway and appear to be dressed in personal clothing, since they each wear a different style of hat, tie, shoes, and slacks. They look more like sophisticated urban denizens than young men who normally wear stark gray school uniforms. Perhaps

FIGURE 5.5
Daniel McKenzie (Kiowa),
September 1915
Photo by Parker McKenzie
Oklahoma Historical Society,
Parker McKenzie Collection,
19650.317

 Shortly after this picture
was taken, Daniel died of
tuberculosis—a common
disease that plagued the
boarding schools.

the student's style of dress was more influenced by the popular actors of the day, including Douglas Fairbanks and Charlie Chaplin, whom they would see on the silver screen during town days. Regardless, these boarding school students are agents of their own images and seem to be acutely aware of the contemporary identities they are projecting.

Parker McKenzie photographed not just his friends and sweetheart but his family as well. One of the earliest photographs he took at Phoenix was a portrait of his brother, Daniel McKenzie, dated September 1915 (figure 5.5). In this image, Daniel is seated behind a desk in the middle of his dorm room. Behind him is a steel-framed bed, a nightstand with several framed photographs, and a few pennants hanging on the wall. By all indications, the students could decorate their space as they saw fit.

Daniel sits facing the viewer with his left arm casually thrown over his chair and his other arm resting on his desk behind a pile of books. He presents himself as a serious student, studying and embracing a new identity. This is apparent not only in his appearance but in his expression. He looks confident and self-assured, the complete antithesis of the typical hollow-eyed students pictured in so many of the officially produced boarding school photographs (see figures 4.8 and 4.9). Here, Daniel's gaze is visually arresting—it is neither welcoming nor challenging. These are Native brothers on either side of the lens, coauthoring their visual narrative of boarding school life.

Nearly a year later, Parker would be photographed in much the same manner. In 1916 he created one of his many self-portraits, which he labeled "Parker McKenzie, Kiowa, at Main Building" (figure 5.6). In this image, the young Parker, like his brother before him, is seated at a desk, leaning back, with his left arm resting on his

FIGURE 5.6

Parker McKenzie self-
portrait, Phoenix Indian
School main building,
c. 1916

Photo by Parker McKenzie
Oklahoma Historical Society,
Parker McKenzie Collection,
19650.309

chair. His right hand, however, is placed atop a typewriter on a desk in front of him. The entire scene is photographed outdoors, on the grass, with a school building in the immediate background.

Instead of facing the viewer, Parker McKenzie chooses a three-quarter profile, gazing off into the distance. This pose, along with the hand on the typewriter, recalls images of famous intellectuals and statesmen—as if he is fashioning himself in the canon of traditional Western portraiture. Indeed, McKenzie responds to the act of producing a portrait by forcing a pose and styling himself in the manner of a distinguished scholar. This reading of the image may be contested, but it is reinforced by McKenzie's later remark that he "owes much to his early training" for becoming a Kiowa scholar and furthering his cultural heritage. Furthermore, he was already thinking about his future as a linguist, stating that "the innocent practice [of passing notes written in Kiowa] was beginning to fascinate me if not my partner. It led me to experiment with words and simple expressions for myself and soon saw some words would not yield to English spelling or be written phonetically with the English alphabet."[8] Although this image foreshadows the later career of McKenzie, what is even more striking is where this scene is photographed—outdoors.

There is evidence that in some years boarding schools were overcrowded, but never to the point that classes took place outside. This is why the desk and typewriter are such an enigma in the self-portrait of Parker McKenzie. Were the items brought outside for the purpose of staging the photograph? Or were these items already outside because they were in the process of moving them in or out of the building? The purported rigid military schedule at the school would give McKenzie little opportunity to stage such an image (much less the permission to play with

FIGURE 5.7

Nettie Odlety, Phoenix
Indian School girls' dorm
room floor, c. 1915

Photo by Lucy Sumpty

Oklahoma Historical Society,

Parker McKenzie Collection,

19650.86

FIGURE 5.8

Nettie Odlety, posing on bed,
c. 1915

Photo by Lucy Sumpty

Oklahoma Historical Society,

Parker McKenzie Collection,

19650.97

school property). As historian Robert Trennert maintains, "Everything operated on a schedule, and the campus resembled an army boot camp. In contrast to the leisurely pace of reservation life, children were required to study, clean their rooms, sleep, and eat at specific times. Sundays were devoted to discipline."[9] So it seems as though the photograph was made surreptitiously, by finding some time to steal away and create the portrait. It is also possible that school administrators did not have a problem with the photograph being taken if they though it supported their civilizing and modernizing goals. If this were true, then he is fashioning himself as an ideal student of their making, yet he is already planning to use the knowledge he acquired to preserve and continue his Native language—which coincidentally was prohibited to be spoken at school.

Nettie Odlety purchased a camera at the same time as Parker McKenzie, and with it she photographed what is perhaps the only existing amateur imagery within the girls' dormitory walls. Odlety and her friend Lucy Sumpty took turns being photographer and subject in a series of snapshots (figures 5.7–5.10) captured sometime around 1915. As the girls alternate posing on the floor and lounging on a bed, the afternoon sun pours through their dorm windows and illuminates the scene. Upon closer inspection, it appears as though they are mimicking each other's pose—from the vantage point as photographer to the body positioning as subject.

It can be said with some certainty that these girls were enjoying using the camera, snapping photos during unsupervised time. Yet this instance of private indulgence was not necessarily an uncommon occurrence. According to curator Margaret Archuleta (Pueblo/Apache), some female students "managed to smuggle bean sandwiches out of the kitchen, tell stories after lights out, even hold peyote meetings in their dorm rooms. Private moments knitted students together in shared joy, shared language, or shared mischief."[10] The photographs seem to back up this idea that the dorm rooms were not just a place for sleeping but a space where friendships were formed and, in this case, recorded.

FIGURE 5.9
Lucy Sumpty, Phoenix
Indian School dorm room
floor, c. 1915
Photo by Nettie Odlety
Oklahoma Historical Society,
Parker McKenzie Collection,
19650.100

FIGURE 5.10
Lucy Sumpty, posing on the
bed, c. 1915
Photo by Nettie Odlety
Oklahoma Historical Society,
Parker McKenzie Collection,
19650.92

FIGURE 5.11
Deoma Doyebi (Kiowa) and
Ethel Roberts (Wichita),
porch of the girls' dormitory,
c. 1915
Photo by Nettie Odlety
Oklahoma Historical Society,
Parker McKenzie Collection,
19650.124

These bonds are further illustrated in a photograph taken by Nettie Odlety of her roommates Deoma Doyebi and Ethel Roberts (figure 5.11). Odlety captures her friends in a moment of camaraderie with their arms looped around each other's shoulders as they enthusiastically grin toward the camera. Sitting close together, the girls are perched on one of several beds that have been placed rail to rail in tightly packed quarters on a sleeping porch. A chain-link fence hovers above their heads, possibly as a safety measure, although it serves as a reminder that they are confined to this school through federal assimilation efforts.

Despite stultifying strategies of assimilation, the girls forged friendships that helped them cope with their ordeal. As one student noted, the schools "were started to stamp out the Indian from the Indian, you know, make us all into white people,

and you know, it didn't work. Actually. . . . it was the exact opposite: It made us stronger as Indian people. It made us more aware of and more proud of who we were."[11] In creating a visual narrative that told of new friendships and romance, Parker McKenzie and Nettie Odlety reframed the boarding school experience to express memorable new beginnings rather than demeaning images that communicate the death of Native cultures.

After Nettie Odlety and Parker McKenzie graduated, they would marry and have five children together. At home in Anadarko, Oklahoma, they continued to photograph important scenes and milestones in their lives. The couple created hundreds of images during their fifty-nine-year marriage, until her death in 1978. McKenzie would live on for another two decades, but before the Kiowa elder passed away at the age of 101 in 1999 he donated his entire photographic collection to the Oklahoma Historical Society and annotated all of the images seen here.

A CHEROKEE "ROSEBUD" PHOTOGRAPHER

Cherokee photographer Jennie Fields Ross Cobb (1881–1959) started taking photographs around 1894, thus making her one of the earliest American Indian photographers on record. Like the other photographers discussed in this chapter, she primarily photographed friends and family, but unlike them she rarely appeared in her own images. Only a few professionally created portraits of her exist, and one (figure 5.12) was taken shortly before she assumed stewardship of her family's house museum in 1949. The antebellum Hunter's Home (formerly known as the George M. Murrell home) appears frequently in Ross's images, and the Cherokee Nation understands it to be part of their cultural heritage.[12]

If the name sounds familiar, it is because Jennie is the great-granddaughter of Principal Chief John Ross (1790–1866), who, along with Sequoyah (creator of the Cherokee syllabary), is perhaps one of the most notable figures in Cherokee history. He led his people from removal in the Southeast to rebuilding their community in Indian Territory, and then through the upheavals of the American Civil War. This is why scholars often refer to John Ross as one of the "Cherokee founding fathers" and his family as "Cherokee aristocracy."[13]

Born in Tahlequah on December 26, 1881, Jennie Ross was the sixth of nine children—five girls and four boys. Her parents, Robert Bruce Ross Sr. and Fanny Thornton Ross, also took in and cared for several orphaned children. Her father supported his large, extended family by serving as clerk for the Cherokee Nation and working as a postmaster in Tahlequah. The family took advantage of every room in Hunter's Home, where they lived from 1894 to 1907.

Sometime between the ages of twelve and sixteen (1893–97), Jennie Ross received a camera as a gift from her father. It was a large Kodak bellows unit with

a double-plate holder and a small viewfinder located on the drop bed.[14] Although amateur photography clubs were popping up across America, especially in the larger cities, it must have been unusual to see a teenager with a large-format camera taking personal photographs in Indian Territory.

FIGURE 5.12
Portrait of Jennie Ross Cobb,
c. 1949
Photographer unknown
Courtesy of Hunter's Home
archives

Despite living in a rural location, Jennie Ross did not have a problem acquiring photographic supplies and developing her film. Mary Elizabeth Good, a local historian who interviewed her in the 1950s, learned that "she used glass negative plates manufactured by two companies—Eastman Kodak Co. of Rochester, N.Y., and the Hammer Dry Plate Co. of St. Louis, Mo." Using a living-room closet as her darkroom, Ross taught herself to develop the plates. Good states that this arrangement "worked very well except during hot weather. Film emulsion then, if placed in solutions even a slight bit too warm, would slide right off the glass. This happened one summer to some pictures she made of Will Rogers."[15]

The total number of photographs Jennie Ross Cobb produced is not known, because she moved frequently throughout her life and often left her glass-plate negatives in storage with various friends and relatives. Over the years many were lost, damaged, or destroyed. Among the Oklahoma Historical Society archives, Cherokee Nation archives, and private collections, I have identified about one hundred images that can be faithfully attributed to her.

Jennie Ross's earliest photographs feature domestic life, including activities of her family and views of Hunter's Home. As she grew older, her photographs depicted life outside of the home, such as community events in Tahlequah and her classmates at school. After graduating from the Cherokee Female Seminary in 1900, Ross taught primary school at a one-room schoolhouse about forty miles from Tahlequah, but by this time her photographic output had already started to decline. Unfortunately, Cobb did not date her images.

The Domestic Sphere

Jennie Ross's earliest photographs reflect the predominant visual codes of the late Victorian era in America. They depict the domestic sphere and its inhabitants—especially

FIGURE 5.13

Family group in the garden
of Hunter's Home, c. 1895
Photo by Jennie Ross Cobb

Image courtesy of Karen
Harrington, personal collection

women and children—in and around the house. The individuals photographed
are not known, but presumably they are close family members. In one print from
a severely damaged negative (not shown), a woman is smiling sweetly toward a
tottering child. In another image, a couple of women and children are gathered in
the garden (figure 5.13). During this time in the mid-1890s, Jennie Ross also pictured
a series of individual children perched on the steps of Hunter's Home (figure 5.14).
In each case, the (unidentified) child is dressed in lace like a delicate porcelain doll.
These are idyllic scenes that convey a sense of peace and tranquility—important
traits in the late Victorian concept of domestic life.

 Not all of Ross's images are anonymous. For instance, with an expression of
cultivated detachment on his face, her nephew Blake Ross can be seen standing with
one foot on the front steps of the house (figure 5.15). In another photograph, her
younger brother Robert Bruce Ross is depicted on horseback (figure 5.16), framed
between the back of the home and the smokehouse. These young men—and the
family members who helped dress and pose them—are acutely aware of their social
standing, and of their roles within the family structure. After all, by the time Jennie
Ross was taking photographs, the Cherokees were no longer a matriarchal society,
and men controlled the property.[16]

FIGURE 5.14

Child with bouquet on steps
of Hunter's Home, c. 1895
Photo by Jennie Ross Cobb
Courtesy of Hunter's Home
archives

It should be noted that highly acculturated, "progressive" Cherokees such as the Ross family did not live the same lifestyle as traditional or "conservative" Cherokees.[17] Their views on economics, religion, education, leisure, and even food were closer to Euro-American culture than to indigenous ways of life. As journalist Anna

FIGURE 5.15

Blake Ross as a young boy, c. 1901

Photo by Jennie Ross Cobb

Oklahoma Historical Society Research Division, Jennie Ross Cobb Collection, 20661.4

FIGURE 5.16

Robert Bruce Ross Jr. on horseback, c. 1900

Photo by Jennie Ross Cobb

Oklahoma Historical Society Research Division, Jennie Ross Cobb Collection, 20661.7

Dawes wrote in 1888, Cherokees were "a nation divided into two sharply opposed classes—the highly civilized class of the towns; and the peasant farmers of the open country, or 'natives' as it is fashion to call them, in an amusing disregard of a common origin."[18] For Cherokees at this time, the phrases "mixed bloods" and "full bloods" identified class and social status more commonly than race.[19] By the late nineteenth century, most full-blood Cherokees lived in simple one- or two-room log cabins (figure 5.17). The Ross family, however, resided in the most opulent house in Indian Territory: Hunter's Home (figure 5.18).

The home included more property than just the mansion, for in addition to the main residence several outbuildings supported the estate and its occupants. Constructed in Greek Revival style, the main structure is a two-story frame house with three bedrooms, parlor, sitting room, library, dining room, kitchen, and enclosed porch. The property also featured a barn with stables, smokehouse, springhouse, blacksmith shop, grist mill, corn cribs, and nine small cabins originally used for housing slaves.[20] During the 1890s, Jennie Ross photographed each of these structures (figures 5.19–5.22).

There is a sense of pride in Jennie Ross's photographs of the built environment, as she draws attention to her subjects by carefully centering each structure within the frame of her photograph. Quite literally, she maps out the domestic scene with her lens. The fact that her family did not own Hunter's Home is moot—this is *her space,* and she stakes claim to the entire estate through her photography.

Not only do Ross's pictures convey the pleasure of living in the most extravagant home in the area, they may also express her pride of living in the Cherokee Nation. A similar sentiment was published in her school newspaper: "Instead of the rudely constructed wigwams of our forefathers which stood there [in the Park Hill area] not more than a half-century-ago, elegant white buildings are seen. . . . everything around denotes taste, refinement, and progress of civilization among our people"[21] This opinion is generally indicative of the "progressive" (i.e., wealthy) Cherokees who viewed such improvements as a movement toward the betterment of their nation.[22]

Jennie Ross did not limit her photography to the exterior of the property, for she also took photographs inside the lavish home. She photographed two of the most important rooms within any Victorian era home: the parlor and the dining room (figures 5.23 and 5.24). Ross's photograph of the parlor—a formal space for entertaining visitors—shows a velvet settee situated in front of a fireplace with a large portrait of her relative, George M. Murrell (figure 5.24). Additional framed portraits are displayed on the mantle along with a few glass jars, which most likely contain family artifacts such as lockets of hair or dried flowers.[23] The display of family relics was not limited to the parlor. In Victorian dining rooms, the sideboard and buffet were often used for the presentation of family treasures. Porcelain and other decorative arts could evoke sentimental memories or reflect the interests of the household.

FIGURE 5.19

The barn at Hunter's Home, c. 1895

Photo by Jennie Ross Cobb

Oklahoma Historical Society Research Division, Jennie Ross Cobb Collection, 20661.10

FIGURE 5.20

The smokehouse at Hunter's Home, c. 1895

Photo by Jennie Ross Cobb

Courtesy of Hunter's Home archives

Ross's photograph of the dining room is focused on the sideboard and the numerous cherished objects on display. Although two people can be seen retreating up the stairs, our attention is directed toward the décor and its extravagant furnishings.

Rooms dedicated exclusively to dining and spaces designed just for sitting (like parlors) were uncommon luxuries in the Cherokee Nation. According to historian Devon Mihesuah (Choctaw):

> Although some Cherokees lived quite comfortably, not all could or even wanted to live in opulence. Most full-bloods and traditional Cherokees preferred to live in relatively isolated areas and had little interest in learning English. . . . In turn, many mixed bloods and nontraditional Cherokees looked upon the less acculturated tribes-people with disdain. Inevitably, friction developed between those who struggled to preserve the traditional Cherokee lifestyle and those who wished to emulate white society.[24]

Race and class tensions plagued the Cherokee Nation as they did the rest of the United States at the turn of the twentieth century.

Like their white neighbors, Cherokees practiced racial segregation. They had separate "colored" schools for black students, and full-blood Cherokees were often ostracized because of their dark skin. A recently found photograph attributed to Jennie Ross conveys just such race and class differences within the Cherokee Nation at the turn of the century (figure 5.25).[25] In a shot taken outdoors near a water source (possibly behind her house), three African American children hold buckets while two women in Victorian dress appear to pause as they walk by. The outfits alone are a study in contrasts. Wearing hats and full-length, white-ruffled dresses, the women

FIGURE 5.23

The parlor of Hunter's Home, c. 1895

Photo by Jennie Ross Cobb

Oklahoma Historical Society Research Division, Jennie Ross Cobb Collection, 20661.8

FIGURE 5.24

The dining room of Hunter's Home, c. 1895

Photo by Jennie Ross Cobb

Courtesy of Hunter's Home archives

are paragons of Victorian summer fashion. The children, on the other hand, are shoeless and dressed in simple cotton shirts and shorts. One of the women seems to be addressing the tallest child as the two others glance back, presumably in the direction from which they came. No one in the image is looking at the photographer. This lack of interest in the camerawoman makes us wonder: Why did she take this photograph? Ross was presumably walking with the two women when they crossed paths with the children. Something about the situation made her step back, ensure that a glass plate was loaded into the camera, and shoot the scene. Although we may never know why she felt it important to record this moment, it reflects the prevailing cultural attitudes of her time.

School Years

The previous photograph was created around 1896, the same year that Jennie Ross's school, the Cherokee Female Seminary, produced a skit titled "Da Dabatin' Club" that featured her teachers and classmates performing in blackface (figure 5.26). Jennie Ross was a "Rosebud"—as the seminarians called themselves—from 1894 until her graduation in 1900, and during that time there were many such productions that made fun of the black community.[26]

Although there is no indication that Jennie herself acted in any of these plays, we do know that it was not just the mixed-blood students who appeared onstage; some of full-blood and darker-skinned Cherokee students participated in the blackface productions as well. In effect, this is a complex performance of identities—that is, of acting black in order to assume whiteness.[27] In other words, students used

FIGURE 5.26

"Da Dabatin' Club" skit,
Cherokee Female Seminary,
1896
Photographer unknown
(school photographer)
Northeastern State University,
John Vaughan Library, University
Archives

performance as a tool to emulate the dominant white culture. As Cherokee activist
Qwo-Li Driskill reasons, "Performance has been used by some Cherokees as a
strategy of reinforcing colonial power relationships . . . [and] in this instance, per-
formance was used as a *strategy* to construct racial differences and dichotomies in
the Cherokee Nation, even while 'blacks' and 'Cherokees' often shared—and share—
both Cherokee and African ancestors in common."[28]

This strategy for social mobility was not limited to performing in blackface; stu-
dents performed in "redface" as well. At a town carnival, Jennie Ross photographed
some boys from the Cherokee Male Seminary school "playing Indian." In the image
(figure 5.27), three boys in partial Native dress act in surprise as a fourth boy in full
headdress and fringed buckskin mockingly raises a tomahawk toward them. All of
the boys wear war paint and appear to be posing for the sake of Ross's camera. Given
that they were being groomed as future leaders of the tribe, they were not performing
"Indianness" for the sake of reinforcing stereotypes. Self-fashioning themselves as
warriors may have been part of their hybrid social identities as both forward-think-
ing students and traditional-minded men.

Scholars (including myself) have focused on the race- and class-based biases at
the school and have thereby portrayed the Cherokee Female Seminary as a relatively
elitist institution.[29] However, the Cherokee Nation, which has built its heritage cen-
ter on the ruins of the old seminary, seem to feel quite differently. On their website
is a quote from Na-Li, one of only two full-blood students enrolled in the seminary
during the 1850s, who wrote the following open letter to the citizens of the Cherokee
Nation:

Long, long ago, mixed bloods and rich people were the only ones that used these schools. This is what we heard. These people were wrong. . . . My parents were Indians. Not rich, not poor, just everyday Cherokee. But, they loved their children in a way these other people can't feel. They have not learned from books. They don't know how to use the right wording. I am alone; my parents are already gone. When I was a child, my mother had a hard cough for a long time and she passed away. A kind teacher took me and cared for me. Children do not think like adults, but she taught me. Because of her, I was able to get into this big school. But, in my opinion, anybody could make it into this school if they set their minds to it.

A simple statement precedes: "The letter was written in Cherokee and sends a wonderful message to youth regarding the availability of an education."[30] In other words, they proudly claim the identity of this school. After all, it was independently owned and operated by the Cherokee Nation.

Cherokee students were not forced to attend the seminary as they were federal boarding schools. Girls could enroll and take a leave of absence, as Jennie Ross did on several occasions. Nevertheless, even in the relatively open campus administrators maintained the rules of Victorian propriety. Every couple of weeks, the teachers escorted the girls to Tahlequah to go shopping. On these outings, Jennie Ross brought her camera and photographed her classmates. One such picture depicts her

FIGURE 5.28

Cherokee Female Seminary
students stroll along
sidewalk, c. 1897
Photo by Jennie Ross Cobb

Oklahoma Historical Society
Research Division, Jennie Ross
Cobb Collection, 20661.13

fellow students walking down a recently constructed boardwalk that led from the
seminary into town (figure 5.28). Since the roads were not paved, mud would inevita-
bly collect on the hem of their long dresses, and wooden walkways made it easier for
them to stroll into town.

Jennie Ross's picture is one of several photographs depicting her classmates in
transit. Rarely does she have her friends pose. In most instances, subjects are walking
away from the camera, so that the viewer is left looking at their backs. This is not to
say that her classmates did not acknowledge Ross's presence; in each image it seems
as though at least one person is turning to look toward the camera—as in a photo-
graph of students returning to campus on a hot summer day (figure 5.29). Shading
herself from the heat, a solitary student appears to be questioning Ross's pause as
they all move forward through the grass.

Jennie Ross graduated on May 25, 1900, but returned to her alma mater in 1902
for the graduation of cousin Elizabeth Van Ross.[31] She photographed the seminary
graduates, standing en masse, at the entrance to the school (figure 5.30). Dressed
in the typical Euro-American fashions of the day, the ladies each wear a white
cotton blouse trimmed in lace, a long skirt belted at the waist, and a hat (some more
embellished than others). They also have corsages pinned to their blouses, presum-
ably in celebration of the occasion. Ross has pictured them in a liminal space at the
perimeter of the school—between the school grounds and the outside world. Thus
her photographs are symbolic of the transition; they are ready to leave campus and

FIGURE 5.31

Members of the Cherokee
Female Seminary graduating
class walking away, 1902
Photo by Jennie Ross Cobb
University of Oklahoma, Western
History Collection, Ann Ross
Piburn photography collection

embark on a new stage in their lives. Jennie Ross steps aside to let them pass, and in doing so she snaps another picture (figure 5.31) in which the last few girls glance at the photographer as their long shadows trail behind them.

The New (Cherokee) Woman

In 1893, Kodak launched an advertising campaign featuring an adventurous young woman who traveled the world "kodaking." The company employed many different models for the Kodak Girl, but overall they usually feature her photographing outdoors, an independent woman, never with a man.[32] Jennie Ross embodied this New Woman aesthetic. Sometimes unchaperoned and always curious, she walked around Tahlequah photographing the major sites and events in the city. For instance, she took pictures of the Cherokee Nation Supreme Court building (figure 5.32) and the Dawes Commission tents (figure 5.33).

Built in 1844, the Cherokee Nation Supreme Court building is the oldest public building in Oklahoma (Hunter's Home is the oldest private residence in the state). At the time of Ross's photograph in 1900 (figure 5.32), the court had moved to its new offices across the street and the building was now occupied by the printing press of the *Cherokee Advocate,* "the Official Newspaper for the Cherokee Nation." To capture the entire structure in the shot, Ross had to position herself in the middle of the

FIGURE 5.32

Cherokee Supreme Court
building, c. 1900

Photo by Jennie Ross Cobb

Oklahoma Historical Society
Research Division, Jennie Ross
Cobb Collection, 20661.15

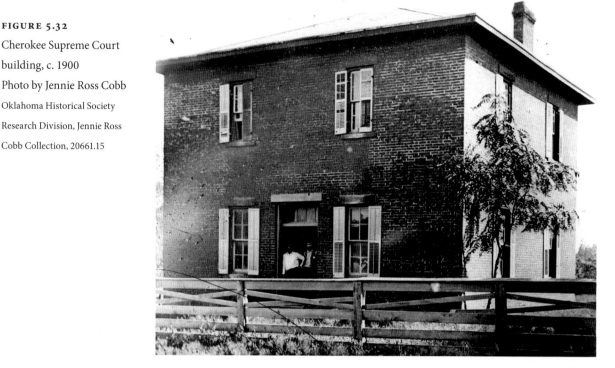

town square. The resulting image dwarfs the two figures who appear in the doorway of the massive brick building—Sheriff Cate Starr on the right, and an unknown figure (possibly the editor) on the left. Given her framing of the scene, Ross seems less interested in capturing the men's portraits and more concerned with recording one of the most prominent buildings in Tahlequah.

That same year, Ross witnessed history as the Dawes Commission arrived in Tahlequah and set up their tents. Part of the General Allotment Act of 1887, the Dawes Commission was tasked with creating a correct roll of the Five Civilized Tribes, which would be used by the U.S. government to divide community-held tribal land into allotments for individuals. Between November 27 and December 20, 1900, the Dawes Commission enrolled Cherokee tribal members in the official register.[33] Sometime within this three-week period, Jennie Ross photographed the commission's tents (figure 5.33). It is tempting to read her image as an indictment against the U.S. government for abolishing communal ownership of land and for destabilizing American Indian families by recognizing men, instead of women, as head of household. Yet historian (and Ross family member) Carolyn Ross Johnston maintains that "a surprising number of women, especially elite Cherokee women, supported allotment and statehood because they thought that the Cherokee Nation could not effectively deal with the problems of violence and alcohol."[34]

Jennie Ross was indeed interested in recording the civic life and lives of the

FIGURE 5.33

Dawes Commission tents,
late 1900

Photo by Jennie Ross Cobb

Image courtesy Karen Harrington,
personal collection

Cherokee Nation. From 1902, one of her photos (figure 5.34) shows her friends walking along the Ozark and Cherokee Central train tracks that were under construction in Tahlequah during that summer. Like some of the previously discussed images, the women in this photograph are not posing. Instead, they look down to ensure that they do not trip as they carefully make their way along the railroad ties. Rather than document a closeup of her friends' faces, Ross's image records their gazes. Like her subjects, Ross takes part in the spectacle of modernity. The women witness, firsthand, the mode of transportation that is quickly changing the social landscape of their region.

Many photographs by Jennie Ross involve women experiencing the city. For instance, two classmates, Bunt Schrimscher and Pixie Mayes, were frequently photographed walking about town (figure 5.35). Jennie Ross and her friends appear to be partaking in a specific form of social behavior of the period, that is, to promenade. Not simply walking to get somewhere, "to promenade" means using the streets and walkways as places for socializing. During this period, it was not uncommon for Cherokee elites to put on their best clothing and stroll with their friends, to see and be seen.

Before they were married and drifted their separate ways, Jennie Ross and her friends were intrepid young ladies who investigated the town and all it had to offer. They went to the carnival (figure 5.35) or met friends for a picnic (figures 5.36), along the way flaunting their independence for Ross's camera. As historian Joan Jensen remarked, "Cobb's Cherokee women defied the stereotypical photographic views of Native women at the time. They were poised, self-assured, fashionable, confident carriers of two cultures."[35]

FIGURE 5.34

When the train came to

Tahlequah, 1902

Photo by Jennie Ross Cobb

Oklahoma Historical Society

Research Division, Jennie Ross

Cobb Collection, 20661.17

FIGURE 5.35

Bunt Schrimscher and
Pixie Mays at Carnival Day,
c. 1900
Photo by Jennie Ross Cobb
Oklahoma Historical Society
Research Division, Jennie Ross
Cobb Collection, 20661.12

FIGURE 5.36

Eating watermelons in Park
Hill, c. 1900
Photo by Jennie Ross Cobb
Oklahoma Historical Society
Research Division, Jennie Ross
Cobb Collection, 20661.21

Free and unencumbered, Jennie Ross's subjects are consistent with Kodak's early marketing schemes that emphasize leisure. She was undoubtedly familiar with Kodak's marketing campaign through the popular magazines and mail-order catalogues that circulated among her friends in Park Hill. As a result, her photographs of leisure activities were quite likely an effort to live up to the image of a Kodak Girl as defined across the United States.

Jennie Ross's photographs can also be read as a type of commentary on the status of the Cherokee Nation. The people in her images can be seen relaxing and enjoying each other's company, so that, less than a century after removal via the Trail of Tears, the Cherokees were able to take leisure time and partake in hobbies such as photography. Proud of their ability to acculturate and survive, the Cherokee Nation publicly proclaim, "Cherokee people have been consistently identified as one of the most socially and culturally advanced of the Native American tribes . . . [continuing] to develop, progressing and embracing cultural elements from European settlers. The Cherokee shaped a government and a society matching the most civilized cultures of the day."[36]

As the carefree days of her teens and twenties gave way to her adult responsibilities, Jennie Ross's photographs came to reflect more serious concerns. She became involved in the Cherokee Temperance Society, an organization founded in 1836 as part of a larger social movement that sought to enact community legislation safeguarding against the abuse of alcohol. Temperance societies provided the means for Cherokees to show how "civilized" they were to self-govern, and it also gave Cherokee women an opportunity to be involved the political arena.[37] An active member of the society, Jennie Ross took at least one photograph of a temperance meeting (figure 5.37). In the picture, a group of women and children are gathered in the shade of woods just beyond a pair of flagpoles. It could be the children's auxiliary unit, the Cold Water Army, created to involve youth in the temperance effort. If so, then this photograph may have been taken be during Fourth of July festivities when the Cold Water Army participated in the annual holiday parade.[38] Jennie Ross's involvement in this children's event would thereby prefigure her career as a schoolteacher.

From 1902 until she married in 1905, Jennie Ross worked as a schoolteacher in Christie, a rural village twenty miles east of Tahlequah. She boarded with a Cherokee family and taught at Owen School, a one-room schoolhouse named for Cherokee politician Robert L. Owen. Her excitement at this first assignment is reflected in a picture she took of her students lined up outside the schoolhouse (figure 5.38). Unlike contemporary photographs taken at federal Indian schools that underscored control and regulation through military dress and rigid postures, Ross's photograph depicts a group of Cherokee children dressed informally and standing somewhat casually in front of their school.[39] It is *their* school, operated by the Cherokee Nation, led by a

FIGURE 5.37

Cherokee Temperance
Society meeting, c. 1900
Photo by Jennie Ross Cobb

Courtesy of Hunter's Home
archives

FIGURE 5.38

Schoolhouse near Christy,
c. 1905
Photo by Jennie Ross Cobb

Oklahoma Historical Society
Research Division, Jennie Ross
Cobb Collection, 20661.20

Cherokee teacher, and with classes taught in Cherokee and English. "It was the first bilingual and bicultural school system in the nation," states American Indian Studies professor Delores Huff (Cherokee), and "judging by today's standards, the system was amazing, with evidence that it produced a 90 percent literate population within a decade. Even today, that record cannot be matched by most states."[40] We can, then, understand Ross's photograph as more than just documenting a new job, for she is expressing pride in a system that improves the lives of her fellow Cherokees.

After her marriage to Jessie Cobb in 1905, Jennie Ross Cobb left the Cherokee Nation and lived in Arlington, Texas, where her husband worked in the oil industry. They had a daughter, Jenevieve, who would have two children of her own. Widowed in 1940, Jennie and her daughter stayed in the area operating their flower shop, The Flower Market. Jenevieve died five years after her father, leaving Jennie Ross Cobb to raise her two grandchildren alone. To be near relatives, she decided to return to the Cherokee Nation in 1949. During this whole time, her photographs and glass plate negatives remained in storage with family members in Park Hill. She would use the photographs as primary source documents in her role as site manager for the newly established George M. Murrell Historic Home.

Photographer as Curator

Jennie Ross Cobb served as a curator for almost ten years. Two photographs (figures 5.39 and 5.40), taken by historian Mary Elizabeth Good, depict her living and working within the Murrell home. She practically became what Barbara Kirshen-blatt-Gimblett calls a "living ethnographic specimen."[41] Ross Cobb's pioneering efforts to restore the home would contribute to the property being listed as a National Historic Landmark and a Certified Trail of Tears site.

According to Ross Cobb's nephew, Bruce Ross Jr., "Aunt Jen and her younger sister, my Aunt Anne (Ross) Piburn, lived on the property from 1949–1959, renovating and conducting tours, [and] they were instrumental in establishing the home as a destination for tourists to Cherokee country."[42] After years of neglect, the historic home was in need of major renovations. Jennie Ross Cobb used her photographs (and her recollections) to reclaim furnishings from family members, renovate the building, and restore the landscaping. Her extensive notes and correspondence often refer to her photographs as evidence of the original features of the home such as the location of patios, paths, furniture, and heirlooms.

For almost forty-five years, the State of Oklahoma employed members of the Ross family to serve as caretakers and curators of the property. Bruce Ross Jr. recalled:

> After Aunt Jen passed away, my mother, Marguerite (nee Clay) Knight Ross became the curator. Mother, dad and I moved there in May 1959. For dad, it was like coming home as he had essentially grown up in the home living there

from 1894–1907. Mother was curator from 1959–1966, when she reached the mandatory state retirement age of 65. Upon mother's retirement, another cousin, Macie Osburn, was there from 1966–1984. It was during her tenure that the home was transferred to the newly formed Oklahoma Tourism and Recreation Department, Division of State Parks. Upon the retirement of Macie Osburn, I was fortunate enough to become Curator/Manager, and got to return to my childhood home.

At some point during their careers, each subsequent curator of Hunter's Home called upon the photographs by Jennie Ross Cobb to help in restoration. For Ross Jr., "Her early photographs and personal accounts aided greatly during the restoration of the home." However, the home was not restored to the period as shown in the images (1890–1905) but to some fifty years *before* the photographs were taken.

Jennie Ross Cobb's photography exemplifies the popular ideals of womanhood prevalent during the late nineteenth century, particularly the upper-class American society to which the Cherokees of Park Hill aspired. Her images of domestic life, schooling, and leisure time are marked not only by a performative femininity of the age but by her elite status within the Cherokee Nation. As a member of the Ross family, she was expected to carry on the family name, and she did so by becoming a leader in the preservation of her family's and tribe's heritage. By serving as the first curator of Hunter's Home, she set the tone for subsequent family curators.

PHOTOGRAPHING FANDANGOS, FRIENDS, AND FAMILY

Among the historical images in the Smithsonian's National Anthropological Archives are thirty-two photos from the 1920s depicting intertribal events, communal hunts, and family gatherings in western Nevada. These are snapshots taken by Harry Sampson (1892–1975), a Northern Paiute and one of the founding fathers of the Reno-Sparks Indian Colony.[43]

FIGURE 5.41

Circus time, near Reno,
Nevada, c. 1920s

Photo by Harry Sampson

Courtesy Estate of Harry Sampson

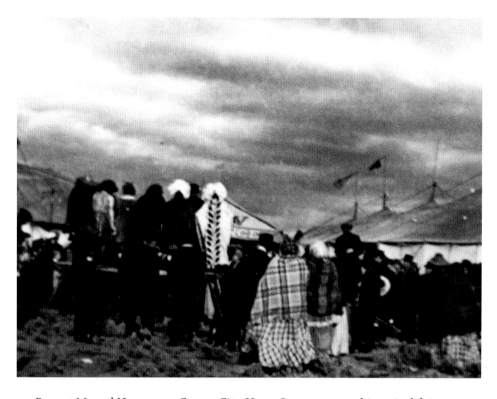

Born at Mound House near Carson City, Harry Sampson spent his entire life in Reno but traveled to nearby Pyramid Lake, Stillwater, and Walker River reservations for intertribal events called *fandangos.* He fostered an avid interest in community affairs, serving as the first tribal chairman for the Reno-Sparks Indian Colony—a position he would hold for almost ten years—and as an active member of the National Congress of American Indians. Sampson became a respected elder with knowledge of native plants and medicine, and when ethnobotanist Willard Z. Parks was in the area doing research he called upon Sampson to be one of his primary consultants. In his spare time, Sampson played the clarinet in a band and took photographs with his Kodak Brownie. Unlike his contemporaries Horace Poolaw and Richard Throssel, who were trained as professional photographers, Harry Sampson was a self-taught hobbyist. By the time he passed away in 1975, he had albums full of snapshots.

In May 1983, the Nevada Historical Society held a month-long exhibition featuring a small selection of Harry Sampson's photographs. Cory Farley, a reporter for the *Reno Gazette-Journal,* reviewed the exhibition, noting that "Sampson wasn't a photographer, and if you go to the museum expecting an indigenous Ansel Adams, you'll be disappointed."[44] True, Sampson's pictures are sometimes blurry, and his subjects are not always centered in the frame, but his photographs do show a sincere interest in his community and their surroundings.

Many of his pictures feature leisure pursuits, such as circuses and intertribal events. In an image captioned "Circus Time!" (1920s), Sampson photographed a large group of people congregated around the entrance of a show tent (figure 5.41). According to the information accompanying this image, the circus was held between Reno and Sparks, a region home to the Northern Paiute, Shoshone, and Washoe tribes as well as prospectors who stayed around after the silver rush.[45] By setting up between the two towns, the circus could draw customers from this diffuse population.

Sampson photographed the scene in a way that focuses on the entire mass of people, not just a single person or small group. Like many of his photographs, he does not zoom in on a face or approach so closely that he crops a figure at the waist. Instead, he preferred full-length shots. Although the crowd is moving away from the viewer, toward the circus tent, everyone seems to be directing their attention to something in front of the big top. The space is so thick with Native and non-Native bodies that some people have got up on a small stage for a better view. We cannot see around them because Sampson has placed himself not in the center of the action but rather on the periphery. Just like a person in the crowd straining to get a better view, we are left to wonder what is capturing the attention of the visitors—and why Sampson felt the need to take a snapshot of this particular moment. Most likely, they are attracted to a carnival barker or sideshow performer who is trying to separate the spectators from their money.

In another snapshot probably taken at the same circus, a young Native couple walks together through the midway (figure 5.42). Sampson's wife, Adele, identified the couple as "Lloyd Alex and Ethel Sam O'Neil—Paiutes, married (now divorced)." It appears as though Sampson was recording his various perambulations around the circus and happened to cross paths with this couple from his community. Lloyd Alex is looking toward the photographer and manages a quick smile, but his wife is looking elsewhere—taking in the event. It is a candid image, slightly blurry, and does not seem to be staged. Like the few individuals visible in the background, the couple appear to be enjoying themselves, engaged in the sights and sounds of the circus.

The most striking element of this image may be the most obvious: Sampson has pictured Native Americans *at* instead of *in* the circus. American Indians are rarely (if ever) considered attendees who casually observe the performance, even though, as historian Janet Davis claims, "Native American players often met with fellow Indians in the audience after the performance."[46] Circus route books have documented the attendance of Native Americans at traveling shows throughout the late nineteenth and early twentieth centuries, and several of these books identify a day or days when a large number of Native people attended a performance. For example, according to the Forepaugh-Sells Brothers route book for the 1896 season,

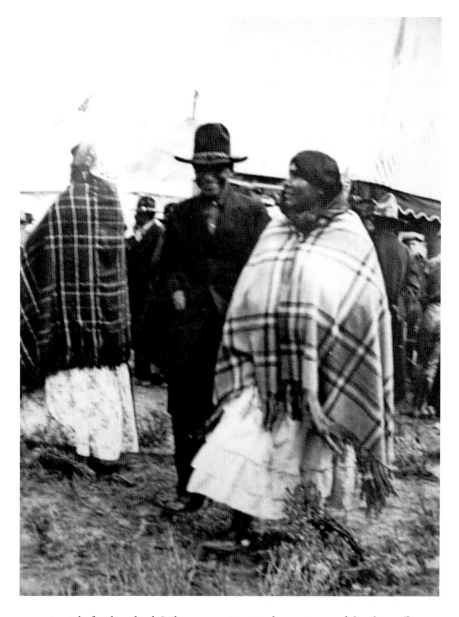

approximately five hundred Ojibwas were in attendance at one of the shows.[47]
Considering that such information was recorded in route books, it is surprising that
more visual materials have not been discovered. There seems to be a preponderance
of photographs depicting Anglo attendees observing the spectacle or posing with
American Indian cast members, but no published images of indigenous spectators at
the performances.

We do know that the BIA did not condone attendance at circuses. If the large
number of letters commenting on circuses is any indication, then Native audiences
caused great distress among agency personnel. In 1889, Indian agent John Crasnic

complained that "the only show that an Indian should be connected with or take an interest in is the State or Country Fair where he can exhibit his farm produce and well-kept stock on the same footing as the white man."[48] In the view of the BIA, the idle amusements of the circus distracted from the work that was expected to promote assimilation. In other words, circuses presented a challenge to the agency and its officers' control.

During the 1920s, James E. Jenkins, superintendent of the Reno Indian Agency, wrote to the commissioner of Indian affairs, "There is the usual percentage of 'loafers' . . . who cannot overcome the propensity to quit work to go 'visiting' or to attend circuses."[49] Another report from the Reno Indian Agency commented on a specific event, the Nevada Round-Up of 1920, which was "greatly augmented this year by the addition of Carnival and Shows." The agent found that

> such attractions are too much for the average person to 'pass up' and but few did. It will seem reasonable to assume that it was the rancher who probably neglected his work and went to Reno to celebrate, leaving the Indian with nothing to do but follow his greater inclination and do likewise. Which he did. Many of the Indians entered the various contests and captured several prizes. Unusual gambling was not reported, or observed, and it is believed that the Indians were given due consideration and treated very fairly throughout their stay in Reno.[50]

Although the Nevada Round-Up was a relatively mild form of escapism for the general populace, keeping account of the Native people under their jurisdiction proved to be frustrating for some BIA officials. Inspector Endicott of the Reno Indian Agency used the circus as another one of his reasons to stop supporting the colony. He insisted that "they will attend the circus and will be taken from their necessary labors on the ranches (especially haying) and the true interests of the entire community will suffer. I again recommend the abolition of this colony."[51]

Because he was actively involved in his tribal council, Harry Sampson probably knew about the agency's concerns and demands. Even before he was chairman, Sampson circulated petitions and wrote to the BIA complaining about the rules and treatment by agency officers.[52] So perhaps the photographs of his people at the circus are actually visual documents of civil disobedience—the Native community going against the wishes of the BIA by attending circuses and using their own money as they see fit.

Similar to Indian fairs and expositions, fandangos were intertribal gatherings where dancing, feasting, and various competitions took place. Although most fandangos have evolved into powwows, which focus more on competitive dancing and drumming, three communities still host annual fandangos: the Ely Shoshone and

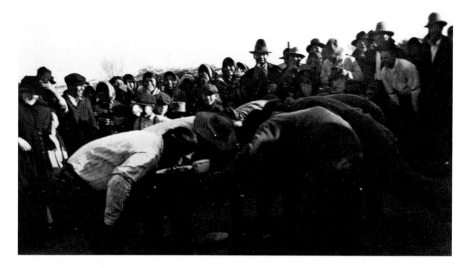

Battle Mountain colonies in Nevada, and the Big Pine Paiutes in California. In the 1920s, however, several Great Basin Indian reservations and colonies produced these multiday events. From his home in Reno, Sampson traveled to fandangos at reservations in Fallon—sixty miles to the east, Walker River—one hundred miles to the southeast, and Pyramid Lake—thirty-five miles to the northeast. If his snapshots are any indication, then Sampson could be found in the front row ready to document the action. He was not alone in his travels, for the number of people and cars featured in his photographs attests to the popularity of these gatherings. At the fandangos, Sampson recorded a wide variety of traditional and newly conceived competitions.

While attending a fandango at Schurz, a town on the Walker River Indian Reservation, Sampson documented a pie-eating contest (figure 5.43). Competitive eating became popular at county fairs during the early twentieth century, and apparently the trend was incorporated into indigenous gatherings.[53] Since their beginnings, eating contests have been a male-dominated sport, and this example was no different. Bent over a wooden table, the men hurriedly devour pies while a mixed group of Native and non-Native men, women, and children cheer them on.

In another photograph taken at a fandango in Stillwater on the Fallon Indian Reservation, Sampson pictured a group of women playing tug-o-war in front of a small group of spectators (figure 5.44). Although Adele Sampson recognized the site and provided an approximate date, she was unable to identify any of the people in the image. In the center, a man holds a striped flag, probably designating the

midpoint marker for the contest. The female competitors pull with all their might, and even in the grainy black-and-white photograph it is possible to see the dust being kicked up. Feats of strength can also be seen in another photograph taken by Sampson, possibly during the same trip to Stillwater. In this image (figure 5.45), two men wrestle in an arena delineated by sticks and surrounded by a large audience. Several cars can be seen in the background, and because the point of view is slightly elevated Sampson may have shot the photo while standing on a running board of a car. Moreover, if the rows of automobiles are any indication, the event as a whole was well attended.

Such attendance at fandangos may not have been possible without cars, given the vast distances between the tribal communities in the Great Basin. As historian Philip Deloria (Dakota) states, "It is no coincidence that the rise of an intertribal powwow circuit began at the same moment as Indian people were acquiring and using automobiles."[54] Perhaps the ease in travel can also account for the influx of non-Native games and competitions into intertribal events.

Although the Great Basin tribes assimilated certain games from Euro-American culture like competitive eating and tug-o-war, they still preferred to play their favorite game of chance—the handgame (also known as the stickgame, sticks and bones, or sticks and stones). Whether because of technological constraints, crowds, or just preference, Sampson photographed only one half of the handgame at any given time. He depicts either the team holding the sticks, known as "the hiders" (figures 5.46 and 5.47), or the opposite team, "the guessers," who are guessing the correct order of the bones (figure 5.48). The attendees are not just neutral observers; they actively cheer

FIGURE 5.44
Tug-o-war, Stillwater Indian Reservation, c. 1920s
Photo by Harry Sampson
Courtesy Estate of Harry Sampson

FIGURE 5.45
Wrestling, Stillwater Indian Reservation, c. 1920s
Photo by Harry Sampson
Courtesy Estate of Harry Sampson

FIGURE 5.46

Handgame, Pyramid Lake
Indian Reservation, c. 1920s
Photo by Harry Sampson
Courtesy Estate of Harry Sampson

❧ *This guessing game was, and
still is, played by many Native
North American communities.
It involves two pair of "bones"
(or stones)—one plain and one
with lines. Two players from the
hiding team each take a pair of
bones, then the guessers (who
have sticks) attempt to select
the correct hands in which
the game pieces are hidden.
For correct guesses, the bones
are handed over, and for each
incorrect guess a stick is forfeit.
The game ends when one side
has all the sticks.*

FIGURE 5.47

Handgame "hiders," Pyramid
Lake Indian Reservation,
c. 1920s
Photo by Harry Sampson
Courtesy Estate of Harry Sampson

❧ *The hiders, seen here,
conceal the bones in their hands
or in their garments while
the rest of their team tries to
distract the guessers by singing.
In some cases, the team uses
traditional musical instruments
such as drums or rattles to help
mislead their opponents.*

on their team and bet on the results. According to the Nevada Historical
Society: "Gambling, especially the handgame, has always been a favorite
pastime of the People [the Paiutes]. Traditional forms of gambling were (and
are) regarded as important forms of entertainment and social discourse,
not as 'vices.' In contrast to the European pattern, gambling matches were
often a part of religious festivals, and success at gambling was believed to
depend upon spiritual powers."[55] Although it has elements of spirituality,
the handgame has no prohibitions about being photographed. In fact, it is
probably the most photographed traditional activity of the Northern Paiutes,
especially by anthropologists and tourists.

During the 1920s, Sampson recorded the subsistence activities of his people, such
as fishing, rabbit hunts, and mudhen drives. One of these photographs, taken on
the east side of Winnemucca Lake (figure 5.49), illustrates the communal character
of the mudhen (or coot) drives. Every fall, families set up camp along the lake and
joined in the cooperative effort to round up birds, which would then be roasted
on-site, and their strips of skin woven into blankets. Sampson presents a glimpse of
this event, depicting his fellow community members, Mark Jones and his son and the
Winnemucca family, among their provisions at camp.

In Sampson's photographs that depict daily life, the people actively engage him,
attesting to the level of familiarity with the photographer. In a snapshot portraying
Nina Smith and Ella and Charlie Winnemucca (figure 5.50), all three turn and
acknowledge Sampson's presence. They might even be posing for his camera, but it
is difficult to read since the image is slightly blurry and the contrast is off. The group
is fishing for *cui-ui*—a lake sucker fish and their primary food source—at a dam on
the Truckee River. To take this photograph, Sampson had to travel thirty-five miles
northeast of his home in Reno to the Pyramid Lake Reservation, where this band
of Northern Paiute lives. Known as the Kuyuidokado ("Cui-ui Eaters"), this band
takes its name from an origin story that ties the group's existence to Pyramid Lake
and the fish.[56] During the 1920s, the BIA pressured the Northern Paiutes to abandon
fishing and take up farming.[57] Simultaneously, the government erected several dams,

including the one pictured in this image, to divert water to more populated areas. The cui-ui fish, native to Pyramid Lake and tied to tribal identity, was going extinct. By the mid-1930s, less than ten years after this photograph was taken, these same people would fight for their water rights to keep the fish alive. Sampson often visited his friends at Pyramid Lake and was undoubtedly aware of their ongoing struggles with the government.

In 1924, at the same time Harry Sampson was taking snapshots of his people, Edward Sheriff Curtis arrived in the area to create images for his *North American Indian* project. In his Northern Paiute, or *Paviosto,* images, Curtis photographed two of Sampson's community members (unknown individuals) around Walker Lake. In one set of images, an indigenous man is pictured in a breechcloth fishing with a gaff-hook (figures 5.51 and 5.52). Poised on the water's edge, the man breaks the glassy surface of the lake with his fishing pole. In both cases, he is depicted as a lone figure in an otherwise empty landscape.

In another pair of images, a Native teen in a breechcloth is depicted as a "primitive artist" creating "phallic symbols" on a rock face (figures 5.53 and 5.54). He stands with his back to the viewer, drawing with his right hand. Curtis titled this image *The Primitive artist—Paviotso* and provided the following description: "A side of the glaciated bowlder [boulder] near the southwestern shore of Walker Lake is covered with phallic symbols in faded red."[58] To ensure that the viewer clearly sees the so-called phallic artwork, Curtis took another photograph of the boulder alone (figure 5.54). In both cases, the central figure is shown dressed as per an earlier state of indigenous existence while inhabiting a rather picturesque landscape.

As I discuss in chapter 2, Curtis wanted to evoke what he conceived to be "traditional" American Indians as they lived before the arrival of Europeans. To do so, he carefully removed all evidence of contemporary life and photographed his subjects

in romantic poses performing traditional activities. Art critic Lucy Lippard argues that "he has inadvertently provided us with a target on which to focus our changing notions of 'authenticity.' Curtis is attacked most often, and most legitimately, for his lack of ethnographic veracity."[59] Indeed, as stated previously, Curtis frequently provided costumes and other props, dressing up his subjects to appear more "Native." His photographs are largely anachronistic and often characterized by dress that is inappropriate for the tribe. For example, Curtis must have provided the loincloth for the men to wear in the Paviotso images, since it is different from the traditional fringed or feathered style of the Northern Paiute dress. After all, by this time, denim Levis had replaced the traditional eagle-down kilts.[60]

Whereas Harry Sampson's images show the Great Basin tribes as a mixed community coming together to take part in sustenance activities and intertribal events, Edward Curtis depicted the people as lone individuals and distinct Native groups. According to museum director W. Richard West Jr. (Cheyenne), "Curtis imposed his own vision and understanding of reality on the subjects he photographed rather than reflecting what may have been their very different perceptions of that same reality."[61] Unfortunately, Curtis's iconic images of "vanishing" American Indians are frequently circulated while many Native-produced photographs like those of Harry Sampson languish in archival storage boxes.

FIGURE 5.51

Shores of Walker Lake— Paviotso, c. 1924
Photo by Edward S. Curtis
The North American Indian, vol. 15, pl. 534
Library of Congress Prints and Photographs Division, Edward S. Curtis Collection, LC-USZ62-49233

FIGURE 5.52

Fishing with a gaff-hook— Paviotso, c. 1924
Photo by Edward S. Curtis
The North American Indian, vol. 15, pl. 538
Library of Congress Prints and Photographs Division, Edward S. Curtis Collection, LC-USZ62-49235

In 2005, Clayton Sampson selected thirty photographs from his father's collection for donation to the Fallon Paiute-Shoshone Tribe Senior Center. The framed and matted prints now adorn the walls of the community room. "The tribal elders are ecstatic at the work," said Sampson, "since many were small children at the time the photos were taken, but they can still identify the subjects."[62]

AN INLAND TLINGIT, HIS CAR, AND A CAMERA

The Tlingit people are a group of fourteen tribes that occupy coastal southeastern Alaska. Lesser known are the Inland Tlingit groups, on the border of British Columbia and Yukon Territory in and around the villages of Atlin and Teslin. With the ocean nearby, the coastal groups have had easy access to a food source, but the Inland Tlingits traditionally had to go berrying in the spring, net salmon in the summer, catch ducks in the autumn, and hunt and trap animals in the winter.[63] According to anthropologist Catherine McClellan, this constant movement was "a prime favorite among coastal dances that simply mimes the poor interior peoples wandering about unceasingly in search of food."[64] Understanding this relationship between Inland Tlingit people and their coastal cousins helps to illuminate the photographic imagery of George Johnston (1897–1972), a Teslin Tlingit also known as Kaash Klaō.

At the end of the nineteenth century, Johnston's family migrated from the Nakina River near Juneau, Alaska, to their new home in Teslin (Deisleen Aayi in Tlingit, meaning "Long, Narrow Waters"), in Yukon Territory.[65] Their new homeland was filled with friends and relatives who also migrated to the southern Yukon during

FIGURE 5.55

Putting on a dirt roof,
Johnston Town, B.C., c. 1900
Left to right: (roof, back row)
William Johnston, Rosie
Morris, David Johnston,
Daisy Johnston, Livingstone
Johnston, Bessie Johnston, and
Ruth Johnston; *(roof, front row)*
Paddy Johnston and George
Johnston (seated holding
shovel); *(foreground)* Philip
Johnston and two unknown
children with their backs to
the camera.
Photographer unknown
Yukon Archives, George Johnston
fonds, 82/428 #32

the 1800s. Like most groups in the area, the Johnstons had a winter camp. "Johnston town," as it was called, was just inside British Columbia on the southern shore of Teslin Lake. The Johnstons spent their summers with other families in the village of Teslin on the north shore. An early photograph from George Johnston's collection shows his large, extended family taking a break during a community project (figure 5.55). Approximately ten years after this photograph was taken, the Johnston family left Johnston town to make Teslin their permanent residence.

Teslin is remote but not necessarily secluded, since the villages of Atlin (Tlingit) and Carcross (Tagish) are only about fifty miles away. Connected by a network of trails, the inhabitants traded, "went visiting," and found spouses from other clans. George Johnston used these trails to visit Lucy James in Carcross, a Tlingit from the Kookhittaan ("Crow") clan, whom he would eventually marry. In 1935 he photographed his young wife and baby daughter (figure 5.56), but this is one of the last images of Lucy. She died in a hunting accident shortly after this photograph was taken, leaving Johnston a widower with an eleven-month-old child. Johnston never remarried, and he raised Dolly with the help of his family (figure 5.57). Dolly Johnston remembers, "I used to go hunting with him. I used to go fishing with him. And I used to go woodcutting with him. He used to tell me how it's done—that's what he taught me."[66]

Hunting and trapping were, and still are, a way of life for many people in the Yukon. Rich with fur-trapping funds in the early twentieth century, Teslin community members often traveled to Whitehorse, the nearest large city, about one hundred miles away, to trade and get supplies. With no roads to get there easily, the Teslin Tlingits went by boat in the summer and by dogsled or snowshoe in the winter. On such a trip in 1928, George Johnston stopped by the newly opened Taylor and Drury

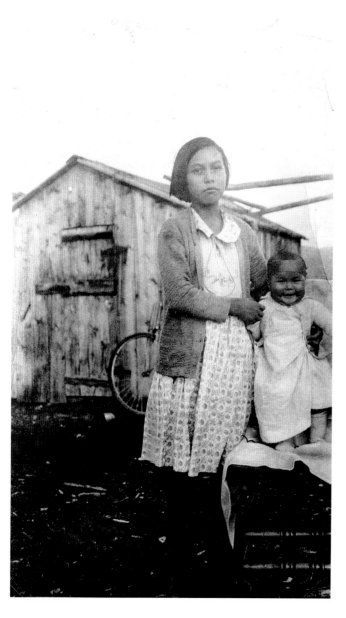

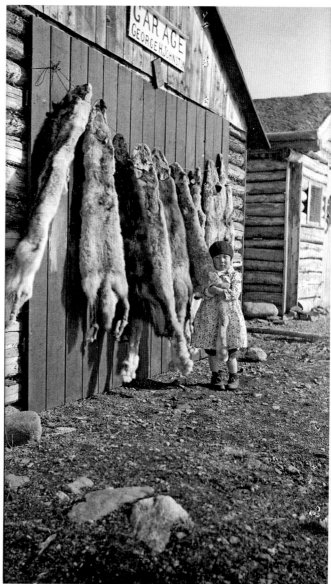

FIGURE 5.56
Lucy and Dolly Johnston,
1935
Photo by George Johnston
Yukon Archives, George Johnston
fonds, 82/428 #5

FIGURE 5.57
Dolly Johnston with wolverine,
fox, and lynx furs at George
Johnston's garage, 1938
Photo by George Johnston
Yukon Archives, George Johnston
fonds, 82/428 #15

Motors and purchased the first car the dealer ever sold—a 1928 four-cylinder model AB Chevrolet. His fur pelts covered most of the $900 purchase price, with $26 dollars extra for the bumper and a spare tire. He did not know how to drive, so the dealer's son gave him lessons.[67] In turn, Johnston taught his brother to drive, but according to community members he was the only one ever known to drive the car. His daughter Dolly recalled that she was not allowed to sit next to her dad in the car—that space was reserved for his camera.[68]

George Johnston purchased his first camera sometime between 1910 and 1920 from Eaton's mail order catalogue (a Canadian retailer similar to Sears, Roebuck and Company).[69] According to Johnston Museum archival notes, Johnston "had no tripod and rarely used a stand or prop, preferring hand-held shots. He stored his camera in a home-made hide box in order to transport it with him in the car, boat, and on foot in a pack. No one else was invited to touch the camera or use it." Using a developing kit, he processed all of his film in a back room of his bush cabin. "He learned how to develop his own pictures," says his nephew Sam Johnston, and "I think that was almost like today's Polaroid, you're gonna see your pictures right away, and I think he really liked that. . . . He developed on his own. He learned how to do that. It must've taken quite something, for a person that never went to school or anything, to still come out with photos like this."[70]

The Yukon Archives attributes 319 photographs to Johnston, but he gave many away more as gifts, so there may be other images still in private hands. The primary subject matter was his own community, and according to the local museum he "was an impulse photographer, stopping people at their work, rushing off to photograph something he'd hear was happening about town or recording the seasonal activities of his own family."[71] One thing is for certain, he constantly had his camera with him. Sam Johnston remembers that, "no matter where he went, whether he was beaver hunting or wherever he is, he always took pictures."[72]

Johnston's images are dated between 1910 and 1945—a period recalled as the "Golden Times of the Teslin Tlingit" because the community was economically, socially, and culturally stable.[73]

Hunting and Trapping Images

One of the earliest photographs in George Johnston's collection is a self-portrait with his young nephew, Matthew Jackson, while the two were on a hunting expedition "somewhere south of Juneau" (figure 5.58). Frontally posed, they stand on a bare patch of ground before a snowy landscape and hold hunting rifles that are almost as tall as they. Identification of the site and subjects was made by daughter Dolly, whose remarks regarding this image are rather telling, for she includes information on the legacy of the firearms, stating that "Frank Johnston [her relative] now has the Savage

300 gun," as seen in the picture. This comment points to the importance of guns within the Teslin Tlingit community.

By the time George Johnston was photographing his people, guns were well incorporated into Tlingit life. Anthropologist George Emmons noted that, "within little more than a generation after the first introduction of firearms, the Tlingit hunters had become dependent on them for subsistence. . . . by 1827, the Tlingit had become so dependent on firearms that they could not kill a single animal without them."[74] This statement is supported by Johnston's images; although other hunting methods, like trapping, still remained important, a large percentage of Johnston's subjects, including men, women, and children, are depicted with their guns.

Inland Tlingits taught both boys and girls hunting and trapping skills at an early age. As elder Moses Jackson recalled, "Well, myself, I learn trapping and hunting from the old people. I teach my kids what I know, and they are pretty good. I teach my Jane how to set snares for gophers." Similarly, Tlingit elder George Sidney remembered, "The first time I start trapping was with my grandpa. The first I remember was 1924 when I was going out trapping. It was a beaver hunt, special. . . . My grandpa, he shows me how to hunt, how to get some meat for the winter, and how to fish."[75] George Johnston participated in this tradition of teaching the youth to hunt, and he photographed his endeavors.

In a pair of images created sometime between 1930 and 1942, Johnston and an unidentified boy are pictured next to their game. In the first image, Johnston is seated in the center flanked by a pair of guns on one side and two dead geese on the other (figure 5.59). He proudly displays his spring catch, a beaver, by propping it against his forearm and leg. Most likely this photograph was taken by his young protégé, so the child was learning not just hunting techniques but photography skills as well. In the next photograph, the subject and photographer reverse positions, so that the young boy is now posed on the far side of the hunting scene (figure 5.60). Unlike the previous picture, in which the guns are somewhat haphazardly placed, Johnston seems to have arranged the objects to be in perfect alignment. In taking the photo, he stepped forward and to the left, so that the edges of the frame are filled with the boy and the objects. In taking the time to compose the scene, Johnston is conveying the message of a successful hunt—and teaching exercise.

It should be noted that these photographs were not taking *during* the hunt. According to anthropologist Garry Marvin, who has written extensively on hunting and hunting photography: "While hunting, the hunter is absorbed in looking outwards towards the animal (a parallel with the tourist who looks outwards to a site/sight of interest), and this is not usually recorded. Photographs recording the hunter with the dead animal reverse the angle of view: the hunter poses behind the animal, looks towards the camera, and not towards the animal. As with tourist photographs, trophy photographs involve a pause and concern with pose."[76]

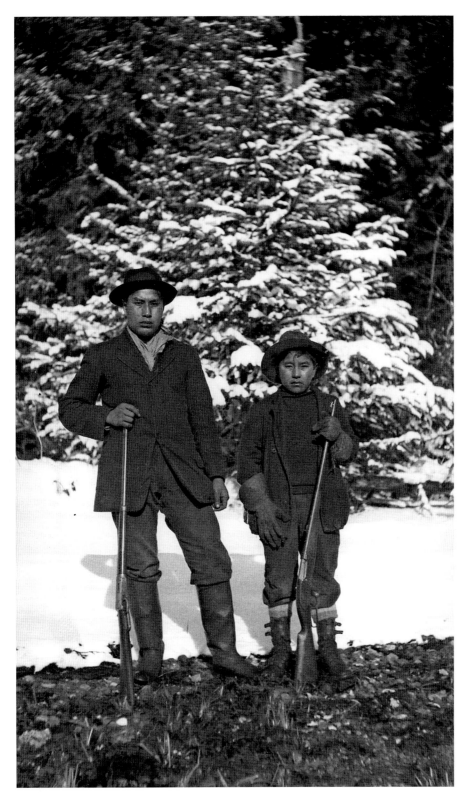

FIGURE 5.58

George Johnston and
nephew Matthew Jackson,
c. 1915

Photographer unknown

Yukon Archives, George
Johnston fonds, 82/428 #41

FIGURE 5.59

George Johnston with game,
1930–42

Photographer unknown

Yukon Archives, George Johnston
fonds, 82/428 #34

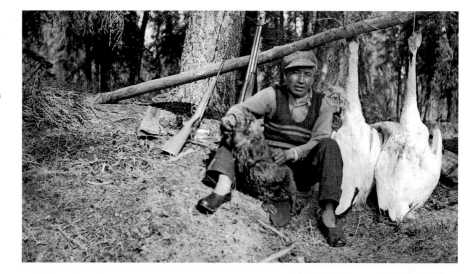

FIGURE 5.60

Unidentified local boy with
game, 1930–42

Photo by George Johnston

Yukon Archives, Their Own
Yukon Project Collection,
82/429 #98. Reprinted with
permission from the Council of
Yukon First Nations

Posing to take a "trophy photograph" suggests hunting for sport and the desire
to have a souvenir of the event, but that may not be the case here. Although some
Inland Tlingits worked for Yukon outfitting companies as big-game hunting guides
or opened their own outfitting business, I could find no historical evidence of First
Nations people hunting for sport. According to elder Virginia Smarch, "[Ancestors]
never thought 'well there's an animal. I'm going to kill it.' They had to have a need
for that animal before they killed it. They never killed anything just for the sport of
killing, because in their ways that was wasteful. And they believed strictly in that—
that they had to treat their animal spirits right, or else they would go without."[77]
Belief in animal spirits, and more specifically "Animal Mother," endured into the
1940s and 1950s, which, according to anthropologist Catherine McClellan, "laid

down certain rules for the proper way for humans to treat her animal children."[78] Since Johnston "believed in all of that old Indian religion," then perhaps, rather than a "trophy" of the kill his photographs memorialize the animal spirit through the pictures he made.[79]

Regardless of the intent, George Johnston's hunting images demonstrate a conscious posing by the people with their game. In three different images from Johnston's collection, Tlingit hunters can be seen standing beside their kill. In one image, George Sidney cradles a gun in his left arm while using his other hand to point a knife toward a dead bear in the foreground (figure 5.61). The vast expanse of the Yukon landscape stretches out behind him, giving the illusion that he is utterly alone in the hunt. In another image, Dick Morris grips the neck of a bald eagle to position it toward the camera, and with his other hand he spreads its wing (figure 5.62). A third image depicts a teen awkwardly holding the head of a bull moose in order to display its full rack of antlers (figure 5.63). Just like the boy discussed earlier (in figure 5.60), he looks like he is learning to hunt.

Like most photographs, hunting images were intended to be narrated by their subjects. Unfortunately, George Johnston's photographs are not accompanied by original commentary from their subjects, but they are no less "enlivened" by narration. Upon viewing the image of David Johnston and Maude the horse (figure 5.64), Tlingit elders shared their stories of this serendipitous hunt:

> This sled was pulled by oxen from Hazelton, B.C. [a distance of more than 1,170 kilometers] up the Telegraph Trail towards Johnston Town. The Army took a lot of stuff like sleighs and toboggans for souvenirs, but they [the family] still have the bobsled. The sled was pulled by oxen, but he [David Johnston] ran out of feed and they were killed. David got runners, built the bobsled, and shod the horse. By hitching the horse to the sled, it was useful for winter hunting. About four miles south of Morley Bay, some moose thought the horse was another moose. The moose in this photo were felled in two shots by George Johnston.[80]

Thus, we learn that George Johnston was such a gifted hunter that each moose was taken down with a single shot. While his younger brother hurriedly butchered the moose to pack it out and safeguard it from scavengers, Johnston took another shot—with his camera. The photograph not only records the almost mythic abilities of George Johnston but points to the resourcefulness of David Johnston. Furthermore, the photograph helped to generate a collective memory about landscape, perseverance, and skills that are now celebrated in the historical record.

During the early twentieth century, the fur trade enriched the Teslin Tlingit economy. An exceptionally talented trapper, George Johnston became relatively

FIGURE 5.61
George Sidney with grizzly
bear, c. 1930–42
Photo by George Johnston
Yukon Archives, George Johnston
fonds, 82/428 #43

FIGURE 5.62
Dick Morris with bald eagle,
c. 1930–42
Photo by George Johnston
Yukon Archives, George Johnston
fonds, 82/428 #78

wealthy from the sale of his pelts. Anthropologist Julie Cruikshank, who interviewed
him in the 1970s, noted that "during the First World War, fur prices were high. Mr.
Johnston remembers when a silver fox was worth $700."[81] This amount is validated
by records of the Anglican Diocese of Yukon. In 1914 it recorded the price for silver
fox at $1,000 and the price for black fox slightly higher.[82] Even into the Great Depres-
sion, the prices for fur remained high. "In 1928 fox is a good price," claimed Teslin
Tlingit elder George Sidney. "Cross fox was worth over $600 or $400. In 1930 prices
come up more. That time outside there was a depression. I never know anything
about it."[83] So while most of the Native and non-Native population struggled during
the first part of the twentieth century, the Inland Tlingits lived a relatively comfort-
able lifestyle.

FIGURE 5.63

Unidentified teen with bull
moose, c. 1930–42

Photo by George Johnston

Yukon Archives, George Johnston
fonds, 82/428 #36

FIGURE 5.64

David Johnston and Maude
(the horse) going to Johnston
Town, c. 1930–42

Photo by George Johnston

Yukon Archives, George Johnston
fonds, 82/428 #46

With fur a key commodity for the Tlingits, it is understandable that trapping
would be a theme of George Johnston's photographs. Cruikshank observed that
"most of these photographs were taken between 1910 and 1940 when furs brought
Indian families a sizeable income. The pictures reflect the optimism of those years."[84]
In many of Johnston's images, people are posed in front of pelts, like one photograph
that depicts a young girl and boy standing in front of thousands of dollars' worth of
lynx and fox furs (figure 5.65). Both children have pelts hanging about their necks,
but the boy has an additional prop; he is holding a rifle.[85] By depicting the boy with
a gun in front of the catch, Johnston may have been cracking a visual joke, implying
that it was he who collected all of the pelts in the background. It could also be that
the image is meant to prefigure the boy's role in growing up as a successful trapper—
or that the gun itself was to be honored by the picture.

FIGURE 5.65

Two children standing in
front of furs, c. 1930–43
Photo by George Johnston

Yukon Archives, George Johnston
fonds, 82/428 #72

FIGURE 5.66

Porch with hanging pelts,
c. 1930
Photo by George Johnston

Yukon Archives, George Johnston
fonds, 82/428 #51

Several photographs in George Johnston's collection feature pelts hanging either with or without locals pictured (like the earlier picture of his daughter, figure 5.57). In an example of the latter (figure 5.66), Johnston has photographed a porch with furs artfully exhibited on the exterior. The mink, wolverine, cross fox, and marten pelts are recognizable commodities and effectively serve as a conspicuous display of wealth. It was this economic prosperity that made it possible for George Johnston to buy developing supplies, purchase film in bulk, and make a much larger purchase—a new car.

Johnston's Car: Seex'wéit

George Johnston is famous for owning the first car in Teslin. Every Teslin Tlingit with whom I spoke (both young and old) seemed to recall a story about that car.

FIGURE 5.67

The *Thistle*, the boat that
delivered George Johnston's
car, c. 1920

Photo by George Johnston

Yukon Archives, George Johnston
fonds, 82/428 #9

When Johnston purchased it in 1928, Yukon Territory had few roads. To even get it
to Teslin, it had to come by boat—the sternwheeler *Thistle*, which delivered goods to
trading posts along the Yukon waterways. The *Thistle* had been built in Teslin, and at
some point during its operation (1919–29) Johnston photographed it (figure 5.67).

It is not known whether this image was taken while the sternwheeler was deliv-
ering his car. But in an audio-recorded interview with Catholic priest Jean-Paul
Tanguay, George Johnston recalled his anticipation waiting for the boat. "I look for
my car every time, my gosh, I was waiting a long time to see my car," said Johnston.
"Pretty soon somebody say, 'Steamboat coming!' they come around the point and
I just walk to the top of the hill to watch. I just wanna see my car."[86] Although the
Thistle had a distinguished career as a delivery vessel and a spectacular demise when
it sank into Lake Labarge in 1929, its memory in Teslin has been forever commemo-
rated as the carrier of Johnston's car. Several sources on the history of the Yukon also
relate the *Thistle*'s role in transporting Johnston's car to Teslin.[87]

While waiting for his car to arrive, Johnston and his brothers widened an exist-
ing footpath to accommodate the vehicle, but it would be another three years before
the ambitious Johnston was able to cut a five-mile stretch of road. When the car
arrived, Pearl Keenen (née Geddes), who was ten years old at the time, remembered
that most of the village gathered on the beach to see the unbelievable arrival of an
automobile in remote, roadless Teslin. Many Tlingits, and Yukoners in general, had
never seen a car, and its arrival was quite a spectacle. The car would not fit on the
deck of the *Thistle*, so it had to be sealed into the hull and cut out of the boat when it
arrived. Charlie Taylor, who delivered the car, noted, "Next was the chore of getting
the prize off the boat and onto the beach. It got stuck in the sand and George asked

some of the young men to help get it out of the sand. About 20 of them came forward
and picked the car right up and moved it onto the bank."[88]

This would not be the only time the car became stuck. During winter, Johnston
used Teslin Lake as an extra ninety miles of roadway. One time, while driving about
fifteen miles south of Teslin, he broke through the ice. Johnston recalled, "I try to
swing around to go back, but my car go down just like that, and it's solid ice again. I
just go dig him out, and pull it out of the ice, and put it in the bush. . . . spring time
when the ice opens I went over there with a nice big boat. I cut a big tree and make a
big raft and put the car on it."[89] He photographed the calm aftermath as the car was
rafted back to Teslin (figure 5.68). In the picture, three boats are tethered together
to tow the car-carrying raft. With a long diagonal and dramatically plunging land-
scape, this photograph is the most aesthetically unusual in Johnston's collection.

Initially, people told George Johnston that he was "crazy" to bring a car into the
"bush."[90] He and his brothers became the laughingstock of town until, "driving up
and down the frozen lake, they hunted for wolves. During that first winter they shot
more than sixty wolves from the car and were paid $75 for each pelt. Laughing at the
Johnston brothers and their car became a dead pastime."[91] This new use for his car

FIGURE 5.69

Hunting by car, c. 1930

Photo by George Johnston

Yukon Archive, *Their Own Yukon*

Project Collection, 2000/37 #77.

Reprinted with permission

from the Council of Yukon First

Nations

was photographed by Johnston (figure 5.69). Unlike his hunting images that picture a single hunter posing with the game, this image portrays an entire hunting group gathered behind dead wolves. The car is close behind them, positioned at an angle and parallel with the shoreline of the frozen lake. In the center is his good friend Edward Jack, holding a gun and surrounded by six other unidentified men.

Although Johnston was praised by his community for hunting more efficiently, motorized hunting represented another innovation introduced to the Inland Tlingits by Johnston, marking a departure from their established practices. In fact, hunting from a motorized vehicle does not appear to have been previously recorded, or pictured, in the history of Native North Americans. Some forty years later, the invention of the snowmobile would expand the hunting ground of most First Nations hunters; but the role of machines in hunting is more commonly cited in the literature of the early American West when passengers on trains shot at buffalo. "In truth," explains Dakota historian Philip Deloria, "automobile purchase often fit smoothly into a different logic—long-lived Indian traditions built around the utilization of the most useful technologies that non-Indians had to offer."[92]

Johnston showed great resourcefulness in caring for his car. When he ran out of gasoline, he fueled it with naphtha, a flammable solvent often used in lanterns. When a tire blew out, he sewed it up and patched it with moose hide. In this period before antifreeze, he kept his car's radiator water over a fire, and when he spotted game out on the frozen lake he replaced the water and "with one crank he was off."[93] Animals became frightened by the large, black automobile lumbering toward them, so to facilitate hunting Johnston camouflaged the car with white house paint, which had to be repainted every winter. In other words, his "indigenuity" (to use the term by Daniel Wildcat) seemingly had no bounds.[94]

FIGURE 5.70

Hauling freight (fur and
grub) on Teslin Lake,
c. 1938–45

Photo by George Johnston

Yukon Archives, George Johnston
fonds, 82/428 #18

In an image depicting his car painted white (figure 5.70), Johnston is not using
it to hunt but instead to haul "fur and grub." Standing in front of the vehicle are his
young relatives, Titus and Paddy Johnston, Father Drean (Teslin Catholic priest,
1938–53), and Watson Smarch. Although it was being used as a hauler in this photo-
graph, the car "always had shotguns in the front seat for hunting," so Johnston was
prepared if game crossed his path.[95]

In addition to being a skilled hunter, Johnston was also an entrepreneur. Long
before the existence of ridesharing companies, he operated his personal car as a
taxi, charging one dollar each way and naming his business the Teslin Rapid Transit
Company. In a photograph that has become a popular postcard (figure 5.71), John-
ston is flanked by Angela Carlick and Fannie Morris, two women who appear to be
his employees.

Based on this image, Johnston's use of assistants to operate his taxi company has
become local lore. However, Angela Carlick and her son Roy Carlick sought to set
the record straight. They wrote to local historian Jim Robb, who featured their story
in his column for the *Yukon News*. In it, Carlick states: "Here is the story about the
famous postcard of George Johnston and car, as told by my mother Angela Carlick.
She was 16 years old in the photo and now she is 83 years old. She is left of George
Johnston. Her sister, Fanny, is standing on the right. George also took them on a tour
of his photo studio at his house." Angela Carlick then tells her story:

This picture was taken outside of George Johnston's house in July 1944 at
Teslin, Yukon. My dad, Liard Tom, knew Johnston and was a good friend
of him and also with a lot of other people in Teslin. Johnston drove down
to Lower Post B.C., in July 1944 to pick up Liard Tom and family for a trip
to Teslin and Whitehorse, Yukon. My family on this trip included my mom

FIGURE 5.71

"Teslin Taxi," 1944

Photo by George Johnston

Yukon Archives, Their Own

Yukon Project Collection,

2000/37 #78. Reprinted with

permission from the Council of

Yukon First Nations

Ada, my sister Fanny, and my brother Frank. This was the first time I had seen Johnston. My dad understood and could speak the Tlingit language of the Teslin people. He had made many trips with his dog team to Atlin B.C., for food and would travel to Teslin visiting with friends. . . . There were a lot of people in Teslin. We would stay in Teslin for about two weeks while my dad was visiting with Johnston. . . . Johnston would take us all in his new car to Whitehorse for a trip. Fanny and I would go shopping for new clothes and hats at the stores in Whitehorse. We went back to Teslin, and Johnston would take this picture of us with his own camera. We were all standing in front of his car by his house in Teslin. Fanny and I were posing with Johnston wearing the new clothes and hats that we bought in Whitehorse. I was 16 years old in that picture. He also took another photograph of us that included my mom and dad, and I think his daughter Dolly. Johnston would drive us back to Lower Post after this visit with Liard Tom.[96]

By publicly sharing her memories of this event, Angela Carlick recontextualizes the photograph and causes us to focus less on George Johnston and his taxi business and more on the relationships his business fostered. Johnston's automobile was so unusual and so novel in the southern Yukon that it became a remarkable aspect of regional life.

Johnston affectionately named his car "Seex'wéit" a Tlingit term of endearment often reserved for sled dogs meaning "my slave/my little workhorse."[97] After all, the car was practically a part of the family, appearing in the background of many of his photographs. Some village elders have fond memories related to Seex'wéit. For example, Pearl Keenen recalled what she was wearing when Johnston picked up her family

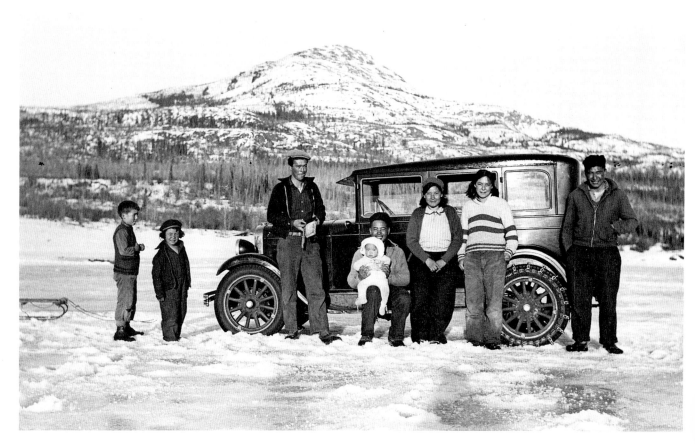

for a ride (figure 5.72). She said, "Let's see . . . that's Louis Fox, and Andy Smith and
his wife, and my two brothers Ted Geddes and Clifford Geddes. Mom made me that
sweater and it was white and orange color and she knit that herself. Soon as we used
to see people coming then we used to run and put on our best dress and make sure
our hair was all brushed and everything with our best gear."[98] Like Angela Carlick,
Pearl Keenen remembers that taking a ride was *more* than taking a ride—in other
words—it was an *event*. By using Johnston's taxi service, the community also demon-
strated that they were economically stable by having sufficient disposable income to
pay for rides in the car.

The Community

As previously mentioned, the Teslin Tlingits thrived between 1920 and 1942. During
this time, they had relatively little contact with non–First Nations people, and most
of the families still made a living hunting and trapping. Village life was tranquil and
punctuated by communal gatherings like picnics, holidays, and sports days.

Then, as now, Teslin Tlingit families congregated every Dominion Day—or
"Canada Day," as the July 1 holiday is now known—to picnic and participate in

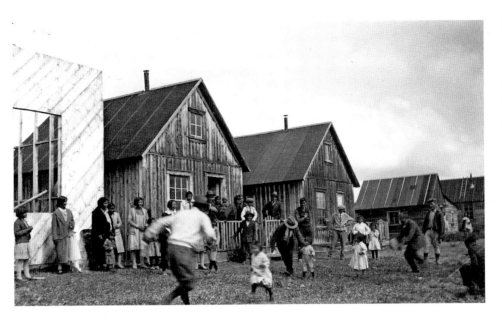

FIGURE 5.73

Teslin, Dominion Day
(July 1), c. 1940

Photo by George Johnston

Yukon Archives, George Johnston
fonds, 82/428 #49

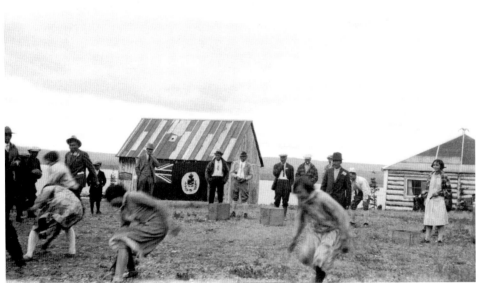

FIGURE 5.74

Canada Day celebrations,
Teslin, c. 1940

Photo by George Johnston

Yukon Archives, George Johnston
fonds, 82/428 #70

games of skill. Johnston had his camera on hand to photograph such events. His images depict villagers of all ages taking part in games and races held throughout the day (figures 5.73–74). Many photographs feature a blur of unidentifiable figures running across the landscape in competition. In each case, a small group of spectators is cheering on the participants, and everyone is wearing their best clothes. "We'd all have new clothing for July 1st," recalled Tlingit elder and Yukon assemblywoman Marianne Horne.[99] To celebrate the national holiday, Teslin Tlingits also proudly displayed the Union Jack (background, figure 5.74).

FIGURE 5.75

Girls' baseball team, c. 1941

Photo by George Johnston

Yukon Archives, George Johnston

fonds, 82/428 #33

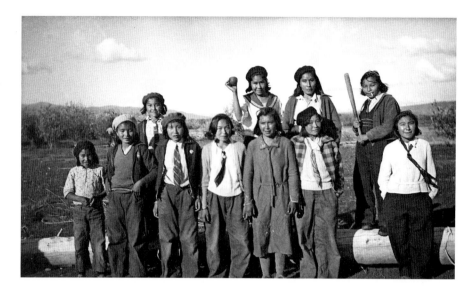

In addition to Canada Day, the community gathered for church picnics and sporting events. During the 1930s, Teslin had a girl's baseball team. George Johnston took several of the group photographs and even appears in some of the pictures. One photograph (figure 5.75), taken at a church picnic at the mouth of the Nitsulin River, features the team lined up in two rows. Although most of the girls are wearing a shirt and tie, they do not appear to be in official uniforms. While examining this image with me, elder Marian Horne expressed that the figure in the top right, identified as Margaret Morris (née Sidney), "seems to always grab my attention . . . with that cigarette and bat. She looks like a feisty gal."[100]

World War II unleashed forces that would end Johnston's photographic hobby. In the spring of 1942, the Teslin Tlingits were surprised by the arrival of U.S. soldiers building the Alaska Highway, and "many of them knew nothing about the construction projects until surveyors, or in some cases bulldozers, arrived in their communities." Teslin residents recalled that a man from Carcross arrived with news of the impending highway construction and told of a large group of people moving in their direction, but the Teslin villagers could not fathom the size and scope of the project.[101]

In addition to the strangers and earthmovers, the troops also brought with them illnesses for which the Inland Tlingits had no immunity. In 1943, a total of 128 of the 135 Teslin Tlingits were sick with measles.[102] They tried to help themselves, to no avail. The Anglican diocese reported that "Bessie Johnston, a young Tlingit woman from the community, assisted with the care of her people, helping with the cooking and cleaning for sixty patients in the makeshift hospital while also caring for her parents at home. Having worked herself to exhaustion, Bessie herself caught measles, lapsed into a coma, and died within twenty-four hours."[103] The Canadian

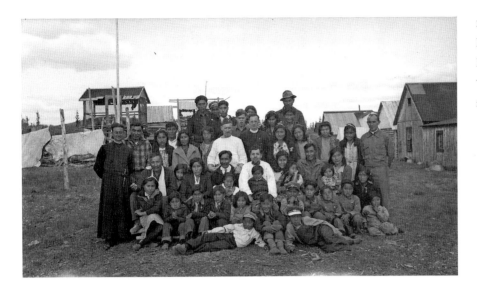

FIGURE 5.76
Inoculation day, Teslin, 1942
Photo by George Johnston
Yukon Archives, George Johnston
fonds, 82/428 #37

government was aware of this tragedy. According to the reports of a Canadian officer working on the highway project:

> The Indians of Teslin and Lower Post bands until the advent of this new era have been almost completely isolated from contacts with white people and have had the least opportunity of creating an immunity to white peoples' diseases. Consequently, they have been distressingly affected by the new contacts. . . . The band of Teslin suffered epidemics of measles and whooping cough, which in some cases developed into pneumonia, last year, and now are plagued with an epidemic of meningitis and have suffered three deaths so far from the latter. There is no doubt in my mind that if events are allowed to drift along at will . . . the Indian bands at Teslin and Lower Post will become completely decimated within the next four years. The problem is how to prevent this, or at least to ameliorate conditions as far as possible.[104]

In an effort to stave off the illness, the government tried vaccinating the population, and George Johnston was there to take a group portrait of inoculation day (figure 5.76). Pictured among the Tlingit men, women, and children are the parish priests, a nurse, and a pair of U.S. Army doctors. They are formally posed in the center of the village, between the houses and pelt-drying lines. According to the caption provided by Dolly Johnston, "twelve people died in one week in Teslin. Villages all over the Yukon and places as far as Fairbanks, Alaska were hit hard. Empty villages were seen, people had died off."[105]

Throughout his life, George Johnston photographed funerals, but the ones wrought by disease were particularly hard. In his way of honoring the dead, Johnston continued to photograph funerals and memorial potlatches. One of his images

FIGURE 5.77

Memorial potlatch, c. 1942

Photo by George Johnston

Yukon Archives, Freddie Johnston

fonds, 79/119 #106

depicts the Inland Tlingit custom of gifting new clothes during a memorial potlatch (figure 5.77). As Sam Johnston recalled, "Brand new clothing would be placed on the fence and the opposite clan of the deceased could each choose an item, then the fence was brought to the gravesite."[106] Although earlier Tlingits practiced cremation and built grave houses, after contact with missionaries their memorial practices changed; they entombed the dead and built fences around the gravesites. By the 1940s the Teslin Tlingits were using lathes to create more elaborate grave fences like the ones seen here (figure 5.78), but they continued their practice of building small grave houses. Inside these structures, they placed objects belonging to the deceased. Archival footage in the form of home videos shows the grave houses being disturbed and ransacked by soldiers temporarily stationed in area.[107]

The death and devastation occurring in the Inland Tlingit community was reflected in the activities of Teslin's children. In a picture taken in the 1940s, George Johnston depicted five Teslin children playing "funeral" (figure 5.79). One child is in a makeshift casket while the others act as grim little pallbearers. The scene takes place on the porch of a general store, with cream soda bottles visible through the window. This image is a sad reminder of that time. When viewing and discussing this photograph, Teslin elders respond with grief, frustration, and anger.

After the highway was completed, George Johnston ceased taking photographs and concentrated his efforts on operating a general store (figure 5.80). Locals, who

FIGURE 5.78

Funeral, c. 1942

Photo by George Johnston

Yukon Archives, George Johnston fonds, 82/428 #58

FIGURE 5.79

Teslin children playing
"funeral," 1943

Photo by George Johnston

Yukon Archives, George Johnston

fonds, 84/428 #69

were children during the 1950 and 1960s, remember Johnston's store and the products he carried, especially the pink popcorn and soda. A few people mentioned that he sold his photographs as postcards, but none could remember exactly which photographs he offered. The Yukon Archives printed some of his photographs on postcard paper, but postcard stock was a popular and inexpensive backing and does not necessarily indicate that postcards per se were meant to be created. Although we may never know which photographs George Johnston offered for sale, we do know that he moved his store closer to the highway to take advantage of the highway traffic.

With the Alaska Highway open to the public in 1948, the village of Teslin became accessible to travelers making their way across northwest Canada. As they passed through, tourists stopped for gas, purchased crafts, and sometimes bought Native-made objects. Pearl Keenen, a respected Tlingit elder who was in her twenties when the highway was completed, remembers Tlingit cultural heritage being removed by passing motorists. Over a cup of Dominion Day tea, she said: "White people from out-of-town bought them old Tlingit costumes and things. They just took them from us. The people just *stole* them. And those pictures are the same way. And if they were to come back, they would be charged with stealing."[108] Her comments reflect the community distress over the loss of material culture and a sustained resentment for the ongoing impact to their lands brought by the opening of the highway.

In the early 1970s, The Teslin Community Club, a neighborhood organization in charge of community events, lobbied for a museum to retain and display Tlingit

FIGURE 5.80

George Johnston in front of his store, 1967

Photo by Edward Bullen

Yukon Archives, Edward Bullen fonds, 82/354 #14

cultural heritage. "The elders were not familiar with the concept of a museum," said leader Bonar Cooley, so members of the community club "went around visiting and explaining exactly what a museum was and what it could do for them."[109] Agreeing that a museum was needed to preserve their culture, the elders lent their support. Although George Johnston was just one of the many elders approached, he was decidedly the most high-profile figure. Already famous for his car and entrepreneurial spirit, Johnston also had a sizable collection of First Nations art and artifacts, as well as his own photographs. The act of "naming the museum after George Johnston wasn't a difficult decision for the Teslin residents."[110] Johnson would not live to see his namesake institution open in 1975, since he passed away while tending to his traplines during the winter of 1972.

Conclusion
Indigenous Photographic Developments

We have been using photography for our own ends as long as we've been flying, which is to say as long as there have been cameras and airplanes. The question isn't whether we love photography, but instead why we love it so much. . . . it's obvious we are a people who adore taking pictures and having pictures taken of us. So it should hardly be a surprise that everything about being Indian has been shaped by the camera.

—**PAUL CHAAT SMITH** (Comanche)

In exploring the relationships between American Indians and photography—as subjects, photographers, and even curators—we see that there is no single Native American way of practicing photography but, instead, multiple photographies. These photographies present the daily existences and shared experiences of Native peoples, thus providing what Teresa Harlan calls "a space for indigenous realities."[1] Although Native-produced photography may afford candid glimpses into the everyday lives of American Indians, we must remember that such pictures often become entangled in personal and tribal agendas.

When I started this book, I operated on the premise that practicing photography is fundamentally different for American Indians, and that that practice is inherently connected to the insider status of the photographer. I had assumed that there was an unspoken duty imposed on indigenous photographers to represent their own communities faithfully—with consent and cooperation. What became apparent, however, is that a photographer's approach is more closely correlated with his or her photographic agenda than to whether that photographer is Native or non-Native. For instance, Native photographers like Louis Shotridge and George Hunt sometimes photographed against the will of community members in order to further

Mrs. Dorothy Ware Poolaw and Justin Lee Ware in cradle, 1928
Photo by Horace Poolaw
Oklahoma Historical Society, Muriel Wright Collection, 19186. Reproduced with permission from the Estate of Horace Poolaw

their own professional ambitions. Yet their actions were not entirely self-centered. They believed that salvage ethnography (recording and collecting as much cultural information as possible before indigenous lifeways went extinct) was the best way to preserve Native traditions. But, overall, indigenous photographic practices seem to reflect an increased sensitivity toward the familiar communities captured, as seen in the work of Harry Sampson and George Johnston, whose pictures appear to be compassionate records that reflect the social realities of their peoples.

By choosing what they wanted to represent and how they wanted to be represented, Native participants and practitioners of photography have exhibited a large degree of agency and awareness of what was being portrayed. As we have seen, indigenous patrons like Red Cloud and Zitkala-Ša commissioned photographic portraits to forward their own professional goals and aspirations, and Native photographers like Richard Throssel and Horace Poolaw acted like photojournalists to record their peoples on behalf of institutions and for posterity. Yet the patrons and practitioners of indigenous photographies are not the only ones with photographic agendas. Some tribal communities and individuals sought to profit from the sale of their images by recognizing the demand and taking advantage of their "exotic" status. Others, such as George Johnston and Harry Sampson, simply enjoyed the hobby and ended up creating large collections for their own personal satisfaction.

Native subjects have represented themselves in different guises—as Indian princesses and brave warriors, European-style statesmen, and Victorian women. They have also used objects of esteem like cars and large homes as backdrops for their status, thereby conveying a sense of pride and distinction. These people were not simply depicted as targets of Western image-making who were being forced into "noble savage" stereotypes; nor were they trying to salvage or reclaim their own "vanishing" past. Moreover, American Indian photographies should not be read as by-products of assimilation into Western culture. By practicing and participating in photography, American Indians were not committing cultural treason or abandoning any aspect of their indigeneity. In point of fact, Native peoples actively participated in the formation of their own constantly developing identities. "These are the people who would not die," proclaims Native author Leslie Marmon Silko (Laguna Pueblo), "because they are always changing."[2]

In practicing photography, Native peoples have been able to harness the power of images to assert their own visual voices and to tell their own stories. Yet as artist Hulleah Tsinhnahjinnie (Taskigi/Diné) points out, "The power of the image is not a new concept to the Native photographer—look at petroglyphs and ledger drawings. What has changed is the process."[3] Despite being involved in the medium almost since its inception, American Indians have typically been regarded as passive subjects and victims of Western image-making. As a matter of fact, indigenous peoples

have been regularly cast in the ethnographic present (i.e., presented as they were prior to Western contact), so that the very concept of American Indians practicing photography seems antithetical to their "traditional" existence. As Silko argues, "Euro-Americans distract themselves with whether a real, or traditional, or authentic Indian would, should or could work with a camera. (Get those Indians back to their basket making!).["4] In the face of this technological and cultural primitivism, American Indians have used photography to assert their rights of self-representation.

In many ways, Native North Americans participating in photography amounts to an act of resistance. In defiance of the vanishing-race narrative, they pictured the next generation—the children—thriving and continuing traditions (figure c.1). We have also seen indigenous subjects wear peyote symbolism and don ceremonial regalia in the face of federal laws that prohibited such expressions of Native culture. By photographing these subjects, the Native photographers become unapologetic accessories to a crime. They are enacting visual sovereignty, and through a Native lens we can view their people as they want to be seen.

I do not want to downplay the image-making practices of some non-Natives, who were not just casual visitors to Native communities but friends and neighbors of the people they pictured. Kate Cory, Mary Schäffer, Lloyd Winter, and Edward Pond all fall into this category, as do other non-Native photographers not discussed here, including Vincent Soboleff, Benedicte Wrensted, and Lee Moorehouse (all of whom are featured in this same book series). These photographers enjoyed close relationships with their Native subjects and were able to create many photographs that do not appear staged or biased, thereby representing American Indian life sensitively and accurately.[5] Despite my use of Edward Curtis as a foil, he too could fall into this category. After all, he could not have made over forty thousand images of Native North Americans without some cooperation from his sitters.

Considering the number of photographs created by Curtis and American Indians themselves, it is somewhat incongruous that so many people think Native Americans feared photography.[6] While I compiled materials for this book, I constantly heard that American Indians thought cameras were "shadow catchers" or "face pullers" that "stole the soul."[7] Although only a few Native people actually expressed this belief, it has been generally ascribed to *all* Native Americans.[8] Those individuals who did express fears or anxieties regarding photography may have been responding to something much less supernatural. "General suspicions of the camera and its operator were not perhaps entirely unfounded," argues historian James Ryan, "since those sitters whom photographers did manage to capture had neither knowledge nor control over the uses and meanings of their likenesses."[9] In other words, after the photographers left with the images in hand, the Native rights to those representations left with them.

In this book I discuss the image-making but not really the destination, or the "social lives" (to use Arjun Appadurai's phrase), of these photographs.[10] What happened to these images and how are they being used by the communities now? Curtis's images are being reclaimed by family members of his subjects, and he photographed so many people that it is not uncommon for tribal members today to be related to a Curtis subject, or to know someone who was. Horace Poolaw's family has made a concerted effort to digitize and archive his two thousand photographs (especially those early images on highly flammable nitrate film), resulting in the 2008 Horace Poolaw Photography Project, a research initiative that gave way to several publications and a solo retrospective at the National Museum of the American Indian in 2014. Harry Sampson's son, Clayton, enlarged all of his father's photographs and placed them on permanent display in the combined Fallon Paiute-Shoshone Senior Center for the elders to enjoy. Jennie Ross Cobb's photographs continue to play a key role in the restoration of Hunter's Home, and they have been featured in exhibits all around in Tahlequah, Oklahoma—the capital of the Cherokee Nation. George Johnston's photographs remain on display at his eponymous museum in Teslin, where one of his landscape photos is enlarged to provide an illusionistic background for his car, Seex'wéit. Other images discussed here are in the process of being digitized by tribal museums and by larger institutions, such as the Smithsonian Institution and National Archives. My hope is that these images will be presented in lieu of, or along with, Western images of indigenous peoples from the same period.

In providing a framework that looks at the photographers on a spectrum of professional to amateur, I give future users one rubric by which to consider the images. I anticipate that more images may be included in the history of American Indian photography as they become available. In fact, as I was completing this book I learned of and simply failed to incorporate the work of additional Native photographers. They include Peter Pitseolak, an Inuit photographer active 1930–60; two Makah photographers, Daniel Quedessa and Shobid Hunter, who pictured their people during the early twentieth century; J. N. B. Hewitt, a Tuscaroran/European linguist with the Bureau of American Ethnology, who photo-documented Iroquois people between 1897 and 1937; Inupiat teacher and photographer Charles Menadelook, active 1907–30; and Canadian Metis James Patrick Brady, who took over a thousand images of his community between 1930 and 1960, interrupted only by his time serving in World War II. I also expect additional female Native photographers to come to light. Hence, by no means is this survey exhaustive. By expanding the discourse with numerous examples of indigenous people who were actively engaged in photography, we can and should refocus the lens on previously excluded and undervalued images.

FIGURE C.1

A Cheyenne warrior of the future, 1907

Photo by Richard Throssel

Library of Congress, Prints and Photographs Division, LC-USZ62-86438

Notes

Introduction

1. Harlan 1993: 7.
2. For more information on Native North American mixed-race identities, see Ellinghaus 2017; Andersen 2015; Ingersoll 2005; and Perdue 2003.
3. See Hume in Southwell and Lovett 2010; Moorehouse in Grafe 2006; Marquis in Liberty 2006; Huffman in Peterson 2005; Soboleff in Kan 2013; Bennett in Hoelscher 2008; and McClintock in Grafe 2009.
4. For example, Momaday 1976; Vizenor 1984, 2009; Silko 1981; Hungry Wolf 1980; and Denetdale 2007.
5. Silko 1981: 1.
6. Indigenous photo-elicitation projects include Cruikshank and Robb 1975; Gold 1983; Collier and Collier 1986; Blinn and Harrist 1991; Harper 2002; Brown and Peers 2006; White 2007; Frank and Hogeland 2007; and Morton and Edwards 2009.
7. Native American photography exhibitions (with catalogs) include Native Indian/Inuit Photographers' Association 1986; Bonita 1991; Aperture Foundation 1995; Johnson 1988; Alison 1988; and Tsinhnahjinnie and Passalacuqua 2006.
8. Some texts on photo repatriation are Pinney and Petersen 2003; Brown and Peers 2006; Isaac 2007; and White 2007.
9. The following authors have discussed inaccuracies in historical photographs: Scherer 1975; Blackman 1981; Lyman 1982; Sandweiss 2002.
10. Lyman 1982. American Indian myths and stereotypes have also been explored by Berkhofer 1978; Stedman 1982; Pinney and Petersen 2003; Brown and Peers 2006; Isaac 2007; White 2007; Edwards 1992; Faris 1996; Dilworth 1996; Vizenor 1998; Huhndorf 2001; Native Indian/Inuit Photographers' Association; and Deloria 2004.

11. For instance, anthropologist James Faris argues that photographs of Native Americans were "produced largely by a dominant, aggressive, and exploitative majority foreign culture with institutional trajectories and disciplines" (1996: xi).

12. The exhibition, *For a Love of His People: The Photography of Horace Poolaw*, ran from August 9, 2014, to February 16, 2015, at the George Gustav Heye Center, Smithsonian's National Museum of the American Indian, New York.

Chapter 1. Native Participants in Photography

1. Lyman 1982; Faris 1996; Maxwell 1999; Trachtenberg 2004.

2. The year 1839 is generally regarded as the birth of photography, since that is when the photographic process became public with dual announcements by Louis Daguerre (daguerreotype) and William Henry Fox Talbot (calotype). For more information on the history of the medium, see Newhall 1982.

3. Per Sandweiss 2002: 208. Scholars previously claimed that a photograph of Peter Jones/ Kahkewaquonaby (1845) was the oldest (see note 6, below), and prior to that Thomas M. Easterly's 1847 portrait of Keokuk, chief of the Sauk tribe, held the title. As more photographs are uncovered in archives, undoubtedly this new claim will be overturned.

4. According to the diary of William Richards, a special envoy who accompanied Timoteo to the United States and Europe, as cited in Davis 1980: 16.

5. See Bush and Mitchell 1994: xvi.

6. Kahkewaquonaby/the Reverend Peter Jones posed for the photographers in both Native and Western dress. The Native dress images were taken outside with foliage as a backdrop, the Western dress images in the studio. He may have recommended the settings, and if so he was conforming to the popular representations of indigeneity. For more information on this image, see Sandweiss 2002: 210; and Zamir 2014: 135–36.

7. Sahlins 1987: 140, 141. *Mana* has several different meanings, such as divine power, sacred essence, and spiritual force. Many prominent anthropologists have attempted to define the concept, including Hubert and Mauss 1899; Pitt-Rivers 1974; and Levi-Strauss 1987.

8. For an excellent discussion on colonial photography, see Maxwell 1999.

9. Maxwell 1999: 193.

10. Queen Emma to Queen Victoria, December 12, 1865, as cited in Hackler 1988: 114.

11. This point is similarly made by Anne Maxwell in her book on colonial photography (1999: 193).

12. The essay "Of Mimicry and Man" is chapter 4 of Bhabha 1994 (quote, 123).

13. Bhabha 1994: 213.

14. Bhabha 1994: 6.

15. For more information about this series of conflicts, also known as Red Cloud's War, see Larson 1999.

16. *Omaha Weekly Herald*, June 1, 1870, 13.

17. Per Goodyear 2003: 49.

18. Brilliant 1991: 10.

19. Mihesuah 1996: 112.

20. Tremblay 1993: 9.

21. For more thorough biographies of Zitkala-Ša, see Michaels 1992; Rappaport 1997; Hafen 2001; and Lewandowski 2016.

22. Her first recorded use of the name Zitkala-Ša was in the caption for the photographs created by Gertrude Käsebier in 1898. Per Smithsonian Institution, Gertrude Käsebier Collection, accession no. 287543.

23. The Carlisle Indian Industrial School newspaper reported, "Miss Simmons is spending part of her vacation in New York City as a guest of the artist Mrs. Kasebier." *Indian Helper* 13, no. 3 (August 12, 1898).

24. As related by Käsebier in "Some Indian Portraits" 1901.

25. Hutchinson 2000: 25.

26. One contemporary critic, Sadakichi Hartmann, recognized Edward Curtis as "*the* photographer of Indians, and will live as such," but considered Käsebier's Indian portraits "way ahead artistically" (emphasis in original). Hartmann 1978: 271.

27. Both Michaels (1992: 70) and Hutchinson (2009: 157) make the point that Gertrude Käsebier removed clothing from her sitters.

28. Hanson 1967: 75, vi.

29. Per Hafen 1998: 104.

30. Hanson 1967: vi–vii.

31. Hafen 1998, 2001; Smith 2001; Lewandowski 2016.

32. Maroukis 2013.

33. The complete quote is in Zitkala-Ša, "The Menace of Peyote" (1916), reproduced in Ša 2003. She also repeats this phrase in "Peyote Causes Race Suicide" (1918), an essay included in U.S. Congress, House Committee on Indian Affairs 1918.

34. "Indian Woman in Capital" 1918.

35. For the rest of her life, Zitkala-Ša allowed journalists to continue the misconception that she was related to Sitting Bull; see Rappaport 1997; Hafen 2001; and Lewandowski 2016.

36. For Mooney and Zitkala-Ša testimonies, see U.S. Congress, House Committee on Indian Affairs 1918: 63, 124.

37. Willard 1991.

38. Scherer 1988: 180.

39. Deloria 1998.

40. For a discussion of the Indian princess stereotype, see Green 1974.

41. Criticisms of Sarah Winnemucca's Indian princess identity, both contemporary and current, can be found in McClure 1999 and Bolton 2010.

42. Deloria 1998: 125.

43. Scherer 1988: 188.

44. Per Richey 1975: 33.

45. Since women in delegations were so rare, I assume that the government did not have dresses available for female delegates. This dress, then, is probably what Winnemucca wore while in the capital.

46. Scherer 1988: 184.

47. As cited in Viola 1995: 180, 187.

48. Both Scherer (1975) and Blackman (1980) discuss the practice of non-Native photographers costuming their sitters.

49. As cited in Cobb 1958: 134.

50. For costuming Native sitters, see Scherer 1975; Blackman 1980; Fleming and Luskey 1993a; and Sandweiss 2002.

51. Green 1992a: 155.

52. This figure is also known as "Mezhukigizhik or Sky Touching the Ground," per the Smithsonian Collections catalog available at http://collections.si.edu/search.

53. According to Scherer, the upstanding feathers of the feather duster imitated Chippewa warrior bonnets (1975: 67).

Chapter 2. Relationships with Photographers

1. As cited in Gidley 1998: 88.

2. Jacknis 1990: 189.

3. "Shooting Indians with a Camera" 1915: E5.

4. Scherer 2006: 121.

5. Painter 1996: 189.

6. Scherer 1988: 192.

7. Geronimo 1915: 197.

8. The largest collection of Sitting Bull photographs in the world is held at Sitting Bull College in North Dakota. Much of their information regarding the photographs comes from the (2000) graduate thesis of German Anthropologist Markus Lindner. He graciously shared his research with me regarding Sitting Bull's photography contracts (Lindner 2001, 2005).

9. Lindner 2001: 41.

10. Russell 1960: 317; Utley 1993: 239.

11. Linder 2005: 10.

12. Masayesva and Younger 1983: 20.

13. Holman 1996b: 101–2. There is early anecdotal evidence of indigenous peoples demanding payment for their images, but it is difficult to determine if women and children received the same amount as male tribal members.

14. The Pasadena Eight were George Wharton James, Adam Clark Vroman, Charles Fletcher Lummis, Frederick Monsen, Carl Moon, C. J. Crandall, Horatio Rust, and Grace Nicholson, per Mitchell (1981: 140). However, George "Ben" Wittick is mentioned as part of the Eight by Bush and Mitchell (1994) and by Goodman (2002), so I include him here as such. These photographs created by the Pasadena Eight can be found in several Los Angeles area collections including the Getty, the Huntington Library, the Southwest Museum of the American Indian, and the Pasadena Central Library.

15. Eldredge et al. 1986: 89.

16. As cited in Graves 1998: 148.

17. James 1902: 7–8.

18. *Santa Fe New Mexican*, August 5, 1913.

19. *Santa Fe New Mexican*, August 3, 1918.

20. As cited in Thomas 1978: 198.

21. Brett 1933: 60.

22. Holman 1996b: 102.

23. As reported by the *Santa Fe New Mexican*, August 6, 1921.

24. Lyon (1988: 239–46) provides an extensive list of when each community prohibited photography.

25. For more information on the prohibition of Native American religions, see Wunder 2013 and Vecsey 1999.

26. Savard 2005: 71–72.

27. As cited in Longo 1980: 12.

28. Crane 1925: 255.

29. Ring 1924: 74.

30. Per Masayesva and Younger 1983: 20.

31. James 1903: 229.

32. Mahood 1961: 90.

33. Horse Capture 1977: 70.

34. As cited in Broder 1990: 36.

35. Given Roosevelt's image as a consummate outdoorsman and other circumstances of the time (e.g., the idealization of American Indians within the Boy Scouts/Campfire Girls groups), it was apposite for the president to write the foreword to Curtis's text.

36. Scholars have thoroughly researched Curtis's life, aesthetics, work, and business ventures, particularly in reference to his *North American Indian* project. Texts, beyond the basic coffee-table book, that I have found useful include Holm and Quimby 1980; Lyman 1982; Davis 1985; Gidley 1994, 1998, 2003a; Northern and Brown 1993; Vizenor 2000; Cardozo

2000; Sandweiss 2001; Rushing 2003; Egan 2006; Scherer 2008; Hausman et al. 2009; Zamir 2014; and Evans and Glass 2014. See also the documentary film by Makepeace 2000.

37. Christopher Lyman (1982) was the first scholar to point out all of the inaccuracies in the photographs by Edward Curtis.

38. Smith 2009: 4.

39. Several scholars have explored readings through the eyes of Native sitters, including Lippard 1992; Northern and Brown 1993; Sandweiss 2001; Tsinhnahjinnie and Passalacuqua 2006; and Zamir 2014.

40. Edward Curtis, *Outline of the North American Indian Project*, 1906, reprinted in Gidley 1998: 44.

41. Lyman 1982: 66–67.

42. Faris 1996: 108.

43. The deceit by the Yeibichai dancers was originally stated in Lyman (1982: 69), and more recently in Anne Makepeace's (2000) documentary.

44. Fleming and Luskey 1993a: 33, 35.

45. According to the image file in the Alaska State Archives, the hereditary owner of the Whale House is named Klart-Reech. My reviewer Sergei Kan noted that there is no phoneme *r* in the Tlingit language. Some scholars refer to Klart-Reech as Shaadaxícht (Emmons 1991; Milburn 1997; Gmlech 2008), but anthropologist Judith Berman (2015: 235n6) states that this is incorrect, and Shotridge called him L-shaadu-xích-x, meaning "Not Clubbed." I use her spelling here and assume that Klart-Reech is the Anglicized spelling of his name.

46. De Laguna 1978; Emmons 1991; Thornton 2008.

47. For more detailed information on the Whale House iconography, see Emmons 1991: 63–65.

48. Wyatt 1989a: 132.

49. Wyatt 1989a: 27–28.

50. Graulich 2003: 73.

51. Per Kate T. Cory collection, MS-208, Museum of Northern Arizona, Flagstaff, Arizona.

52. Graulich 2003: 82.

53. An excellent source on female photographers is Bernardin et al. 2003.

54. Scherer 2006: 51.

55. A list of female photographers working between 1870 and 1920 is available in Scherer 2006: 14.

56. Lippard 1992: 18.

57. Per the eponymous Bernardin et al. 2003.

58. Bernardin et al. 2003: 185.

59. Per court documents 858F.2d 618: Lillie Benally and Grant Benally on Behalf of Norman Benally, an Adult, Plaintiffs-appellants v. Amon Carter Museum of Western Art Defendant-appellee, *Justia.com*, http://law.justia.com/cases/federal/appellate-courts /F2/858/618/446864.

60. For more on Native image rights and indigenous intellectual property, see Lydon 2012; Geismar 2013; and Lai 2014.

61. According to Krouse (2007: 170), Dixon printed and circulated approximately 350 photographs of the 11,000 negatives he created during the Wanamaker Expedition. *The Sunset of a Dying Race* is one of the more famous images from the expedition.

62. Dixon 1913: 206.

63. Dixon 1913: 207.

64. Dixon 1913: 203, 208.

65. Vizenor 1998: 15.

66. Silko 1996: 177.

Chapter 3. Professional Native Photographers

1. McMaster 1992: 66.
2. Jacknis 1992: 143.
3. George Hunt to Franz Boas, February 15, 1896, Franz Boas Professional Papers, American Philosophical Society, Philadelphia, Pennsylvania (hereafter Boas Papers); Boas 1921.
4. Per Wastell 1955: 20. Since Eastman is not especially known for his own photographic style, we cannot know how much this training influenced the photo-aesthetics of the indigenous communities.
5. George Hunt to Franz Boas, January 9, 1900, Boas Papers.
6. Bracken 1997: 243.
7. For a fascinating study of women's roles in the collecting activities of Boas and Hunt, see Bruchac 2014.
8. According to his autobiography, "I Desired to Learn the Ways of the Shaman" (1930), Hunt was initially skeptical of shamanism, believing shamans to be charlatans whom he intended to expose as frauds, but he later learned that the power of healing comes from the belief in, and the performance of, practicing rituals. With this in mind, his photographs should be read as coming from a type of anthropological participant-observer who is acutely aware of his position within the culture.
9. George Hunt is the same Quesalid discussed in Levi-Strauss's works. See Whitehead 2000.
10. See American Museum of Natural History catalog 22868.
11. As cited in Berman 1994: 508.
12. Darnell et al. 2015: 171.
13. See American Museum of Natural History, caption to image 22858.
14. Darnell et al. 2015: 167.
15. Photographs of David Hunt dancing the Hamat'sa at the fair were taken by John Grabill and can be found in photo collections at the American Museum of Natural History, New York, and the Peabody Museum at Harvard University.
16. Several years later, in 1910, George Hunt performed as a Hamat'sa initiate for a series of Edward Curtis photographs. However, these pictures are not the typical Curtisean images, and it is difficult to see Hunt's face, so I opt not to incorporate them in my discussion. See Glass 2009.
17. For an interesting scholarly analysis of Curtis's film paired with indigenous responses to the ephemera (music, props, and other material culture), see Evans and Glass 2014.
18. Per Wilmer 2009: 50.
19. Holm and Quimby 1980: xiv.
20. Paraphrased from Edward Curtis's (1907–1930) description of the image in *The North American Indian*, "List of Large Plates Supporting Volume Ten."
21. George Hunt to Franz Boas, May 4 and June 7, 1920, Boas Papers.
22. Coined by anthropologist Jacob Gruber (1970), "salvage ethnography" refers to the practice, originated by Franz Boas, of assuming that a group is going extinct and therefore acting upon an urgent need to record as much of their culture as possible. For a newer, more nuanced explanation of this concept, see Clifford 1989.
23. Jonaitis 1999.
24. George Hunt to Franz Boas, June 22 1904, as cited in Jonaitis 1999: 59.
25. Jonaitis 1999: 72.
26. This percentage of items collected by Hunt was determined by Ira Jacknis 1991: 180.
27. Williams 2003: 11.
28. Shotridge led the Wanamaker Expedition of 1915 to collect artifacts in the Pacific Northwest.
29. Cole 1995: 189–217.

30. See "Louis Shotridge, Tlingit Indian Genealogy notes and information 1915–1926," MS37, Alaska State Library Historical Collections, Juneau. The cause and rumors of his death are further explored by Enge 1993; Cole 1995; Milburn 1997; and Preucel 2015.

31. Shotridge 1919a: 45.

32. Louis Shotridge to George Byron Gordon, June 28, 1918, Louis Shotridge Digital Archive (hereafter Shotridge Digital Archive), available online at the University of Pennsylvania Museum of Archaeology and Anthropology, Philadelphia, https://www.penn.museum/collections /shotridge/index.html.

33. The concept that photography can change things and people into possessions has been examined by many scholars. For example, Susan Sontag wrote that photography "turns people [and things] into objects that can be symbolically possessed" (1977: 14), and Susan Stewart considers that photography is a type of souvenir that "reduces the public, the monumental, and the three-dimensional into the miniature . . . that which can be appropriated within the privatized view of the individual subject" (1992: 137).

34. Shotridge 1919b: 140.

35. For more information on Shotridge's collecting practices, see Williams 2015: 69.

36. As cited in Enge 1993.

37. According to the introduction of the Shotridge Digital Archive, Shotridge returned to Philadelphia only three times to perform his duties as curator.

38. Shotridge 1919b: 131.

39. As cited in Dean 1998: 208.

40. Lucy Williams (2015: 70) provides a long list of named portraits taken by Shotridge, but I would argue that this is a very small amount in relation to his larger collection of images.

41. Since he has the names of some of his sitters, perhaps others were unwilling to provide their names.

42. All of the following quotes are from the photography cards (ms37-350-ms37-364) in the Shotridge Digital Archives.

43. As cited in Cole 1995: 265.

44. Albright 1997: 24.

45. *Annual Report of the Commissioner of Indian Affairs*, June 30, 1911, as cited in Albright 1997: 38.

46. Similar state-sponsored photographs that promote "progress" can been seen in the colonial imagery of the Belgian Congo. See Roberts 2013: 129–51.

47. For examples of hysteria in photography, see Didi-Huberman 2003 and Showalter 1987.

48. See Foucault 2008.

49. U.S. Office of Indian Affairs 1911: 4.

50. As cited in Albright 1997: 26.

51. Zamir 2014: 149–53.

52. Albright 1997: 26.

53. As cited in Albright 1997: 120.

54. From the introduction of Richard Throssel's promotional brochure, *Western Classics from the Land of the Indian* (1925), University of Wyoming American Heritage Center, Richard Throssel Papers, Accession Number 02394, Box 45, TP1167.

55. Throssel served two terms (1924–28) as an assemblyman representing Yellowstone County.

56. Tsinhnahjinnie 1993: 30.

57. Annette Island is the only Indian reserve in Alaska. Other Alaska Native communities received land, especially under the Alaska Native Allotment Act of 1906, but that legislation was rescinded and replaced with Alaska Native Regional Corporations in 1971, and those are all known as "villages," not reserves.

58. G. Davis 1904: 123.

59. Parham 1996: 37.
60. Per Askren 2006a: 31–32. Although Tsimshians do have a tradition of burning personal effects of deceased family members, this large number of glass plates (featuring different people) appears to have been discarded accidently.
61. Benyon 1941.
62. Askren 2006a: 51–52.
63. Per Miller 1997: 142.
64. Parham 1996: 37.
65. Williams 2003: 141.
66. Duncan's "Declaration of Residents" is reproduced in its entirety in Arctander 1909: 299–300.
67. Askren 2007: 46.
68. Dangeli 2015: 275.
69. Bourdieu 1990: 22.
70. There are 162 Haldane images in the Ketchikan Museum and another two hundred in the National Archives at Seattle. A few other archives, such as the Royal British Columbia Museum, Duncan Cottage Museum, and the Alaska State Archives, have smaller collections of Haldane photographs.
71. Askren 2006a: 51.
72. Davis 1904; Arctander 1909.
73. Wyatt 1989b: 49.

Chapter 4. Semiprofessional Native Photographers

1. The exhibition, *For a Love of His People: The Photography of Horace Poolaw*, ran from August 9, 2014, to February 16, 2015 at the National Museum of the American Indian, New York.
2. Poolaw 1990.
3. Poolaw 1990: 13.
4. Poolaw 1990: 12.
5. Jerman 2011.
6. Mithlo 2014.
7. Poolaw 2014: 32.
8. Johnson 1998: 168.
9. Linda Poolaw, personal correspondence, February 26, 2019.
10. Linda Poolaw, personal correspondence, February 26, 2019.
11. Smith 2011: 126.
12. Smith 2008: 78.
13. For more on peyote imagery, see Swan 1999: 49.
14. Paterek 1996: 119. Smith (2011) found that some of these vests were acquired from the Cheyennes.
15. As cited in Smith 2011: 128.
16. Poolaw 1990: 12–13.
17. Meadows 2008: 142–43. For more on tipis, see Rosoff and Zeller 2011.
18. The Kiowa Six, formerly known as the Kiowa Five, are a group of artists from Oklahoma who worked in a flat style derived from ledger art and hide painting. The members were Spencer Asah, James Auchiah, Jack Hokeah, Stephen Mopope, Monroe Tsatoke, and Lois Smoky. The latter had left the group to start a family, and she was often left out of art historical accounts. Recent efforts have corrected the omission, and here I am using the new nomenclature.
19. Smith 2011: 140.
20. Burchardt 1977: 5; Eugene Chadbourne, *AllMusic*, https://www.allmusic.com/artist/belo-cozad -mn0001834345.

21. As cited in Poolaw 1990: 23.

22. The phrase "culture in transition" comes from the first exhibition of Horace Poolaw's work at Stanford University, *War Bonnets, Tin Lizzies, and Patent Leather Pumps: Kiowa Culture in Transition, 1925–1955*, October 5–December 14, 1990.

23. For a more thorough discussion on this dichotomy, see Simard 2017.

24. Momaday 1995: 14.

25. Poolaw 1990: 13.

26. Coleman 1993.

27. Adams 1995: 136–64.

28. "The Leupp Indian Art Studio" 1907: 1.

29. "A Successful Indian" 1904.

30. Turner 2004: 14.

31. Cooper 1999; Child and Lomawaima 2000; Churchill 2004; Adams 1995.

32. Witmer 1993: 116.

33. Turner 2004: 17.

34. Witmer 1993: 118.

35. Per the Cumberland Historical Society, Carlisle, Pennsylvania.

36. Tolman 2016

37. Durham 2009: 76.

38. The National Archives and Records Administration (hereafter NARA) dates the world's fair image to 1879, and the Dickinson College archives, Carlisle, Pennsylvania, dates the same image to 1893.

39. *Indian Helper*, November 1895.

40. As more archives take the time to record and digitize information of the verso of images, we may find more stamped images by Leslie.

41. Mauro 2011: 125.

42. As cited in De Danaan 2013: 200.

43. See his obituary, "Life Ends for John Leslie" 1956: 6.

44. Beach Comber, "Famous Shipping Men I Have Met," June 26, 1926, clipping, Mason County Historical Society, Shelton, Washington.

45. Witmer 1993: 118.

46. "A Successful Indian" 1904: 177.

47. Chalcraft 2004: 62, 63.

48. As cited in De Danaan 2013: 200.

Chapter 5. Amateur Native Photographers

1. McKenzie coauthored *Popular Account of the Kiowa Language* (McKenzie and Harrington 1948) and *A Grammar of Kiowa* (Watkins and McKenzie 1984). His honorary doctorate was awarded in 1991 by the University of Colorado.

2. According to an August 1, 1990, unpublished interview with Clyde Ellis, Parker and his brother Daniel McKenzie were enrolled in Rainy Mountain by their father in June 1904. They transferred to the Phoenix Indian School in September 1914 to complete their education.

3. Letter from Parker McKenzie to Bill Welge, March 10, 1996, Oklahoma Historical Society archives, Oklahoma City (hereafter OHS).

4. Adams 1995: 117.

5. Per McKenzie's letters accompanying his photography collection, OHS.

6. Ellis 2006: 74.

7. Trennert 1988: 133–36.

8. Parker McKenzie letter to Oklahoma Historical Society dated March 10, 1996, OHS.

9. Trennert 1988: 117.

10. Archuleta et al. 2000: 48.

11. As cited in Archuleta et al. 2000: 19.

12. Even though Hunter's Home is owned and operated by the State of Oklahoma, the Cherokee Nation is no less supportive of the government's activities. They have donated thousands of dollars to the Hunter's Home educational fund and have included the home in their list of Cherokee historical sites in Tahlequah.

13. McLoughlin 1986; Anderson 1991; Perdue and Green 2007.

14. Jennie Ross's original glass-plate camera is housed in the archives of Hunter's Home in Park Hill, Oklahoma.

15. Good 1961: 6.

16. Mihesuah 1993: 10.

17. Harmon 2010.

18. Anna Laurens Dawes in *Harper's Magazine*, as cited in Harmon 2010: 144.

19. Harmon 2010: 144.

20. According to the Hunter's Home archives, approximately forty slaves lived on-site, and most likely they were the builders of the home and its outbuildings.

21. As cited in Mihesuah 1993: 41.

22. Anderson 1991: 115.

23. For an interesting discussion of such ephemera used as domestic memory devices, see Batchen 2004.

24. Mihesuah 1993: 11–12.

25. This photo is from a collection of glass-plate negatives found in a basement of a Ross family relative. Jennie Ross Cobb had stored these photographs along with other personal effects. During an estate sale, Karen Harrington of Black Valley Trading Post purchased the lot for resale in her antique store. Ms. Harrington generously provided me with scans from the lot. Thanks to David Fowler, director of Hunter's Home, for bringing this collection to my attention.

26. Mihesuah 1993: 83.

27. Performing in blackface and acting in minstrel shows can also be seen in Africa, where the Ghanaian people used it strategically to "imagine themselves as members of an expanded transnational and transcultural black community." Therefore these performances are not about racism per se as much as they are about "racial affinity." See Cole 2001: 37.

28. Driskill 2008: 37.

29. In her notes, Mihesuah (1998: 168n42) states that at least one Cherokee consultant objected to her characterizing the school as elitist.

30. Originally written in Cherokee and published in the August 2, 1854, issue of *Cherokee Rose Buds*, the newspaper of the Cherokee National Female Seminary. Translated by Anna Huckaby, language training coordinator of the Cherokee Nation's Cultural Resource Center, https://www.cherokee.org/AboutTheNation/History/Facts/TheCherokeeRosebuds.aspx.

31. Per the original enrollment and graduation records for the Cherokee Female Seminary School, University Archives at Northeastern State University, Tahlequah.

32. N. West 2000: 54.

33. Cherokees had already supplied a roll of their members in 1880, but the Curtis Act (1898) amended the law and required that the federal government create a "correct" and "final roll." Hence, the commission had to go out into the field and create the rolls. The dates and schedule of Dawes Commission field appointments can be found at *Oklahoma Historical Society*, https://www.okhistory.org/research/forms/DawesCommissionMG.pdf.

34. Johnston 2003: 129.

35. Jensen 1998.

36. Per *Cherokee Nation*, https://cherokee.org/About-The-Nation/History/Facts/Our-History.

37. Perdue and Green 2008: ix.

38. Although the last documented Cold Water Army parade was in 1860, historian Grant Foreman (1934: 139) claimed that after the Civil War "temperance again became a vital subject with the Indians." So perhaps the Cold Water Army parade was reinstituted.

39. Margolis 2004: 94.

40. Huff 1997: 3.

41. Kirshenblatt-Gimblett 1998: 34.

42. This and following quotes are per my phone conversations with Bruce Ross Jr. as well as his biography posted on his personal website, http://www.kuwiskuwi.net (last updated September 4, 2014).

43. The Northern Paiutes are also known as the Paviotso and the Numa, meaning "the People."

44. Farley 1983: 6.

45. Harry Sampson's wife, Adele Sampson, identified all the images and provided extended notes to Joanna Cohan Scherer for use in the Smithsonian's *Handbook of North American Indians*. See Series 2, Papers of the Handbook of North American Indians, circa 1966–2008, NARA.

46. Davis 2002: 184.

47. In *The Official Route Book of Adam Forepaugh and Sells Bros Combined Circuses of 1898*, the entry for July 27 states: "Conspicuous among the vast audience were a number of 'big Injun chiefs' from the territory." The next entry (for July 28) states that "Indians and gypsies camped on all roads leading to the city, having come miles to enjoy the wonders promised and fulfilled by America's greatest shows." *Milner Library, Illlinois State University*, http://digital.library.illinoisstate.edu/cdm/ref/collection/p15990coll5/id/878.

48. Box 578, file no. 35938, Devil's Lake Agency, John W. Cransic to CIA, December 10, 1889, RG 75, NARA.

49. Box 1, file no. 27955, Reno Indian Agency, James E. Jenkins to Commissioner of Indian Affairs, November 22, 1922, RG 75, NARA.

50. Box. 1, no. 57349, Reno Indian Agency, L.A. Dorrington to Commissioner of Indian Affairs, August 16, 1920, RG 75, NARA.

51. Box 1, file no. 57349, Reno Indian Agency, Washington Endicott to Commissioner of Indian Affairs, July 2, 1920, RG 75, NARA.

52. Many documents originated by Sampson can be found in the aforementioned Reno Indian Agency files, NARA.

53. Although some indigenous gatherings (such as potlatches in the Pacific Northwest) had eating events that could be considered "competitive" because they challenged rival clans to consume unappealing food (like grease), these events were not structured as a timed contest, nor were they open to all in the same manner as competitive eating games at county fairs and fandangos. For more information, see Jonaitis 2006. For general competitive eating, see Suddath 2008.

54. Deloria 2004: 153.

55. "Views of Early Twentieth-Century Indian Life" 1983.

56. "Stone Mother," *Pyramid Lake Paiute Tribe*, http://plpt.nsn.us/story.html (accessed September 1, 2016).

57. Knack and Stewart 1984.

58. Curtis 1907–1930: vol. 15.

59. Lippard 1992: 25.

60. "The People: A History of Native Nevadans through Photography," virtual exhibit, Nevada Historical Society, http://museums.nevadaculture.org/new_exhibits/nhs-expeople/eth591.htm (accessed November 1, 2012).

61. As cited in Johnson 1998: xiii.

62. Per my phone conversation with Clayton Sampson in June 2009. He is also quoted similarly in Johnson 2005.

63. For food sources, see Oberg 1973 and Schuster 2010.

64. McClellan 1953: 50.

65. George Johnston's year of birth is debatable. The Yukon Archives, Whitehorse, and the George Johnston Museum, Teslin, have claimed three possible years: 1884, 1894, and 1897. Based on the age he appears in some of his early photographs, I am placing his birth in 1897.

66. Dolly Johnston interviewed by Carol Geddes in her 1997 documentary, *Picturing a People: George Johnston, Tlingit Photographer.*

67. "First Sale," *Whitehorse Star*, Monday, June 11, 1962; George Johnston to Father Tanguay, unpublished tape-recorded interview, March 1968, Yukon Archives.

68. Per George Johnston Museum wall label; per Sharon Chatterton, director of the George Johnston Museum during an undated interview with Dolly Johnston.

69. Although the George Johnston Museum has not found his original camera, it is reported to be a Kodak 616 Bellows. But the 616 was not in production until 1932, so his first camera was probably a Kodak 116 Bellows, which was first available in 1899. Eastman Kodak Company 1997.

70. Geddes 1997.

71. "George Johnston and His World: Life and Culture of the Inland Tlingit," virtual exhibition hosted by Virtual Museums of Canada, http://www.virtualmuseum.ca/sgc-cms/histoires_de _chez_nous-community_stories/pm_v2.php?id=exhibit_home&fl=0&lg=English &ex=00000339&pg=1.

72. Sam Johnston in Geddes 1997.

73. Thornton 2000: 155.

74. Emmons 1991: 132.

75. Jackson and Sidney quoted in McClellan 1987: 320.

76. Marvin 2010: 113.

77. McClellan 1987: 322.

78. McClellan 2007: 90.

79. Suggested in my interview with Sam Johnston.

80. This story was collected by the Yukon Archives during the Teslin Tlingit Council Project elders meeting held in Teslin on March 10, 2009. The George Johnston Museum replicates this story with slightly more detail. My quotation includes information from both institutions.

81. Cruikshank 1975: 43.

82. Series 1, Diocesan Records, COR 258, 6, Anglican Church, Diocese of Yukon fonds, Yukon Archives.

83. McClellan 1987: 320.

84. Cruikshank and Robb 1975: 41.

85. These children have been identified, but there seems to be some confusion about who they are. In one version of this image they are identified as Don and Eva Porter, and in another version they are identified as Moses and Ida. Lacking confirmed identification, I treat them as anonymous figures.

86. George Johnston interview with Father Tanguay, Jean-Paul Tanguay Fonds, Teslin Posting, 1967–68, Yukon Archives.

87. The role of the *Thistle* in delivering Johnston's car is recounted by several sources including Warner 1975; Wuttunee 1992; and Coates and Morrison 1992.

88. MacDonald 1987: 13–14.

89. Per interview with Father Tanguay, Yukon Archives.

90. Johnston interview with Tanguay.

91. "Rapid Transit in the Bush" 1971: 29.

92. Deloria 2004: 152.

93. Wall label, George Johnston Museum.

94. Wildcat 2009: 67.

95. Per George Johnston Museum.

96. Robb 2011b.

97. Sam Johnston, unpublished interview by Ryan Durak, manager of the George Johnston Museum, May 16, 2019.

98. Geddes 1997.

99. Per my discussion with elder Marianne Horne at the George Johnston Museum on July 1, 2012.

100. Horne discussion, July 1, 2012.

101. Coates and Morrison 1992: 73.

102. Coates 1991: 102.

103. As cited in Coates and Morrison 1992: 79.

104. Letter from C. K. LeCapelain to A. R. Gibson dated July 17, 1943, Record Group 1, ser. 1, vol. 9, file 149B, Yukon Government Records, White Pass and Yukon Route Collection, Yukon Archives.

105. Yukon Archives, caption to image 82/428 #37.

106. Yukon Archives, caption to image 79/119 #106.

107. Geddes's documentary film *Picturing a People* (1997) features short clips of servicemen stationed in the southern Yukon during the 1940s, and in these clips the picnicking couples can be seen disturbing the gravesites.

108. Pearl Keenan interview with the author, July 1, 2011.

109. Per phone conversation with Bonar and Bess Colley, August 2011.

110. "Teslin Museum to Open July 18," *Whitehorse Star*, July 21, 1975. See also "Ideas Made Museum," *Whitehorse Star*, July 11, 1975.

Conclusion

1. Harlan 1998: 23.

2. Silko 1996: 178.

3. Tsinhnahjinnie 1993: 30.

4. Silko 1996: 178.

5. Thanks to reviewer Sergei Kan for illuminating this point.

6. "Staged portraits" does not mean that the sitter was particularly willing or comfortable with the medium. In some cases, photographers and anthropologists paid, or otherwise coerced, the impoverished Indians for their participation. See Gidley 2000.

7. Several texts on Native American photography perpetuate the use of the term "shadow-catcher," for example, Brumbaugh 1996 and Fleming 1996. In Canada, shadowcatchers are also known as "facepullers." See Silversides 1994.

8. Anthropologist Ira Jacknis (1996) references a few specific examples of the shadowcatcher belief among the Yurok and Creek tribes, but he (like me) is unable to locate the first recorded usage of the term.

9. Ryan 1997: 143.

10. Appadurai 1988.

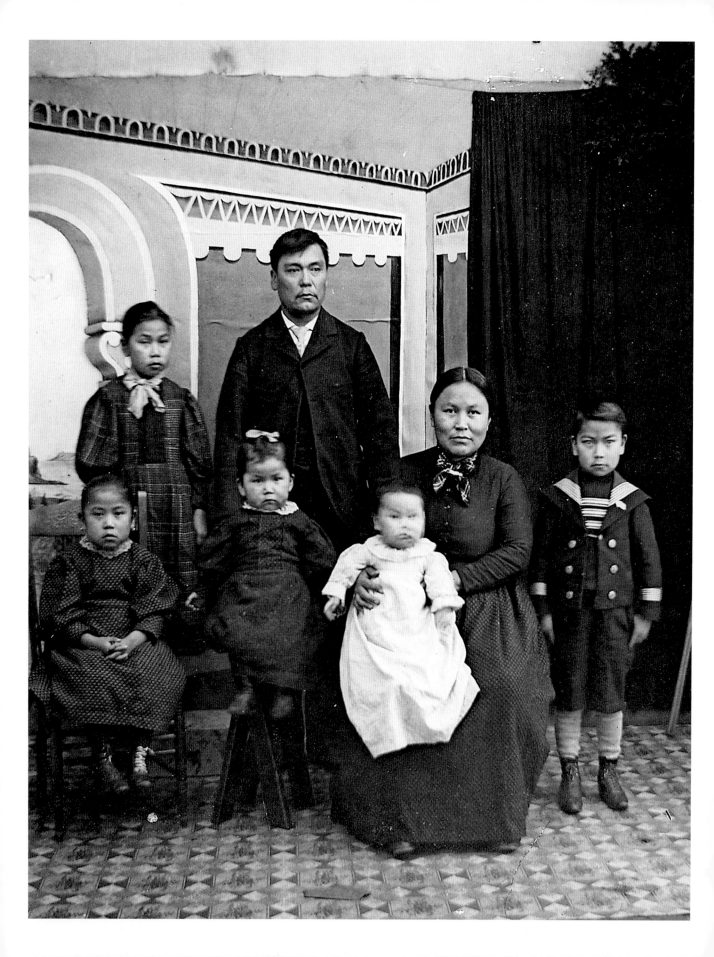

Bibliography

Adams, David Wallace. 1995. *Education for Extinction: American Indians and the Boarding School Experience, 1875–1928*. Lawrence: University Press of Kansas.

Albers, Patricia. 1984. "Utah's Indians and Popular Photography in the American West: A View from the Picture Postcard." *Utah Historical Quarterly* 52 (1): 72–91.

———. 1990. "Private and Public Images: A Study of Photographic Contrasts in Postcard Pictures of Great Basin Indians, 1898–1919." *Visual Anthropology* 3: 343–66.

Albers, Patricia, and William James. 1985. "Images and Reality: Postcards of Minnesota's Ojibway People, 1900–1980." *Minnesota History* 49 (6): 229–40.

Albright, Peggy. 1997. *Crow Indian Photographer: The Work of Richard Throssel*. Albuquerque: University of New Mexico Press.

Aldama, Arturo. 2001. *Disrupting Savagism: Intersecting Chicana/o, Mexican Immigrant, and Native American Struggles for Self-Representation*. Durham, N.C.: Duke University Press.

Alexander, Don. 1986. "Prison of Images: Seizing the Means of Representation." *Fuse Magazine*, February/March, 45–46.

Alison, Jane, ed. 1998. *Native Nations: Journeys in American Photography*. London: Barbican Art Gallery.

Andersen, Chris. 2015. *Métis: Race, Recognition, and the Struggle for Indigenous Peoplehood*. Vancouver: UBC Press.

Anderson, William, ed. 1991. *Cherokee Removal: Before and After*. Athens: University of Georgia Press.

Andrews, Ralph. 1963. *Indians as the Westerners Saw Them*. New York: Bonanza.

Aperture Foundation, 1995. *Strong Hearts: Native American Visions and Voices (Aperture 139)*. New York: Aperture Foundation.

Appadurai, Arjun, ed. 1988. *The Social Life of Things: Commodities in Cultural Perspective*. Cambridge: Cambridge University Press.

Archuleta, Margaret, et al., eds. 2000. *Away from Home: American Indian Boarding School Experiences, 1879–2000.* Phoenix, Ariz.: Heard Museum.

Arctander, John. 1909. *The Apostle of Alaska: The Story of William Duncan, of Metlakahtla.* New York: Fleming H. Revell.

Askren, Mique'l Icesis. 2006a. "From Negative to Positive: B. A. Haldane, Nineteenth Century Tsimshian Photographer." M.A. thesis, University of British Columbia.

———. 2006b. "Benjamin A. Haldane (Tsimshian, 1874–1941)." In *Our People, Our Land, Our Images: International Indigenous Photographers,* edited by Hulleah Tsinhnahjinnie and Veronica Passalacqua, 2. Davis: C. N. Gorman Museum, University of California and Heyday Books.

———. 2007. "Bringing Our History into Focus: Redeveloping the Work of B. A. Haldane, 19th-Century Tsimshian Photographer." *BlackFlash: Lens, Site, Scene.* 24 (3): 41–47.

———. 2009. "Memories of Glass and Fire." In *Visual Currencies: Reflections on Native Photography,* edited by Henrietta Lidchi and Hulleah Tsinhnahjinnie, 91–108. Edinburgh: National Museums of Scotland.

Bass, Althea. 1937. *A Cherokee Daughter of Mount Holyoke.* Muscatine, Iowa: Prairie Press.

Bataille, Gretchen, ed. 2001. *Native American Representations: First Encounters, Distorted Images, and Literary Appropriations.* Lincoln: University of Nebraska Press.

Batchen, Geoffrey. 2004. *Forget Me Not: Photography and Remembrance.* New York: Princeton Architectural Press.

———. 2008. "Snapshots: Art History and the Ethnographic Turn." *Photographies* 1 (2) (September): 121–42.

Beard-Moose, Christina Taylor. 2009. *Public Indians, Private Cherokees: Tourism and Tradition on Tribal Ground.* Tuscaloosa: University of Alabama Press.

Benyon, William. 1941. "The Tsimshians of Metlakatla, Alaska." *American Anthropologist* 43 (1): 83–88.

Berkhofer, Robert F., Jr. 1978. *The White Man's Indian: Images of the American Indian from Columbus to the Present.* New York: Alfred A. Knopf.

Berlo, Janet, ed. 1992. *The Early Years of Native American Art History.* Seattle: University of Washington Press; Vancouver: UBC Press.

Berlo, Janet, and Ruth B. Phillips. 1995. "Our (Museum) World Turned Upside Down: Representing Native American Arts." *Art Bulletin* 77 (1): 6–23.

Berman, Judith. 1994. "George Hunt and the Kwakw'ala Texts." *Anthropological Linguistics* 36 (4): 483–514.

———. 2015. "Relating Deep Genealogies, Traditional History, and Early Documentary Records in Southeast Alaska: Questions, Problems, and Progress." In *Sharing Our Knowledge: Tlingit and Their Coastal Neighbors,* edited by Sergei Kan, 187–246. Lincoln: University of Nebraska Press.

Bernardin, Susan, et al. 2003. *Trading Gazes: Euro-American Women Photographers and Native North Americans, 1880–1940.* New Brunswick, N.J.: Rutgers University Press.

Bhabha, Homi K. 1994. *The Location of Culture.* London: Routledge.

Bird, S. Elizabeth, ed. 1996. *Dressing in Feathers: The Construction of the Indian in American Popular Culture.* Boulder, Colo.: Westview.

Blackman, Margaret. 1980. "Posing the American Indian." *Natural History* 89 (10): 68–74.

———. 1981. *Window on the Past: The Photographic Ethnohistory of the Northern and Kaigani Haida.* Ottawa: National Museums of Canada.

———. 1981/1982. "'Copying People': Northwest Coast Native Response to Early Photography." *BC Studies,* no. 52 (Winter): 87–112.

Blinn, Lynn, and Harrist, Amanda. 1991. "Combining Native Instant Photography and Photo-Elicitation." *Visual Anthropology* 4: 175–92.

Bloom, John. 2000. *To Show What an Indian Can Do: Sports at Native American Boarding Schools*. Minneapolis: University of Minnesota Press.

Boas, Franz. 1921. "Ethnology of the Kwakiutl." *35th Annual Report of the Bureau of American Ethnology*, 1222–48. Washington D.C.: Smithsonian Institution.

Bolton, Linda. 2010. *Facing the Other: Ethical Disruption and the American Mind*. Baton Rouge: Louisiana State University Press.

Bonita, Pena. 1991. *No Borders: Works by Four North American Native Photographers*. Hamilton, Ont.: Native Indian/Inuit Photographers' Association Gallery.

Bourdieu, Pierre. 1990. *Photography: A Middle-Brow Art*. Stanford, Calif.: Stanford University Press.

Bracken, Christopher. 1997. *The Potlatch Papers: A Colonial Case History*. Chicago: University of Chicago Press.

Brett, Dorothy. 1933. *Lawrence and Brett, a Friendship*. Philadelphia: J. D. Lippincott.

Brilliant, Richard. 1991. *Portraiture*. Cambridge, Mass.: Harvard University Press.

Broder, Patricia Janis. 1990. *Shadows on the Glass: The Indian World of Ben Wittick*. Savage, Md.: Rowman and Littlefield.

Brown, Alison, and Laura Peers. 2006. *"Pictures Bring Us Messages": Photographs and Histories from the Kainai Nation*. Toronto: University of Toronto Press.

Brown, James, and Patricia Sant. 1999. *Indigeneity: Construction and Re/Presentation*. New York: Nova Science.

Brown, Jennifer, and Elizabeth Vibert. 1996. *Reading beyond Words: Contexts for Native History*. Ontario: Broadview.

Brown, Michal F. 2003. *Who Owns Native Culture?* Cambridge, Mass.: Harvard University Press.

Bruchac, Margaret. 2014. "My Sisters Will Not Speak: Boas, Hunt, and the Ethnographic Silencing of First Nations Women." *Curator: The Museum Journal* 57 (2): 153–71.

Brumbaugh, Lee Philip. 1996. "Shadow Catchers or Shadow Snatchers? Ethical Issues for Photographers of Contemporary Native Americans." *American Indian Culture and Research Journal* 20 (3): 33–49.

Bryant, Barbara. 1993. "Native American Images: Collection Documents a Period in Nation's History." *Library of Congress Information Bulletin* 52 (15): 302–5.

Bullen, Edward. 1968. "An Historical Study of the Education of the Indians of Teslin, Yukon Territory." M.A. thesis, University of Alberta.

Burchardt, Bill. 1977. "The Kiowa Sacred Flute." *Oklahoma Today*, Spring, 5.

Bush, Alfred, and Lee Clark Mitchell. 1994. *The Photograph and the American Indian*. Princeton, N.J.: Princeton University Press.

Byers, Paul. 1966. "Cameras Don't Take Pictures." *Columbia University Forum* 9 (1): 27–31.

Byrne, Christopher. 1993. "*Chilkat Indian Tribe v. Johnson* and NAGPRA: Have We Finally Recognized Communal Property Rights in Cultural Objects?" *Journal of Environmental Law and Litigation* 8: 109–31.

Cardozo, Christopher. 2000. *Sacred Legacy: Edward S. Curtis and the North American Indian*. Introduction by Joseph D. Horse Capture. New York: Simon and Schuster.

Catlin, George. 1993. *North American Indians*. Edited by Peter Matthiessen. New York: Penguin.

Chalcraft, Edwin. 2004. *Assimilation's Agent: My Life as a Superintendent in the Indian Boarding School System*. Edited by Gary C. Collins. Lincoln: University of Nebraska Press.

Chalfen, Richard. 1989. "Native Participation in Visual Studies: From Pine Springs to Philadelphia." In *Eyes across the Water*, edited by Robert Boonzajer Flaes. Amsterdam: Het Spinhuis.

Chambers, Frank, comp. 1988. *Hayden and His Men: Being a Selection of 108 Photographs by William Henry Jackson of the United States Geological and Geographical Survey of the Territories for the Years 1870–1878, Ferdinand V. Hayden, Geologist in Charge*. New York: Francis Paul Geoscience Literature.

Champagne, Duane. 1999. *Contemporary Native American Cultural Issues*. Walnut Creek, Calif.: Altamira.

Child, Brenda. 1998. *Boarding School Seasons: American Indian Families, 1900–1940*. Lincoln: University of Nebraska Press.

Child, Brenda, and K. Tsianina Lomawaima. 2000. *Away from Home: American Indian Boarding School Experiences 1879–2000*. Phoenix, Ariz.: Heard Museum.

Churchill, Ward. 2004. *Kill the Indian, Save the Man: The Genocidal Impact of American Indian Residential Schools*. San Francisco: City Lights.

Clavir, Miriam. 2002. *Preserving What Is Valued: Museums, Conservation, and First Nations*. Vancouver: UBC Press.

Clerici, Naila, ed. 1993. *Victorian Brand, Indian Brand: The White Shadow on the Native Image*. Torino: Il Segnalibro.

Clifford, James. 1989. "The Others: Beyond the 'Salvage' Paradigm. *Third Text* 3 (6): 73–78.

———. 1991. "Four Northwest Coast Museums: Travel Reflections." In *Exhibiting Cultures: The Poetics and Politics of Museum Display*, edited by Ivan Karp and Steven Lavine. Washington D.C.: Smithsonian Institution Press.

———. 1997. "Museums as Contact Zones." In *Routes: Travel and Translation in the Late Twentieth Century*. Cambridge, Mass.: Harvard University Press.

———. 2001. "Indigenous Articulations." *Contemporary Pacific* 13 (2): 468–90.

———. 2004. "Looking Several Ways: Anthropology and Native Heritage in Alaska." *Current Anthropology* 45 (1) (February): 5–30.

Coates, Ken. 1991. *Best Left as Indians: Native-White Relations in Yukon Territory, 1840–1873*. Quebec City: McGill-Queen's University Press.

Coates, Ken, and William Morrison. 1992. *The Alaska Highway in World War II: The U.S. Army of Occupation in Canada's Northwest*. Norman: University of Oklahoma Press.

Cobb, Josephine. 1958. "Alexander Gardner." *Image* 7 (6): 124–36.

Coe, Brian, and Paul Gates. 1977. *The Snapshot Photograph: The Rise of Popular Photography 1888–1939*. London: Ash and Grant.

Cole, Catherine. 2001. *Ghana's Concert Party Theatre*. Bloomington: Indiana University Press.

Cole, Douglas. 1995. *Captured Heritage: The Scramble for Northwest Coast Artifacts*. Seattle: University of Washington Press.

Coleman, A. D. 1998. "Edward Curtis: Photographer as Ethnographer." In *Depth of Field: Essays on Photography, Media, and Lens Culture*, edited by A. D. Coleman, 133–58. Albuquerque: University of New Mexico Press.

Coleman, Michael C. 1993. *American Indian Children at School, 1850–1930*. Jackson: University Press of Mississippi.

Collier, John, Jr., and Malcolm Collier. 1986. *Visual Anthropology: Photography as Research Method*. Albuquerque: University of New Mexico Press.

Conn, Steven. 2004. *History's Shadow: Native Americans and Historical Consciousness in the Nineteenth Century*. Chicago: University of Chicago Press.

Cooper, Karen. 2008. *Spirited Encounters: American Indians Protest Museum Policies and Practices*. Lanham, Md.: AltaMira Press.

Cooper, Karen, and Nicolasa Sandoval. 2006. *Living Homes for Cultural Expression: North American Native Perspectives on Creating Community Museums*. Washington D.C.: Smithsonian Institution.

Cooper, Michael. 1999. *Indian School: Teaching the White Man's Way*. New York: Clarion.

Crane, Leo. 1925. *Indians of the Enchanted Desert*. Boston: Little, Brown.

Cronin, J. Keri. 2000. "Changing Perspectives: Photography and First Nations Identity." M.A. thesis, Queen's University.

Cruikshank, Julie, and Jim Robb. 1975. *Their Own Yukon: A Photographic History by Yukon Indian People*. Whitehorse: Yukon Native Brotherhood.

Curtis, Edward S. 1907–1930. *The North American Indian*. 20 vols. Edited by Frederick Webb Hodge. Cambridge, Mass: The University Press.

———. 2001. *The Plains Indians Photographs of Edward S. Curtis*. Lincoln: University of Nebraska.

Dangeli, Mique'l. 2015. "Bringing to Light a Counternarrative of Our History: B. A. Haldane, Nineteenth-Century Tsimshian Photographer." In *Sharing Our Knowledge: The Tlingit and Their Coastal Neighbors,* edited by Sergei Kan and Steve Henrikson, 265–93. Lincoln: University of Nebraska Press.

———. 2017. "Dancing Our Archive: Bringing to Life B. A. Haldane's Photography." In *Native Art Now!* edited by Veronica Passalacqua and Kate Morris, 262–83. Indianapolis: Eiteljorg Museum of American Indians and Western Art.

Daniels, Valerie. 2002. "The Outsider and the Native Eye: The Photographs of Richard Throssel." http://xroads.virginia.edu/~MA02/daniels/curtis/throssel/vanishing.html.

Darnell, Regna, et al., eds. 2015. *The Franz Boas Papers,* Vol. 1: *Franz Boas as Public Intellectual-Theory, Ethnography, Activism*. Lincoln: University of Nebraska.

Dauenhauer, Nora, and Richard Dauenhauer, eds. 1994. *Haa Kusteeyí: Tlingit Life Stories*. Seattle: University of Washington Press.

Davis, Barbara. 1985. *Edward S. Curtis: The Life and Times of a Shadow Catcher*. San Francisco: Chronicle Books.

Davis, George T. B. 1904. *Metlakahtla: A True Narrative of the Red Man*. Chicago: Ram's Horn.

Davis, Janet M. 2002. *The Circus Age: Culture and Society under the American Big Top*. Chapel Hill: University of North Carolina Press.

Davis, Lynn. 1980. *Na Pa'i Ki'i: The Photographers in the Hawaiian Islands, 1845–1900*. Honolulu: Bishop Museum Press.

Dean, Jonathan. 1998. "Louis Shotridge, Museum Man: A 1918 Visit to the Nass and Skeena Rivers." *Pacific Northwest Quarterly* 89 (4): 202–10.

De Danaan, Llyn. 2013. *Katie Gale: A Coast Salish Woman's Life on Oyster Bay*. Lincoln: University of Nebraska Press.

De Laguna, Frederica. 1960. "The Story of a Tlingit Community: A Problem in the Relationship between Archeological, Ethnological, and Historical Methods." *Bulletin of the Smithsonian Institution Bureau of American Ethnology* 172.

———. 1978. "Tlingit." *Handbook of North American Indians,* Vol. 7: *Northwest Coast*. Edited by William Sturtevant and Wayne Suttles, 203–28. Washington D.C.: Smithsonian Institution.

Delaney, Michelle. 2007. *Buffalo Bill's Wild West Warriors: A Photographic History by Gertrude Käsebier*. Washington D.C.: Smithsonian National Museum of American History.

Deloria, Philip. 1998. *Playing Indian*. New Haven, Conn.: Yale University Press.

———. 2004. *Indians in Unexpected Places*. Lawrence, Kans.: University Press of Kansas.

Deloria, Vine, Jr. 1982. "Introduction." In *The Vanishing Race and Other Illusions: Photographs of Indians by Edward S. Curtis,* by Christopher Lyman. Washington D.C.: Smithsonian Institution Press.

———. 2001. "Traditional Technology." In *Power and Place: Indian Education in America*, by Vine Deloria Jr. and Daniel Wildcat. Golden, Colo.: Fulcrum.

Denetdale, Jennifer Nez. 2007. *Reclaiming Dine History: The Legacies of Navajo Chief Manuelito and Juanita*. Tucson: University of Arizona Press.

De Oca, Jeffrey Montez, and Jose Prado. 2014. "Visualizing Humanitarian Colonialism: Photographs from the Thomas Indian School." *American Behavioral Scientist* 58 (1): 145–70.

Didi-Huberman, Georges. 2003. *Invention of Hysteria: Charcot and the Photographic Iconography of the Salpêtrière*. Cambridge: MIT Press.

Dilworth, Leah. 1996. *Imagining Indians in the Southwest.* Washington, D.C.: Smithsonian Institution.

Dippie, Brian. 1992a. "Representing the Other: The North American Indian." In *Anthropology and Photography, 1860–1920,* edited by Elizabeth Edwards, 132–36. New Haven, Conn.: Yale University Press.

———. 1992b. "Photographic Allegories and Indian Destiny." *Montana: The Magazine of Western History* 42 (3): 40–57.

Dixon, Joseph Kossuth. 1913. *The Vanishing Race: The Last Great Indian Council.* Garden City, N.Y.: Doubleday, Page.

Doe, Wesley. 1971. "Rapid Transit in the Bush." *Alaska: Magazine of Life on the Last Frontier,* November, 29.

Doty, C. Stewart, et al. 2002. *Photographing Navajos: John Collier Jr. on the Reservation, 1948–1953.* Albuquerque: University of New Mexico Press.

Driskill, Qwo-Li. 2008. "Yelesalehe Hiwayona Dikanohogida Naiwodusv/God Taught Me This Song, It Is Beautiful: Cherokee Performance Rhetorics as Decolonization, Healing, and Continuance." Ph.D. diss., Michigan State University.

Dubin, Margaret. 1999. "Review Article: Native American Imagemaking and the Spurious Canon of the 'of and by.'" *Visual Anthropology Review* 15 (1): 70–74.

Durham, Roger. 2009. *Carlisle Barracks.* Mount Pleasant, S.C.: Arcadia.

Earenfight, Phillip, ed. 2004. *Visualizing a Mission: Artifacts and Imagery of the Carlisle Indian School, 1879–1918.* Exhibition catalogue, Trout Gallery (January 30–February 28, 2004). Carlisle, Penn.: Dickinson College.

Eastman Kodak Company. 1997. *History of Kodak Cameras.* Rochester, N.Y.: Eastman Kodak.

Edwards, Elizabeth. 1990. "Photographic 'Types': The Pursuit of Method." *Visual Anthropology* 3 (2–3): 235–58.

———, ed. 1992. *Anthropology and Photography, 1860–1920.* New Haven, Conn.: Yale University Press.

———. 2001. *Raw Histories: Photographs, Anthropology and Museums.* Oxford: Berg.

———. 2002. "Material Beings: Objecthood and Ethnographic Photographs." *Visual Studies* 17 (1): 67–75.

———. 2005. "Photographs and the Sounds of History." *Visual Anthropology Review* 21 (1): 27–46.

———. 2009. "Photography and the Material Performance of the Past." *History and Theory* 42 (December): 130–50.

———. 2012. *The Camera as Historian: Amateur Photographers and Historical Imagination, 1885–1918.* Durham, N.C.: Duke University Press.

Edwards, Elizabeth, Chris Gosden, and Ruth B. Philips, eds. 2006. *Sensible Objects: Colonialism, Museums and Material Culture.* New York: Berg.

Edwards, Elizabeth, and Janice Hart, eds. 2004. *Photographs Objects Histories: On the Materiality of Images.* London: Routledge.

Egan, Shannon. 2006. "Yet in a Primitive Condition: Edward S. Curtis's North American Indian." *American Art* 20 (3): 58–83.

Egan, Timothy. 2012. *Short Nights of the Shadow Catcher: The Epic Life and Immortal Photographs of Edward Curtis.* Boston: Houghton Mifflin Harcourt.

Eicher, Joanne. 1995. *Dress and Ethnicity: Change across Space and Time.* Oxford: Berg.

Eiteljorg Museum. 2003. *Path Breakers: The Eiteljorg Fellowship for Native American Fine Art, 2003.* Introduction by Lucy Lippard. Indianapolis, Ind.: Eiteljorg Museum of American Indians and Western Art.

Eldredge, Charles, Julie Schimmel, and William Truettner. 1986. *Art in New Mexico 1900–1945: Paths to Taos and Santa Fe.* New York: Abbeville Press.

Ellinghaus, Katherine. 2017. *Blood Will Tell: Native Americans and Assimilation Policy.* Lincoln: University of Nebraska Press.

Ellis, Clyde. 1996. *To Change Them Forever: Indian Education at the Rainy Mountain Boarding School, 1893–1920.* Norman: University of Oklahoma Press.

———. 2006. "'We Had a Lot of Fun, but of Course, That Wasn't the School Part': Life at the Rainy Mountain Boarding School, 1893–1920." In *Boarding School Blues: Revisiting American Indian Educational Experiences,* edited by Clifford Trafzer et al. Lincoln: University of Nebraska Press.

Emmons, George Thornton. 1914. "Portraiture among the North Pacific Coast Tribes." *American Anthropologist* 16 (1): 59–67.

———. 1991. *The Tlingit Indians.* Edited by Frederica de Laguna. Seattle: University of Washington Press.

Enge, Marliee. 1993. "Collecting the Past: Tlingit Nobleman Louis Shotridge, Son of a Keeper of the Whale House, Becomes a Scholar of His People—and a Controversial Collector." *Whale House Series* in the *Anchorage Daily News,* April 7. http://www.ankn.uaf.edu/curriculum/Tlingit/WhaleHouse/part3.html.

Euler, Robert. 1966. *Southern Paiute Ethnohistory.* Salt Lake City: University of Utah.

Evans, Brad, and Aaron Glass. 2014. *Return to the Land of the Head Hunters: Edward S. Curtis, the Kwakwaka'wakw and the Making of Modern Cinema.* Seattle: University of Washington Press.

Evans, Walker. (1931) 1980. "The Reappearance of Photography." In *Classic Essays on Photography,* edited by Alan Trachtenberg. New Haven, Conn.: Leete's Island.

Ewers, John. 1947. "An Anthropologist Looks at Early Pictures of North American Indians." *New York Historical Society Quarterly* 31 (1): 223–34.

———. 1964. "The Emergence of the Plains Indian as the Symbol of the North American Indian." In *Annual Report of the Board of Regents of the Smithsonian Institution,* 531–44. Washington, D.C.: Smithsonian Institution.

Faris, James. 1996. *Navajo and Photography: A Critical History of the Representation of an American People.* Albuquerque: University of New Mexico Press.

Farley, Corey. 1983. "Photos Reflect Early Years in Reno Indian Colony," *Reno Gazette-Journal,* May 6, E6.

Farr, William. 1984. *The Reservation Blackfeet, 1882–1945: A Photographic History of Cultural Survival.* Seattle: University of Washington Press.

Fiddick, Thomas. 1995. "Noble Savages, Savage Nobles: Revolutionary Implications of European Images of Amerindians." In *Issues in Native American Cultural Identity,* edited by Michael K. Green. New York: Peter Lang.

Fisher, Jean. 1992. "In Search of the 'Inauthentic': Disturbing Signs in Contemporary Native American Art." *Art Journal* 51 (3): 44–50.

Fixico, Donald. 1997. *Rethinking American Indian History.* Albuquerque: University of New Mexico Press.

Fleckner, John. 1984. *Native American Archives: An Introduction.* Chicago: Society of American Archivists.

Fleming, Paula Richardson. 2000. "An 'Accumulation' of Native American Portraits." *History of Photography* 24 (1): 57–58.

———. 2003. *Native American Photography at the Smithsonian: The Shindler Catalogue.* Washington D.C.: Smithsonian Institution.

Fleming, Paula Richardson, and Judith Luskey. 1986. *The North American Indians: In Early Photographs.* New York: Dorset Press.

———. 1993a. *Grand Endeavors of Great American Indian Photographs.* Washington D.C.: Smithsonian Institution.

———. 1993b. *The Shadow Catchers: Images of the American Indian*. London: Laurence King.

Foote, Amanda. 2010. "Fishing for Tourists: Cultural Tourism and Its Origins in Teslin, Yukon Territory, Canada." M.A. thesis, University of Alaska.

Ford, Colin, ed. 1989. *The Kodak Museum: The Story of Popular Photography*. London: Century Hutchinson; National Museum of Photography, Film and Television.

Foreman, Grant. 1934. "A Century of Prohibition." *Chronicles of Oklahoma* 12 (2): 133–41.

Foucault, Michel. 2008. *The Birth of Biopolitics*. New York: Palgrave Macmillan.

Fowler, Don. 1989. *The Western Photographs of John K. Hillers*. Washington D.C.: Smithsonian Institution Press.

Frank, L., and Kim Hogeland. 2007. *First Families: Photographic History of California Indians*. Berkeley, Calif.: Heyday.

Fryxell, Fritiof. 1939. "William H. Jackson, Photographer, Artist, Explorer." *American Annual of Photography* 33: 208–20.

Furgeson, Elizabeth. 1907. "The Cherokee: A Retrospective Glance." *Home Mission Monthly* 21 (4): 88.

Garfield, Viola. 1939. "Tsimshian Clan and Society." Ph.D. diss., University of Washington.

Garroutte, Eva Marie. 2003. *Real Indians: Identity and the Survival of Native America*. Berkeley: University of California Press.

Geddes, Carol. 1997. *Picturing a People: George Johnston, Tlingit Photographer*. Video (VHS). Montreal: National Film Board of Canada.

———. 2003. "The Use of Film as a Vehicle for Traditional Storytelling Forms." *Artic Anthropology* 40 (2): 65–69.

Geismar, Haidy. 2013. *Treasured Possessions: Indigenous Interventions into Cultural and Intellectual Property*. Durham, N.C.: Duke University Press.

Geronimo. 1915. *Geronimo's Story of His Life*. Edited by S. M. Barrett. New York: Duffield.

Gidley, Mick. 1992. *Representing Others: White Views of Indigenous Peoples*. Exeter: University of Exeter Press.

———. 1994. "Three Cultural Brokers in the Context of Edward S. Curtis' *The North American Indian*." In *Between Indian and White Worlds: The Cultural Broker*, edited by Margaret Connell Szasz, 197–215. Norman: University of Oklahoma Press.

———. 1998. *Edward S. Curtis and the North American Indian, Incorporated*. Cambridge: Cambridge University Press.

———. 2000. "Reflecting Cultural Identity in Modern American Indian Photography." In *Mirror Writing: (Re-)Constructions of Native American Identity*, edited by Thomas Claviez and Maria Moss. Berlin: Galda and Wilch Verlag.

———. 2003a. *Edward S. Curtis and the North American Indian Project in the Field*. Lincoln: University of Nebraska Press.

———. 2003b."Photography by Native Americans: Creation and Revision." In *Representing Realities: Essays on American Literature, Art and Culture*, edited by Beverly Maeder, 107–27. Tübingen: Gunter Narr.

———, ed. 2010. *Writing with Light: Words and Photographs in American Texts*. Oxford: Peter Lang.

Glass, Aaron. 2009. "A Cannibal in the Archive: Performance, Materiality, and (In)visibility in Unpublished Edward Curtis Photographs of the Hamat'sa." *Visual Anthropology Review* 25 (2): 128–49.

Glenn, James. 1983. "De Lancey W. Gill: Photographer for the Bureau of American Ethnology." *History of Photography* 7 (1): 7–21.

Gmlech, Sharon Bohn. 2008. *The Tlingit Encounter with Photography*. Philadelphia: University of Pennsylvania Museum of Archaeology and Anthropology.

Goetzmann, William. 1991. *The First Americans: Photographs from the Library of Congress*. Washington D.C.: Starwood.

Gold, Peter. 1983. "Returning Photographs to the Indians." *Studies in Visual Communication* 9 (5): 2–14.

Goldchain, Rafael. 2008. *I Am My Family: Photographic Memories and Fictions*. With an essay by Martha Langford. New York: Princeton Architectural Press.

Good, Mary Elizabeth. 1961. "It Was Indian Country: Old Photos by the Late Jennie Ross Cobb." *Tulsa World News*, January 19, 6.

Goodman, Audrey. 2002. "A Little History of Southwestern Photography." *Translating Southwestern Landscapes: The Making of an Anglo Literary Region*. Tucson: University of Arizona Press.

Goodyear, Frank H., III. 2003. *Red Cloud: Photographs of a Lakota Chief*. Lincoln: University of Nebraska Press.

———. 2009. *Faces of the Frontier: Photographic Portraits from the American West, 1845–1924*. Norman: University of Oklahoma Press.

Gordon, Deborah. 1993. "Among Women: Gender and Ethnographic Authority of the Southwest, 1930–1980." In *Hidden Scholars: Women Anthropologists and the Native American Southwest*, edited by Nancy Parezo. Albuquerque: University of New Mexico Press.

Gover, C. Jane. 1988. *The Positive Image: Women Photographers in Turn of the Century America*. Albany: State University of New York Press.

Grafe, Stephen. 2006. *Peoples of the Plateau: The Indian Photographs of Lee Moorhouse, 1898–1915*. Norman: University of Oklahoma Press.

———. 2009. *Lanterns on the Prairie: The Blackfeet Photographs of Walter McClintock*. Norman: University of Oklahoma Press.

Graulich, Melody. 2003. "'I Became the Colony': Kate Cory's Hopi Photographs." In *Trading Gazes: Euro-American Women Photographers and Native North Americans, 1880–1940*, by Susan Bernardin et al. New Brunswick, N.J.: Rutgers University Press.

Graves, Laura. 1998. *Thomas Varker Keam, Indian Trader*. Norman: University of Oklahoma Press.

Green, Rayna. 1974. "The Pocahontas Perplex: The Image of Indian Women in American Culture." *Massachusetts Review* 16 (4): 698–714.

———. 1992a. "Repatriating Images: Indians and Photography." *Rendezvous: Idaho State University Journal of Arts and Letters* 28 (1–2): 151–60.

———. 1992b. *Women in American Indian Society*. New York: Chelsea House.

———. 2000. "Gertrude Käsebier's 'Indian' Portraits." *History of Photography* 24 (1): 58–60.

Grier, Katherine. 1992. "The Decline of the Memory Place: The Parlor after 1890." In *American Home Life, 1880–1930: A Social History of Spaces and Services*, edited by Jessica Foy and Thomas Schlereth. Knoxville: University of Tennessee Press.

Grinnel, George. 1905. "Portraits of Indian Types." *Scribner's Magazine* 37 (3): 258–73.

Grover, Katherine. 1992. *Hard at Play: Leisure in America, 1840–1940*. Amherst: University of Massachusetts Press.

Gruber, Jacob. 1970. "Ethnographic Salvage and the Shaping of Anthropology." *American Anthropologist*. 72 (6): 1289–99.

Hackler, Rhoda. 1988. "'My Dear Friend': Letters of Queen Victoria and Queen Emma." *Hawaiian Journal of History* 22: 114.

Hafen, P. Jane, ed. 1998. "A Cultural Duet: Zitkala-Ša and the Sun Dance Opera. *Great Plains Quarterly* 18 (2): 102–11.

———. 2001. *Dreams and Thunder: Stories, Poems, and the Sun Dance Opera*, by Zitkala-Ša. Lincoln: University of Nebraska Press.

Haines, Robert. 1982. *Carl Moon: Photographer and Illustrator of the American Southwest*. San Francisco, Calif.: Argonaut Book Shop.

Halpin, Marjorie. 1990. *Our Chiefs and Elders: Photographs by David Neel, Kwagiutl.* Exhibition Catalogue, UBC Museum of Anthropology. Vancouver: University of British Columbia.

Hanson, William F. 1967. *Sun Dance Land.* Provo, Utah: J. Grant Stevenson.

Harlan, Theresa. 1993. "Message Carriers: Native Photographic Messages." *Views: The Journal of Photography in New England* 13–14 (Winter): 3–7.

———. 1994. *Watchful Eyes: Native American Women Artists.* Phoenix, Ariz.: Heard Museum.

———. 1995. "Creating a Visual History: A Question of Ownership." *Aperture Magazine* 139 (Spring): 20–32.

———. 1998. "Indigenous Photographies: A Space for Indigenous Realities." In *Native Nations: Journeys in American Photography*, edited by Jane Alison. London: Barbican Art Gallery.

———. 1999. "Adjusting the Focus for an Indigenous Presence." In *Overexposed: Essays on Contemporary Photography.* New York: New Press.

———. 2001. "Visual Visitations: Connecting Past and Present Photographic Realities." *Re-Imagining the West: A New History*, special issue of *Camerawork: A Journal of Photographic Arts* 28 (1): 10–13.

Harmon, Alexandra. 2010. *Rich Indians: Native People and the Problem of Wealth in American History.* Chapel Hill: University of North Carolina Press.

Harper, Douglas. 2002. "Talking about Pictures: A Case for Photo Elicitation." *Visual Studies* 17 (1): 13–26.

Harrell, Thomas. 1995. *William Henry Jackson: An Annotated Bibliography, 1862–1995.* Nevada City, Nev.: Carl Mautz.

Hartmann, Sadakichi. 1978. *The Valiant Knights of Daguerre: Selected Critical Essays on Photography and Profiles of Photographic Pioneers.* Edited by Harold Lawton. Berkeley: University of California Press.

———. 1991. *Critical Modernist: Collected Art Writings.* Edited by Jane Calhoun Weaver. Berkeley: University of California Press.

Hausman, Gerald, et al. 2009. *The Image Taker: The Selected Stories and Photographs of Edwards S. Curtis.* Bloomington, Ind.: World Wisdom.

Hayden, Ferdinand V. 1877. *Ninth Annual Report of the United States Geological and Geographical Survey of the Territories for the Year 1875.* Washington, D.C.: Government Printing Office.

"The Hayden Survey." 1875. *New York Times,* March 27, 1.

Heiferman, Marvin. 2008. *Now Is Then: Snapshots from the Maresca Collection.* New York: Princeton Architectural Press.

Hendry, Joy. 2005. *Reclaiming Culture: Indigenous People and Self-Representation.* New York: Palgrave Macmillan.

Hiesinger, Ulrich. 1994. *Indian Lives: A Photographic Record from the Civil War to Wounded Knee.* Munch: Prestel.

Hight, Eleanor, and Gary Sampson. 2002. *Colonialist Photography: Imag(in)ing Race and Place.* London: Routledge.

Hill, Richard W., Sr. 1986. *NIIPA Portrayals: Photography by Native Indian/Inuit People.* Hamilton, Ontario: Native Indian/Inuit Photographers' Association.

———. 1990. "Photography's Next Era." *Center Quarterly* 11 (2): 24–26.

Hillers, John. 1972. *'Photographed All the Best Scenery': Jack Hillers's Diary of the Powell Expeditions, 1871–1875.* Edited by Don Fowler. Salt Lake City: University of Utah Press.

Hirschfelder, Arlene. 2000. *Native Americans: A History in Pictures.* New York: Dorling Kindersley.

Hoelscher, Steven. 2008. *Picturing Indians: Photographic Encounters and Tourist Fantasies in H. H. Bennett's Wisconsin Dells.* Madison: University of Wisconsin Press.

Holm, Bill, and George Quimby. 1980. *Edward S. Curtis in the Land of the War Canoes: A Pioneer Cinematographer in the Pacific Northwest.* Seattle: University of Washington Press.

Holman, Nigel. 1996a. "Curating and Controlling Zuni Photographic Images." *Curator* 39 (2) (June): 108–22.

———. 1996b. "Photography as Social and Economic Exchange: Understanding the Challenges Posed by Photography of Zuni Religious Ceremonies." *American Indian Culture and Research Journal* 20 (3): 93–109.

Horace Poolaw Photography Project. 2008. *The Poolaw Photography Project*. Chickasha, Okla.: Smith College and the University of Science and Arts in Oklahoma.

Horse Capture, George. 1977. "The Camera Eye of Sumner Matteson and the People Who Fooled Them All." *Montana: The Magazine of Western History* 27 (3): 58–71.

———. 1993. "Forward." In *Native Nations: First Americas as Seen by Edward S. Curtis*. Edited by Christopher Cardozo. Boston: Little Brown.

Horse Capture, George, Duane Champagne, and Chandler Jackson. 2007. *American Indian Nations: Yesterday, Today, and Tomorrow*. Lanham, Md.: AltaMira Press.

Horne, Ester Burnett, and Sally McBeth. 1998. *Essie's Story: The Life and Legacy of a Shoshone Teacher*. Lincoln: University of Nebraska Press.

Hoxie, Frederick. 1984. *A Final Promise: The Campaign to Assimilate the Indians, 1880–1920*. Lincoln: University of Nebraska Press.

Hubbard, Jim. 1994. *Shooting Back from the Reservation: A Photographic View of Life by Native American Youth*. New York: New Press.

Hubert, Henri, and Marcel Mauss. 1899 [1964]. *Sacrifice: Its Nature and Function*. Translated by W. D. Halls. Chicago: Unversity of Chicago Press.

Huff, Delores. 1997. *To Live Heroically: Institutional Racism and American Indian Education*. Albany: State University of New York Press.

Huhndorf, Shari. 2001. *Going Native: Indians in the American Cultural Imagination*. Ithaca: Cornell University Press.

Hungry Wolf, Beverly. 1980. *The Ways of My Grandmothers*. New York: Morrow.

Hunt, George. 1930. "I Desired to Learn the Ways of the Shaman." In Franz Boas, *The Religion of the Kwakiutl Indians,* part 2, *Translations*, 1–41. New York: Columbia University Press.

Hutchinson, Elizabeth. 2000. "Native American Identity in the Making: Gertrude Käsebier's 'Girl with the Violin.'" *Exposure* 33 (1): 21–32.

———. 2009. *The Indian Craze: Primitivism, Modernism, and Transculturation in American Art, 1890–1915*. Durham, N.C.: Duke University Press.

Image and Self in Contemporary Native American Photoart. 1995. Exhibition catalogue. Hanover, N.H.: Hood Museum of Art; Dartmouth College.

"Indian Woman in Capital to Fight Growing Use of Peyote Drug—Mrs. Gertrude Bonnin, Carlisle Graduate, Relative of Sitting Bull, Describes Effects of Mind Poison." 1918. *Washington Times*, February 17.

Ingersoll, Thomas. 2005. *To Intermix with Our White Brothers: Indian Mixed Bloods in the United States*. Albuquerque: University of New Mexico Press.

Isaac, Gwyneira. 2007. *Mediating Knowledges: Origins of a Zuni Tribal Museum*. Tucson: University of Arizona Press.

Jacknis, Ira. 1990. "James Mooney, Ethnographic Photographer." *Visual Anthropology* 3 (2–3): 179–212.

———. 1991. "George Hunt, Collector of Indian Specimens." *Chiefly Feasts: The Enduring Kwakwaka'wakw Potlatch*, edited by Aldona Jonaitis. Seattle: University of Washington Press.

———. 1992. "George Hunt, Kwakiutl Photographer." In *Anthropology and Photography, 1860–1920*, edited by Elizabeth Edwards. New Haven, Conn.: Yale University Press.

———. 1996. "Preface to *The Shadowcatcher*: The Uses of Native American Photography." *American Indian Culture and Research Journal* 20 (3): 1–14.

———. 2002. *The Storage Box of Tradition: Kwakiutl Art, Anthropologists, and Museums, 1881–1981*. Washington, D.C.: Smithsonian Institution Press.

———. 2005. "New Questions for Old Images: Recent Contributions to the History of Photography of Native Americans." *Current Anthropology* 46 (3): 491–92.

Jackson, Clarence. 1947. *Picturemaker of the Old West: William H. Jackson*. New York: Charles Scribner's Sons.

Jackson, Peter. 1992. "Constructions of Culture, Representations of Race: Edward Curtis's 'Way of Seeing.'" In *Inventing Places: Studies in Cultural Geography*, edited by Kay Anderson and Fay Gale. Melbourne: Wiley.

Jackson, William H. 1875. *Descriptive Catalog of the Photographs of the United States Geological Survey of the Territories for the Years 1869 to 1875 Inclusive*. 2 ed. Washington, D.C.: Government Printing Office.

———. 1877. *Descriptive Catalogue of Photographs of North American Indians*. Washington, D.C.: Government Printing Office.

———. 1959. *The Diaries of William Henry Jackson*. Edited by LeRoy Hafen. Glendale, Calif.: Arthur H. Clark.

Jacobs, David. 1981. "Domestic Snapshots: Toward a Grammar of Motives." *Journal of American Culture* 4 (1): 93–105.

James, Daniel, and Mirta Zaida Lobato. 2004. "Family Photos, Oral Narratives, and Identity Formation: The Ukrainians of Berisso." *Hispanic American Historical Review* 84 (1): 5–36.

James, George Wharton. 1902. "The Snake Dance of the Hopis." *Camera Craft* 6 (1): 3–10.

———. 1903. *Indians of the Painted Desert Region: Hopis, Navahoes, Wallapais, Havasupais*. Boston: Little, Brown.

Jenkins, David. 1993. "The Visual Domination of the American Indian: Photography, Anthropology, and Popular Culture in the Late Nineteenth Century." *Museum Anthropology* 17 (1): 9–21.

Jensen, Joan M. 1998. "Native American Women as Storytellers." *Women Artists of the American West*. https://www.cla.purdue.edu/WAAW/Jensen/NAW.html.

Jerman, Hadley E. 2009. "Kiowa America: Photographic Portraits by Horace Poolaw, 1925–1955." M.A. thesis, University of Oklahoma.

———. 2011. "Acting for the Camera: Horace Poolaw's Film Stills of Family, 1925–1950." *Great Plains Quarterly* 31 (2): 105–23.

Jessup, Lynda, and Shannon Bagg, eds. 2002. *On Aboriginal Representation in the Gallery*. Quebec: Canadian Museum of Civilization.

Johnson, Josh. 2005. "Rare Photos of Fallon Tribe Unveiled Saturday." *Lahontan Valley News*, May 6, n.p.

Johnson, Tim, ed. 1998. *Spirit Capture: Photographs from the National Museum of the American Indian*. Washington D.C.: Smithsonian Institution Press.

Johnston, Carolyn. 2003. *Cherokee Women in Crisis: Trail of Tears, Civil War, and Allotment, 1838–1907*. Tuscaloosa: University of Alabama Press.

Johnston, Patricia. 1978. "The Indian Photographs of Roland Reed." *American West* 15 (2): 44–57.

Jonaitis, Aldona. 1986. *Art of the Northern Tlingit*. Seattle: University of Washington Press.

———. 1999. *The Yuquot Whalers' Shrine*. Seattle: University of Washington Press.

———. 2002. "First Nations and Art Museums." In *On Aboriginal Representation in the Gallery*, edited by Lynda Jessup and Shannon Bagg. Quebec: Canadian Museum of Civilization.

———. 2006. "Smoked Fish and Fermented Oil: Taste and Smell among the Kwakwaka'wakw." In *Sensible Objects: Colonialism, Museums, and Material Culture*, edited by Elizabeth Edwards et al. Oxford: Berg.

Jones, Zachary. 2015. "Images of the Surreal: Contrived Photographs of Native American Indians in Archives and Suggested Best Practices." *Journal of Western Archives* 6 (1): 1–18.

Kan, Sergei. 2013. *A Russian American Photographer in Tlingit Country: Vincent Soboleff in Alaska*. Norman: University of Oklahoma Press.

———, ed. 2015. *Sharing Our Knowledge: The Tlingit and Their Coastal Neighbors*. Lincoln: University of Nebraska.

Katakis, Michael, ed. 1998. *Excavating Voices: Listening to Photographs of Native Americans*. Philadelphia: University of Pennsylvania Museum.

Kaufmann, Carole. 1969. "Changes in Haida Indian Argillite Carvings, 1820–1910." Ph.D. diss., University of California–Los Angeles.

Kavanagh, Thomas. 1991. "Whose Village? Photographs by William S. Soule, Winter 1872–1873." *Visual Anthropology* 4 (1): 1–24.

Keegan, M. K. 1990. *Enduring Culture: A Century of Photography of the Southwest Indians*. Santa Fe, N.Mex.: Clear Light.

Keenan, Catherine. 1998. "On the Relationship between Personal Photographs and Individual Memory." *History of Photography* 22 (1): 60–64.

Kelsey, Robin. 2007. *Archive Style: Photographs and Illustrations for U.S. Surveys, 1850–1890*. Berkeley: University of California Press.

Kelsey, Robin, and Blake Stimson, eds. 2008. *The Meaning of Photography*. Williamstown, Mass.: Sterling and Francine Clark Art Institute.

King, J. C. H., and Henrietta Lidchi, eds. 1998. *Imaging the Artic*. Seattle: University of Washington Press.

Kirshenblatt-Gimblett, Barbara. 1998. *Destination Culture: Tourism, Museums, and Heritage*. Berkeley: University of California Press.

Knack, Martha, and Omer C. Stewart. 1984. *As Long as the River Shall Run: An Ethnohistory of Pyramid Lake Indian Reservation*. Berkeley: University of California Press.

Koltun, Lilly, ed. 1984. *Private Realms of Light: Amateur Photography in Canada, 1839–1940*. Ontario: Fitzhenry and Whiteside.

Kopytoff, Igor. 1988. "The Cultural Biography of Things: Commoditization as Process." In *The Social Life of Things: Commodities in Cultural Perspective*, edited by Arjun Appadurai. Cambridge: Cambridge University Press.

Kotchemidova, Christina. 2005. "Why We Say 'Cheese': Producing the Smile in Snapshot Photography." *Critical Studies in Media Communication* 22 (1): 2–25.

Kotkin, Amy. 1978. "The Family Photo Album as a Form of Folklore." *Exposure* 16 (1): 4–8.

Kowalski, Kathe. 1994. *Stand: Four Artists Interpret the Native American Experience: Rebecca Belmore, Hachivi Edgar Heap of Birds, Hulleah Tsinhnahjinnie, Richard Ray (Whitman)*. Erie, Pa.: Erie Art Museum.

Kramer, Jennifer. 2006. *Switchbacks Art, Ownership, and Nuxalk National Identity*. Vancouver: University of British Columbia Press.

Kratz, Corinne. 2002 *The Ones That Are Wanted: Communication and the Politics of Representation in a Photographic Exhibition*. Berkeley: University of California.

Krouse, Susan Applegate. 1987. "Filming the Vanishing Race." In *Visual Explorations of the World*, edited by Martin Taureg and Jay Ruby. Aachen: Rader Verlag.

———. 2006. "Speaking the Album: An Application of the Oral-Photographic Framework." In *Locating Memory: Photographic Acts*, edited by Annette Kuhn and Kirsten Emiko McAllister. New York: Berghahn.

———. 2007. *North American Indians in the Great War*. Lincoln: University of Nebraska.

Lai, Jessica. 2014. *Indigenous Cultural and Intellectual Property Rights*. Cham: Springer.

Langford, Martha. 2001. *Suspended Conversations: The Afterlife of Memory in Photographic Albums*. London: McGill-Queens' University Press.

Langton, Marsha. 1994. "Aboriginal Art and Film: The Politics of Representation." *Race and Class* 35 (4): 89–106.

LaPointe, Ernie. 2009. *Sitting Bull: His Life and Legacy*. Layton, Utah: Gibbs Smith.

Larsen, Jonas. 2005. "Families Seen Sightseeing: Performativity of Tourist Photography." *Space and Culture* 8 (4): 416–34.

Larson, Robert. 1999. *Red Cloud: Warrior-Statesman of the Lakota Sioux*. Norman: University of Oklahoma Press.

Lawlor, Mary. 2006. *Public Native America: Tribal Self-Representations in Museums, Powwows and Casinos*. New Brunswick, N.J.: Rutgers University Press.

"The Leupp Indian Art Studio." 1907. *The Arrow, Publication of the United States Indian School, Carlisle, Pa.* 3 (24): 1–2.

Leuthold, Steven. 1997. "Native American Documentary: An Emerging Genre?" *Film Criticism*. 22 (1): 74–89.

———. 1998. *Indigenous Aesthetics: Native Art, Media, and Identity*. Austin: University of Texas.

———. 1999. "Educational Uses of Native American Historical Films and Videos." *Perspectives: The American Historical Association newsletter* 37 (4): 1–5.

———. 2001. "Rhetorical Dimensions of Native American Documentary." *Wicazo Sa Review* 16 (2): 55–73.

Levi-Strauss, Claude. 1987 [1950]. *Introduction to the Work of Marcel Mauss*. Translated by Felicity Baker. London: Routledge and Kegan Paul.

Levine, Barbara, and Stephanie Snyder. 2006. *Snapshot Chronicles: Inventing the American Photo Album*. New York: Princeton Architectural Press.

Lewandowski, Tadeusz. 2016. *Red Bird, Red Power: The Life and Legacy of Zitkala-Ša*. Norman: University of Oklahoma Press.

Liberty, Margo, ed. 2006. *A Northern Cheyenne Album: Photographs by Thomas B. Marquis*. Norman: University of Oklahoma Press.

Libhart, Myles, and Arthur Amiotte. 1971. *Photographs and Poems by Sioux Children from the Porcupine Day School, Pine Ridge Indian Reservation, South Dakota*. Exhibition organized by Indian Arts and Crafts Board, U.S. Department of the Interior. Rapid City, S.Dak.: Tipi Shop.

Lidchi, Henrietta, and Hulleah Tsinhnahjinnie. 2009. *Visual Currencies: Reflections on Native Photography*. Edinburgh: National Museums Scotland.

"Life Ends for John Leslie. Sage of Squaxin: College Graduate, Ex-Sound Engineer, Admired by All." 1956. *Shelton-Mason County Journal*, April 5, 6.

Lindauer, Owen. 1997. *Not for School, but for Life: Lessons from the Historical Archaeology of the Phoenix Indian School*. Tempe: Arizona State University Office of Cultural Resource Management.

Lindner, Markus. 2001. "Goggles, Family, and the 'Wild West': The Photographs of Sitting Bull." *European Review of Native American Studies* 15 (1): 37–48.

———. 2005. "Family, Politics, and Show Business: The Photographs of Sitting Bull." *North Dakota History* 72 (3): 2–21.

Lippard, Lucy. 1991. "Doubletake: The Diary of a Relationship with an Image." *Third Text* 16/17 (Winter): 135–44.

———, ed. 1992. *Partial Recall: Essays on the Photographs of Native North Americans*. New York: New Press.

———. 1999. "Independent Identities." In *Native American Art in the Twentieth Century*, edited by W. Jackson Rushing, 134–47. New York: Routledge.

Lomawaima, K. Tsianina. 1994. *They Called It Prairie Light: The Story of Chilocco Indian School*. Lincoln: University of Nebraska Press.

Lomawaima, K. Tsianina, and Teresa McCarty. 2006. *To Remain an Indian: Lessons in Democracy from a Century of Native American Education*. New York: Teachers College, Columbia University.

Longo, Donna. 1980. "Photographing the Hopi." *Pacific Discovery Magazine* 33 (3): 11–19.

Lydon, Jane. 2012. *The Flash of Recognition: Photography and the Emergence of Indigenous Rights.* Sydney: University of New South Wales.

Lyman, Christopher. 1982. *The Vanishing Race and Other Illusions: Photographs of Indians by Edward S. Curtis.* Washington D.C.: Smithsonian Institution Press.

Lyon, Luke. 1988. "History of Prohibition of Photography of Southwestern Indian Ceremonies." In *Reflections: Papers on Southwestern Culture History in Honor of Charles H. Lange*, edited by Anne V. Poore. Albuquerque, N.Nex.: Archaeological Society of New Mexico.

MacDonald, Joanne. 1987. "Teslin's First Car." *Shakat Summer Journal.* 2: 13–14.

Mahood, Ruth, ed. 1961. *Photographer of the Southwest: Adam Clark Vroman, 1856–1916.* [Los Angeles]: Ward Ritchie.

Makepeace, Anne. 2000. *Coming to Light: Edward S. Curtis and the American Indians.* Video recording. Reading, Pa.: Bullfrog Films.

———. 2001. *Edward S. Curtis: Coming to Light.* Washington D.C.: National Geographic.

Malmsheimer, Lonna. 1985. "'Imitation White Man': Images of Transformation at the Carlisle Indian School." *Studies in Visual Communication* 11 (4): 54–74.

———. 1987. "Photographic Analysis as Ethnohistory: Interpretive Strategies. *Visual Anthropology* 1 (1): 21–36.

Margolis, Eric. 2000. "Class Pictures: Representations of Race, Gender and Ability in a Century of School Photography." *Education Policy Analysis Archives* 8 (31): 1–27.

———. 2004. Looking at Discipline, Looking at Labour: Photographic Representations of Indian Boarding Schools." *Visual Studies* 19 (1): 72–96.

Margolis, Eric, and Jeremy Rowe. 2004. "Images of Assimilation: Photographs of Indian Schools in Arizona." *History of Education* 33 (2): 199–230.

Maroukis, Thomas C. 2013. "The Peyote Controversy and the Demise of the Society of American Indians." *Studies in American Indian Literatures* 25 (2): 161–80.

Marr, Carolyn. 1989. "Taken Pictures: On Interpreting Native American Photographs of the Southern Northwest Coast." *Pacific Northwest Quarterly* 80 (2): 52–61.

Marvin, Garry. 2010. "Living with Dead Animals? Trophies as Souvenirs of the Hunt." In *Hunting—Philosophy for Everyone: In Search of the Wild Life*, edited by Nathan Kowalsky. Malden: Wiley-Blackwell.

Masayesva, Victor, Jr. 2006. *Husk of Time: The Photographs of Victor Masayesva.* Tucson: University of Arizona Press.

Masayesva, Victor, Jr., and Erin Younger. 1983. *Hopi Photographers, Hopi Images.* Tucson: Sun Tracks and University of Arizona Press.

Mauro, Hayes Peter. 2011. *The Art of Americanization at the Carlisle Indian School.* Albuquerque: University of New Mexico Press

Mauzé, Marie, Michael E. Harkin, and Sergi Kan, eds. 2004. *Coming to Shore: Northwest Coast Ethnology, Traditions, and Visions.* Lincoln: University of Nebraska Press.

Maxwell, Anne. 1999. *Colonial Photography and Exhibitions: Representations of the 'Native' and the Making of European Identities.* London: Leister University Press.

McAndrews, Edward, comp. 1998. *Great Spirit: North American Indian Portraits.* Nevada City, Nev.: Carl Mautz.

———, comp. 2002. *American Indian Photo Post Card Book.* Los Angeles, Calif.: Big Heart.

McClellan, Catherine. 1953. "The Inland Tlingit." In *Asia and North America Transpacific Contacts*, edited by Marian Smith. *Memoirs of the Society for American Anthropology* 9: 47–52.

———. 1954. "The Interrelations of Social Structure with Northern Tlingit Ceremonialism." *Southwestern Journal of Anthropology* 10 (1): 75–96.

———. 1981. "The Inland Tlingit." In *Handbook of North American Indian*, Vol. 6: *Subartic.* Edited by William Sturtevant and June Helm. Washington D.C.: Smithsonian Institution.

———. 1987. *Part of the Land, Part of the Water: A History of the Yukon Indians*. Vancouver: Douglas and McIntyre.

———. 2007. *My Old People's Stories: A Legacy for Yukon First Nations*. Part 3: *Inland Tlingit Narrators*. Whitehorse: Yukon Tourism and Culture.

McClure, Andrew. 1999. "Sarah Winnemucca: [Post]Indian Princess and Voice of the Paiutes." *MELUS* 24 (2): 29–51.

McKenzie, Parker, and John P. Harrington. 1948. *Popular Account of the Kiowa Indian Language*. Sante Fe, N.Mex.: School of American Research.

McLoughlin, William. 1986. *Cherokee Renascence in the New Republic*. Princeton, N.J.: Princeton University Press.

McMaster, Gerald. 1992. "Indigena: A Native Curator's Perspective." *Art Journal* 51 (3): 66–73.

McMaster, Gerald, and Lee-Ann Martin, eds. 1992. *Indigena: Contemporary Native Perspectives*. Quebec: Canadian Museum of Civilization.

McMaster, Gerald, and Clifford Trafzer, eds. 2004. *Native Universe: Voices of Indian America*. Washington D.C.: National Museum of the American Indian; National Geographic.

McRae, William. 1989. "Images of Native Americans in Still Photography." *History of Photography* 13: 321–42.

Meadows, William. 2008. *Kiowa Ethnogeography*. Austin: University of Texas Press.

Meany, Edmond. 1908. "Hunting Indians with a Camera." *World's Work* 15 (5): 104–11.

Michaels, Barbara. 1992. *Gertrude Käsebier: The Photographer and Her Photographs*. New York: Harry N. Abrams.

Mihesuah, Devon. 1993. *Cultivating the Rosebuds: The Education of Women at the Cherokee Female Seminary, 1851–1909*. Urbana: University of Illinois Press.

———. 1996. *American Indians: Stereotypes and Reality*. Atlanta, Ga.: Clarity.

———. 1998. "American Indian Identities: Issues of Individual Choices and Development." *American Indian Culture and Research Journal* 22 (2): 193–226.

Milburn, Maureen E. 1997. "The Politics of Possession: Louis Shotridge and the Tlingit Collections of the University of Pennsylvania Museum." Ph.D. diss., University of British Columbia.

Miles, George. 1992. "To Hear an Old Voice: Rediscovering Native Americans in American History." In *Under an Open Sky: Rethinking America's Western Past*, by William Cronen, George Miles, and Jay Gitlin. New York: W. W. Norton.

Miles, Tiya. 2005. *Ties That Bind: The Story of an Afro-Cherokee Family in Slavery and Freedom*. Berkeley: University of California Press.

Miller, Jay. 1997. *Tsimshian Culture: A Light through the Ages*. Lincoln: University of Nebraska Press.

"Miss Simmons Is Spending Part of Her Vacation in New York City as a Guest of the Artist Mrs. Kasebier." 1898. *Indian Helper* 13 (3): n.p.

Mitchell, Lee Clark. 1981. *Witnesses to a Vanishing Race: The Nineteenth-Century Response*. Princeton, N.J.: Princeton University Press.

Mithlo, Nancy Marie. 2004. "'Red Man's Burden': The Politics of Inclusion in Museum Settings." *American Indian Quarterly* 28 (3/4): 743–63.

———. 2008. *"Our Indian Princess": Subverting the Stereotype*. Santa Fe, N.Mex.: School for Advanced Research.

———, ed. 2014. *For a Love of His People: The Photography of Horace Poolaw*. Washington D.C.: National Museum of the American Indian.

Moeller, Madelyn. 1992. "Ladies of Leisure: Domestic Photography in the Nineteenth Century." In *Hard at Play: Leisure in America, 1840–1940*, edited by Kathryn Grover. Rochester, N.Y.: Strong Museum.

Momaday, N. Scott. 1976. *The Names: A Memoir*. Tucson: University of Arizona Press.

———. 1995. "The Photography of Horace Poolaw." *Aperture* 139: 14–15.

Moore, Sarah. 1995. "No Women's Land: Arizona Adventurers." In *Independent Spirits. Women Painters of the American West, 1890–1945*, edited by Patricia Trenton. Los Angeles: Autry Museum of Western Heritage; Berkeley: University of California Press.

Moreland, William J. 1990/1991. "American Indians and the Right to Privacy: A Psycholegal Investigation of the Unauthorized Publication of Portraits of American Indians." *American Indian Law Review* 15 (2): 237–77.

Morris, Rosalind C. 1994. *New Worlds from Fragments: Film, Ethnography, and the Representation of Northwest Coast Cultures*. Boulder, Colo.: Westview Press.

Morton, Christopher, and Elizabeth Edwards. 2009. *Photography, Anthropology and History: Expanding the Frame*. Burlington, Vt.: Ashgate.

Moses, L. G., and Raymond Wilson, eds. 1985. *Indian Lives: Essays on Nineteenth- and Twentieth-Century Native American Leaders*. Albuquerque: University of New Mexico.

Native Indian/Inuit Photographers' Association. 1986. *Silver Drum: Five Native Photographers—George Johnston, Dorothy Chocolate, Richard Hill, Murray McKenzie, Jolene Rickard*. Hamilton, Ontario: Native Indian/Inuit Photographers' Association.

Newhall, Beaumont. 1982. *The History of Photography from 1839 to the Present*, New York: Museum of Modern Art.

Newhall, Beaumont, and Diana Edkins. 1974. *William H. Jackson*. Fort Worth, Tex.: Amon Carter; Morgan and Morgan.

Northern, Tamara, and Wendi-Starr Brown. 1993. *To Image and to See: Crow Indian Photographs by Edward S. Curtis and Richard Throssel, 1905–1910*. Exhibition Catalogue (July 1–September 5). Hanover: Hood Museum of Art.

Nott, J. C. 1854. *Types of Mankind, or, Ethnological Researches, Based upon the Ancient Monuments, Paintings, Sculptures, and Crania of Races, and upon Their Natural, Geographical, Philological, and Biblical history*. Philadelphia: Lippincott and Grambo.

Oberg, Kalervo. 1973. *The Social Economy of the Tlingit Indians*. Seattle: University of Washington Press.

Oliver, Marc. 2007. "George Eastman's Modern Stone-Age Family: Snapshot Photography and the Brownie." *Technology and Culture* 48 (1): 1–19.

Olson, Wallace. 1991. *The Tlingit: An Introduction to Their Culture and History*. Auke Bay, Alas.: Heritage Research.

Oritz, Simon, ed. 2004. *Beyond the Reach of Time and Change: Native American Reflections on the Frank A. Rinehart Photograph Collection*. Tucson: University of Arizona Press.

Owens, Louis. 2001. *I Hear the Train: Reflections, Inventions, Refractions*. Norman: University of Oklahoma Press.

———. 2003. "Their Shadows before Them: Photographing Indians." Afterword to *Trading Gazes: Euro-American Women Photographers and Native North Americans, 1880–1940*, edited by Susan Bernardin et al. New Brunswick, N.J.: Rutgers University Press.

Paakspuu, Kalli. 2016. "Re-reading the Portrait and the Archive's Social Memory." *Canadian Review of American Studies* 46 (3): 311–38.

Padget, Martin. 2006. *Indian Country: Travels in the American Southwest*. Albuquerque: University of New Mexico Press.

Painter, Nell. 1996. *Sojourner Truth: A Life, A Symbol*. New York: W. W. Norton.

Parham, R. Bruce. 1996. "Benjamin Haldane and the Portraits of a People." *Alaska History* 11 (1): 37–45.

Paterek, Josephine. 1996. *Encyclopedia of American Indian Costume*. New York: W. W. Norton.

Paul, R. Eli. ed. 1997. *Autobiography of Red Cloud: War Leader of Oglalas*. Helena: Montana Historical Society Press.

Payne, Carol, and Andrea Kunard, eds. 2011. *The Cultural Work of Photography in Canada*. Montreal: McGill-Queen's University Press.

Pearlstone, Zena, and Allan Ryan. 2006. *About Face: Self-Portraits by Native American, First Nations and Inuit Artists*. Santa Fe, N.Mex.: Wheelwright Museum of the American Indian.

Pelton, Mary, and Jacqueline DiGennero. 1992. *Images of a People: Tlingit Myths and Legends*. Englewood, Colo.: Libraries Unlimited.

Penny, David, Lisa Ann Seppi, and Nancy Barr, 1994. *Images of Identity: American Indians in Photographs*. Exhibition catalogue. Detroit: Detroit Institute of Arts Founders Society.

Perdue, Theda. 2003. *Mixed Blood Indians: Racial Construction in the Early South*. Athens: University of Georgia Press.

Perdue, Theda, and Michael Green. 2007. *The Cherokee Nation and the Trail of Tears*. New York: Viking.

———. 2008. "Series Preface." In *Bad Fruits of the Civilized Tree: Alcohol and the Sovereignty of the Cherokee Nation*, by Izumi Ishii. Lincoln: University of Nebraska Press.

Peterson, Larry Len. 2005. *L. A. Huffman: Photographer of the American West*. Missoula, Mont.: Mountain Press.

"Picturing Cultures: Historical Photographs in Anthropological Inquiry." 1990. *Visual Anthropology* 3, no. 2.

Pinney, Christopher. 2011. *Photography and Anthropology*. London: Reaktion.

Pinney, Christopher, and Nicholas Peterson, eds. 2003. *Photography's Other Histories*. Durham, N.C.: Duke University Press.

Piquemal, Nathalie. 2001. "Free and Informed Consent in Research Involving Native Americans." *American Indian Culture and Research Journal* 25 (1): 65–79.

Pitt-Rivers, Julian. 1974. *Mana: An Inaugural Lecture*. London: London School of Economics and Political Science.

Poister, Geoffrey. 2001. "Inside vs. Outside Meaning in Family Photographs." *Visual Anthropology* 14 (1): 49–64.

———. 2002. *A Cross-Cultural Study of Family Photographs in India, China, Japan and the United States*. Lewiston, N.Y.: Edwin Mellen Press.

Poolaw, Linda. 1990. *War Bonnets, Tin Lizzies, and Patent Leather Pumps: Kiowa Culture in Transition, 1925–1955: The Photographs of Horace Poolaw*. Exhibition catalogue. Stanford, Calif.: Stanford University.

———. 2014. "For a Love of His People." In *For a Love of His People: The Photography of Horace Poolaw,* edited by Nancy Marie Mithlo, 29–48. Washington D.C.: National Museum of the American Indian.

Poolaw, Thomas. 2011. "Horace Poolaw: Photographer, Mentor, Grandfather." *Great Plains Quarterly* 31 (2): 147–48.

Porter, Joy, ed. 2007. *Place and Native American Indian History and Culture*. Oxford: Lang.

Preucel, Robert. 2015. "Shotridge in Philadelphia: Representing Native Alaskan Peoples to East Coast Audiences." In *Sharing Our Knowledge: The Tlingit and Their Coastal Neighbors*, edited by Sergei Kan, 41–62. Lincoln: University of Nebraska Press.

Racette, Sherry. 2011. "Returning Fire, Pointing the Canon: Aboriginal Photography as Resistance." In *The Cultural Work of Photography in Canada*, edited by Carol Payne and Andrea Kunard, 70–93. Quebec: McGill-Queens University Press.

———. 2018. "'Enclosing Some Snapshots': James Patrick Brady, Photography, and Political Activism." *History of Photography*. 42 (3): 269–87.

Ramirez, Susan Berry Brill de. *Native American Life-History Narratives: Colonial and Postcolonial Navajo Ethnography*. Albuquerque: University of New Mexico Press, 2007.

"Rapid Transit in the Bush." 1971. *Alaska, Magazine of Life on the Last Frontier*, November, 29.

Rappaport, Doreen. 1997. *The Flight of Red Bird: The Life of Zitkala-Ša*. New York: Dial Books.

Reyhner, Jon, and Jeanne Eder. 2004. *American Indian Education: A History*. Norman: University of Oklahoma Press.

Richey, Elinor. 1975. "Sagebrush Princess with a Cause." *American West* 12 (November): 30–33, 57–63.

Rickard, Jolene. 1995. "Sovereignty: A Line in the Sand." In *Strong Hearts: Native American Visions and Voices*, special edition of *Aperture*, edited by Peggy Roalf. New York: Aperture Foundation.

———. 1998. "The Occupation of Indigenous Space as 'Photograph.'" In *Native Nations: Journeys in American Photography*, edited by Jane Alison, 57–71. London: Barbican Art Gallery.

———. 2002. "Indigenous Is the Local." In *On Aboriginal Representation in the Gallery*, edited by Lynda Jessup and Shannon Bagg. Quebec: Canadian Museum of Civilization.

———. 2007. "Absorbing or Obscuring the Absence of a Critical Space in the Americas for Indigeneity: The Smithsonian's National Museum of the American Indian." *Res* 52 (Autumn): 52–92.

Ring, Mildred. 1924. "Kodaking the Indians." *Camera Craft* 31 (2): 72–76.

Roalf, Peggy, ed. 1995. *Strong Hearts: Native American Visions and Voices*. Special edition of *Aperture*. New York: Aperture Foundation.

Robb, Jim. 2005. "Vintage Bush Planes of Yesterday's Yukon." *Whitehorse Star,* August 12.

———. 2011a. "George Johnston Preserved His People's History. *Yukon News*, August 10.

———. 2011b. "Teslin Taxi" *Yukon News*, November 2.

Roberts, Allen F. 2013. *A Dance of Assassins: Performing Early Colonial Hegemony in the Congo*. Bloomington: Indiana University Press.

Robotham, Tom. 1994. *Native Americans in Early Photographs*. San Diego, Calif.: Thunder Bay Press.

Rony, Fatimah Tobing. 1994/1995. "Victor Masayesva, Jr., and the Politics of *Imagining Indians*." *Film Quarterly* 48 (2): 20–33.

Rose, Gillian. 2003. "Family Photographs and Domestic Spacings: A Case Study." *Transactions of the Institute of British Geographers* 28 (1): 5–18.

———. 2008. "Using Photographs as Illustrations in Human Geography." *Journal of Geography in Higher Education* 32 (10): 151–60.

———. 2010. *Doing Family Photography: The Domestic, the Public and the Politics of Sentiment*. Surrey: Ashgate.

Rosier, Paul. 2009. *Serving Their Country: American Indian Politics and Patriotism in the Twentieth Century*. Cambridge, Mass.: Harvard University Press.

Rosoff, Nancy, and Susan Zeller. 2011. *Tipi: Heritage of the Great Plains*. New York: Brooklyn Museum.

Ruby, Jay. 1992. "Speaking for, Speaking about, Speaking with, or Speaking Alongside: An Anthropological and Documentary Dilemma." *Journal of Film and Video* 44 (1–2): 42–66.

———. 2000. *Picturing Culture: Explorations of Film and Anthropology*. Chicago: University of Chicago Press.

Rushing, W. Jackson. 1990. "Native American Subjects: Photography, Narrative, Local History." *Artspace* 15 (November–December): 60–63.

———. 2003. "Native Authorship in Edward Curtis's 'Master Prints.'" *American Indian Art Magazine* 29 (1): 58–63.

Russell, Catherine. 1999. "Playing Primitive." In *Experimental Ethnography: The Work of Film in the Age of Video*. Durham, N.C.: Duke University Press.

Russell, Don. 1960. *The Lives and Legends of Buffalo Bill*. Norman: University of Oklahoma.

Ryan, James. 1997. *Picturing Empire: Photography and the Visualization of the British Empire*. Chicago: University of Chicago Press.

Sahlins, Marshall. 1987. *Islands of History*. Chicago: University of Chicago Press.

Sands, Kathleen M., and Allison Sekaquaptewa Lewis. 1990. "Seeing with a Native Eye: A Hopi Film on Hopi." *American Indian Quarterly* 14 (4): 387–96.

Sandweiss, Martha. 2001. "Picturing Indians: Curtis in Context." In *The Plains Indians Photographs of Edward S. Curtis*, by Edward S. Curtis. Lincoln: University of Nebraska Press.

———. 2002. *Print the Legend: Photography and the American West*. New Haven, Conn.: Yale University Press.

Sapir, J. David. 1994. "On Fixing Ethnographic Shadows." *American Ethnologist* 21 (4): 867–85.

Savard, Dan. 2005. "Changing Images: Photographic Collections of First Peoples of the Pacific Northwest Coast Held in the Royal British Columbia Museum, 1860–1920." *B.C. Studies* 145 (Spring): 55–96.

Scarles, Caroline. 2010. "Where Words Fail, Visuals Ignite: Opportunities for Visual Autoethnography in Tourism Research." *Annals of Tourism Research* 37 (4): 905–26.

Scherer, Joanna C. 1970. *Indian Images: Photographs of North American Indians, 1847–1928*. Washington, D.C.: National Museum of Natural History.

———. 1975. "You Can't Believe Your Eyes: Inaccuracies in Photographs of North American Indians." *Studies in the Anthropology of Visual Culture* 2 (2): 67–79.

———. 1988. "The Public Faces of Sarah Winnemucca." *Cultural Anthropology* 3 (2): 178–204.

———. 1990. "Historical Photographs as Anthropological Documents: A Retrospect." *Visual Anthropology* 3 (2–3): 131–55.

———. 1992. "The Photographic Document: Photographs as Primary Data in Anthropological Inquiry." In *Anthropology and Photography, 1860–1920*, edited by Elizabeth Edwards, 32–41. New Haven, Conn.: Yale University Press.

———. 2006. *A Danish Photographer of Idaho Indians: Benedicte Wrensted*. Norman: University of Oklahoma Press.

———. 2008. *Edward Sheriff Curtis*. London: Phaidon.

Scherer, Joanna Cohan, and Jean Burton Walker. 1973. *Indians: The Great Photographs That Reveal North American Indian Life, 1847–1929*. New York: Crown.

Schuster, Roseanne. 2010. "What's in Your Freezer? Traditional Food Use and Security in Two Yukon First Nation Communities." Master's thesis, University of North British Columbia.

Schwartz, Joan, and James Ryan, eds. 2003. *Picturing Place: Photography and the Geographical Imagination*. London: I. B. Tauris.

Schwarz, Maureen T. 1997. "'The Eyes of Our Ancestors Have a Message': Studio Photographs at Fort Sumner, New Mexico, 1866." *Visual Anthropology* 10: 17–47.

Seabrook, Jeremy. 1989. "Photography and Popular Consciousness: 'My Life Is in That Box.'" *Ten-8* 34 (Autumn): 34–41.

"Shooting Indians with a Camera." 1915. *Detroit Free Press*, August 22, E5.

Shotridge, Louis. 1919a. "War Helmets and Clan Hats of the Tlingit Indians." *Museum Journal* 10 (1–2): 43–48.

———. 1919b. "A Visit to the Tsimshian Indians: The Skeena River." *Museum Journal* 10 (3): 49–67, 117–48.

Showalter, Elaine. 1987. *The Female Malady: Women, Madness and English Culture, 1830–1980*. London: Virago.

Silko, Leslie Marmon. 1981. *Storyteller*. New York: Little, Brown.

———. 1996. *Yellow Woman and a Beauty of the Spirit: Essays on Native American Life Today*. New York: Simon and Schuster.

Silversides, Brock. 1994. *The Face Pullers: Photographing Native Canadians, 1871–1939*. Markham, Ont.: Fifth House.

Simard, Jean-Jacques. 2017. "White Ghosts, Red Shadows: The Reduction of North American Natives." In *The Invented Indian: Cultural Fictions and Government Policies*, edited by James Clifton, chap. 17. New York: Routledge.

Skoda, Jennifer. 1996. "Image and Self in Contemporary Native American Photoart." *American Indian Art Magazine* 21 (2): 45–57.

Smith, Catherine Parsons. 2001. "An Operatic Skeleton on the Western Frontier: Zitkala-Ša, William F. Hanson, and the Sun Dance Opera." *Women and Music: A Journal of Gender and Culture* 5: 1–31.

Smith, Jane, and Robert Kvasnicka, eds. 1976. *Indian-White Relations: A Persistent Paradox.* Washington D.C.: Howard University Press.

Smith, Laura. 2008. "Obscuring the Distinctions, Revealing the Divergent Visions: Modernity and Indians in the Early Works of Kiowa Photographer Horace Poolaw, 1925–1945." Ph.D. diss., Indiana University.

———. 2011. "Modernity, Multiples, and Masculinity: Horace Poolaw's Postcards of Elder Kiowa Men." *Great Plains Quarterly* 31 (2): 125–45.

———. 2016. "Complex Negotiations: Beadwork, Gender, and Modernism in Horace Poolaw's Portrait of two Kiowa Women." In *Locating American Art: Finding Art's Meaning in Museums, Colonial Period to the Present*, edited by Cynthia Fowler, 215–28. New York: Routledge.

Smith, Linda Tuhiwai. 1999. *Decolonizing Methodologies: Research and Indigenous People.* London: Zed Books.

Smith, Paul Chaat. 2009. *Everything You Know about Indians Is Wrong.* Minneapolis: University of Minnesota Press.

"Some Indian Portraits." 1901. *Everybody's Magazine* 4 (17): 3–24.

Sontag, Susan. 1977. *On Photography.* New York: Farrar, Straus and Giroux.

Soukup, Katarina. 2006. "Travelling through Layers: Inuit Artists Appropriate New Technologies." *Canadian Journal of Communication* 31 (1): 239–46.

Southwell, Kristina, and John Lovett. 2010. *Life at the Kiowa, Comanche, and Wichita Agency: The Photographs of Annette Ross Hume.* Norman: University of Oklahoma Press.

Spence, Jo, and Patricia Holland, eds. 1991. *Family Snaps: The Meanings of Domestic Photography.* London: Virago Press.

Stedman, Raymond William. 1982. *Shadows of the Indian: Stereotypes in American Culture.* Norman: University of Oklahoma Press.

Stewart, Susan. 1992. *On Longing: Narratives of the Miniature, the Gigantic, the Souvenir, the Collection.* Durham, N.C.: Duke University Press.

Stokely, Michelle. 2015. "Picturing the People: Kiowa, Comanche and Plains Apache Postcards." *Plains Anthropologist* 60 (234): 99–123.

"A Successful Indian." 1903. *The Friend: A Religious and Literary Journal* 77 (15): 177.

Suddath, Claire. 2008. "A Brief History of Competitive Eating." *Time*, July 3. http://content.time.com/time/nation/article/0,8599,1820052,00.html.

Swan, Daniel. 1999. *Peyote Religious Art: Symbols of Faith and Belief.* Jackson: University Press of Mississippi.

Swanton, John R. 1904/5. "Social Conditions, Beliefs, and Linguistic Relationships of the Tlingit Indians." *Annual Report of the Bureau of American Ethnology to the Secretary of the Smithsonian Institution.* Washington D.C.: Smithsonian Institution.

Sweet, Jill, et al. 2001. *Staging the Indian: The Politics of Representation.* Saratoga Springs, N.Y.: Tang Teaching Museum and Art Gallery at Skidmore College.

Szaz, Margaret Connell. 1974. *Education and the American Indian: The Road to Self-Determination, 1928–1973.* Albuquerque: University of New Mexico Press.

———. 1994. *Between Indian and White Worlds.* Norman: University of Oklahoma Press.

"Telling History by Photographs: Records of North American Indians being Preserved." *The Craftsman* 9 (6): 846–49.

Teslin Tlingit Calendar 1983. 1982. Teslin: Teslin Indian Band; Whitehorse: Folklore Research Program, Council for Yukon Indians.

Thomas, Diane. 1978. *The Southwestern Indian Detours: The Story of the Fred Harvey/Santa Fe Railway Experiment in Detourism.* Phoenix, Ariz.: Hunter.

Thornton, Thomas. 1986. *Tlingit Light—Tlingit Photography, 1900–1940*, compiled by Robin Armour. Whitehorse: Yukon Archives.

———. 2000. "Picturing a People: George Johnston, Tlingit Photographer." *American Anthropologist* 102 (1): 155–56.

———. 2008. *Being and Place among the Tlingit*. Seattle: University of Washington Press.

Tolman, Carolyn. 2016. "The Carlisle Indian School Farmhouse: A Major Site of Memory." In *Carlisle Indian Industrial School: Indigenous Histories, Memories, Reclamations*, edited by Jacqueline Fear-Regal and Susan Rose, 274–91. Lincoln: University of Nebraska Press.

Tonkovich, Nicole. 2003. "Lost in the General Wreckage of the Far West: The Photographs and Writings of Jane Gay." In *Trading Gazes: Euro-American Women Photographers and Native North Americans, 1880–1940*, edited by Susan Bernardin et al., 33–72. New Brunswick, N.J.: Rutgers University Press.

Trachtenberg, Alan. 1989. *Reading American Photographs: Images as History, Mathew Brady to Walker Evans*. New York: Hill and Wang.

———. 2004. *Shades of Hiawatha: Staging Indians, Making Americans, 1880–1930*. New York: Hill and Wang.

Trafzer, Clifford, Jean A. Keller, and Lorene Sisquoc, eds. 2006. *Boarding School Blues: Revisiting American Indian Educational Experiences*. Lincoln: University of Nebraska Press.

Tremblay, Gail. 1993. "Constructing Images, Constructing Reality: American Indian Photography and Representation." *Views: The Journal of Photography in New England,* Winter, 8–13.

Trennert, Robert, Jr. 1982. "Educating Indian Girls at Nonreservation Boarding Schools, 1878–1920." *Western Historical Quarterly* 13 (3): 271–90.

———. 1988. *The Phoenix Indian School: Forced Assimilation in Arizona, 1891–1935*. Norman: University of Oklahoma Press.

Troy, Timothy. 1992. "Anthropology and Photography: Approaching a Native American Perspective." *Visual Anthropology* 5: 43–61.

Tsinhnahjinnie, Hulleah. 1993. "Compensating Imbalances." *Exposure* 29 (1).

Tsinhnahjinnie, Hulleah, and Veronica Passalacuqua, eds. 2006. *Our People, Our Land, Our Images: International Indigenous Photographers*. Davis: University of California, C. N. Gorman Museum.

Turner, Laura. 2004. "John Nicholas Choate and the Production of Photography at the Carlisle Indian School." In *Visualizing a Mission: Artifacts and Imagery of the Carlisle Indian School, 1879–1918*, edited by Phillip Earenfight. Carlisle, Pa.: Dickinson College.

Updike, John. 2007. "Visual Trophies: The Art of Snapshots." *New Yorker* 83 (41): 144–48.

Usher, Jean. 1974. "William Duncan of Metlakatla: A Victorian Missionary in British Columbia." Ph.D. diss., University of British Columbia.

U.S. Congress, House Committee on Indian Affairs. 1918. *Peyote Hearings before a Subcommittee of the Committee on Indian Affairs of the House of Representatives on HR 2614 to Amend Sections 2139 and 2140 of the Revised Statutes and the Acts Amendatory Thereof. and for Other Purposes*. Washington, D.C: Government Printing Office.

U.S. Office of Indian Affairs. 1911. *Annual Report of The Commissioner of Indian Affairs, for the Year 1911*. Washington, D.C.: Government Printing Office.

Utley, Robert. 1993. *Sitting Bull: The Life and Times of an American Patriot*. New York: Henry Holt.

Vecsey, Christopher. 1999. *Handbook of American Indian Religious Freedom*. New York: Crossroad Press.

"Views of Early Twentieth-Century Indian Life: The Harry Sampson Photo Exhibit." 1983. *Nevada Historical Society Quarterly* 26 (2): 122–26.

Viola, Herman. 1995. *Diplomats in Buckskins: Delegations in Washington City*. Norman: University of Oklahoma Press.

Virtual Museum of Canada. n.d. "George Johnston and His World: Life and Culture of the Inland Tlingit." Virtual Exhibit. Canadian Heritage Information Network (CHIN), Department of Canadian Heritage. http://www.virtualmuseum.ca/pm_v2.php?lg=English&ex=00000339&fl=0&id=exhibit_home.

Vizenor, Gerald. 1984. *The People Named the Chippewa: Narrative Histories*. Minneapolis: University of Minnesota Press.

———. 1998. *Fugitive Poses: Native American Indian Scenes of Absence and Presence*. Lincoln: University of Nebraska Press.

———. 2000. "Edward Curtis: Pictorialist and Ethnographic Adventurist." In *Special Presentation—Edward S. Curtis in Context*, at the Library of Congress online exhibit: Edward S. Curtis's *The North American Indian. Curtis Library, Northwestern University*, http://curtis.library.northwestern.edu.

———. 2007. "Forward." In *We Are at Home: Pictures of the Ojibwe People,* by Bruce White. St. Paul: Minnesota Historical Society Press.

———. 2009. *Interior Landscapes: Autobiographical Myths and Metaphors*. 2nd ed. Albany: State University of New York Press.

Warburg, Aby. 1998. "Images from the Region of the Pueblo Indians of North America." In *The Art of Art History: A Critical Anthology*, edited by Donald Preziosi. Oxford: Oxford University Press.

Warley, Linda. 2009. "Captured Childhoods: Photographs in Indian Residential School Memoir." In *Photographs, Histories, and Meanings*, edited by Marlene Kadar et al. New York: Palgrave Macmillan.

Warner, Iris. 1975. "Taylor and Drury, Ltd.—Yukon Merchants." *Alaska Journal* 5 (2):74–80.

Warner, Marina. 2006. "The Camera Steals the Soul." In *Phantasmagoria: Spirit Visions, Metaphors, and Media into the Twenty-First Century*. Oxford: Oxford University Press.

Wastell, Alfred M. 1955. "Alert Bay and Vicinity, 1870–1954." Vancouver: Vancouver Archives.

Watkins, Laurel J., with Parker McKenzie. 1984. *A Grammar of Kiowa*. Lincoln: University of Nebraska Press.

Weitenkampf, Frank. 1950. *Early Pictures of North American Indians: A Question of Ethnology*. New York: New York Public Library.

West, Ian. 1995. *Portraits of Native Americans*. New York: Smithmark.

West, Nancy M. 2000. *Kodak and the Lens of Nostalgia*. Charlottesville: University Press of Virginia.

West, Richard W., ed. 2000. *The Changing Presentation of the American Indian: Museums and Native Cultures*. Washington D.C.: Smithsonian Institution.

Weston, Mary Ann. 1996. *Native Americans in the News: Images of Indians in the Twentieth Century Press*. Westport, Conn.: Greenwood.

White, Bruce. 2007. *We Are at Home: Pictures of the Ojibwe People*. St. Paul: Minnesota Historical Society Press.

Whitehead, Harry. 2000. "The Hunt for Quesalid: Tracking Levi-Strauss' Shaman." *Anthropology and Medicine* 7 (2): 149–68.

Wildcat, Daniel. 2009. *Red Alert! Saving the Planet with Indigenous Knowledge*. Golden, Colo.: Fulcrum.

Willard, William. 1991. "The First Amendment, Anglo-Conformity and American Indian Religious Freedom." *Wicazo Sa Review* 7 (1): 25–41.

Williams, Carol. 2003. *Framing the West: Race, Gender and the Photographic Frontier in the Pacific Northwest*. Oxford: Oxford University Press.

Williams, Lucy Fowler. 2003. *Guide to the North American Ethnographic Collections at the University of Pennsylvania Museum of Archaeology and Anthropology*. Philadelphia: University

of Pennsylvania Museum of Archaeology and Anthropology.

———. 2015. "Louis Shotridge: Preserver of Tlingit History and Culture." In *Sharing Our Knowledge: The Tlingit and Their Coastal Neighbors*, edited by Sergei Kan, 63–78. Lincoln: University of Nebraska Press.

Wilmer, S. E., ed. 2009. *Native American Performance and Representation*. Tucson: University of Arizona Press.

Witmer, Linda. 1993. *The Indian Industrial School, Carlisle, Pennsylvania, 1879–1918*. Carlisle, Pa.: Cumberland County Historical Society.

Woodenlegs, John. 2007. *A Northern Cheyenne Album: Photographs by Thomas B. Marquis*. Edited by Margot Liberty. Norman: University of Oklahoma Press.

Wong, Hertha D. Sweet. 2000/2001. "Native American Visual Autobiography: Figuring Place, Subjectivity, and History." *Iowa Review* 30 (3): 145–56.

Worth, Sol, and John Adair. (1972) 1997. *Through Navajo Eyes: An Exploration in Film Communication and Anthropology*. Introduction by Richard Chalfen. Albuquerque: University of New Mexico Press.

Wunder, John, ed. 2013. *Native American Cultural and Religious Freedoms*. Lincoln: University of Nebraska Press.

Wuttunee, Wanda Ann. 1992. *In Business for Ourselves: Northern Entrepreneurs: Fifteen Case Studies of Successful Small Northern Businesses*. Montreal: McGill-Queen's University Press.

Wyatt, Victoria. 1989a. *Images from the Inside Passage: An Alaskan Portrait by Winter and Pond*. Seattle: University of Washington Press.

———. 1989b. "Alaskan Indian Wage Earners in the 19th Century: Economic Choices and Ethnic Identity on Southeast Alaska's Frontier." *Pacific Northwest Quarterly* 78 (1–2): 43–49.

———. 1991. "Interpreting the Balance of Power: A Case Study of Photographer and Subject in Images of Native Americans." *Exposure* 28 (3): 23–33.

Zamir, Shamoon. 2007a. "Living among the Dead: Richard Throssel and the Picturing of History at Little Big Horn." In *Place and Native American Indian History and Culture*, edited by Joy Porter, 49–70. Oxford: Peter Lang.

———. 2007b. "Native Agency and the Making of 'The North American Indian': Alexander B. Upshaw and Edward S. Curtis." *American Indian Quarterly* 31 (4): 613–53.

———. 2014. *The Gift of Face: Portraiture and Time in Edward S. Curtis's* The North American Indian. Chapel Hill: University of North Carolina Press.

Zitkala-Ša. 2003. *American Indians Stories, Legends, and other Writings*. Edited by Cathy Davidson and Ada Norris. New York: Penguin Books.

Index

References to illustrations appear in *italic* type.